We are dressed for a party to celebrate our **25**ᵗʰ anniversary...

Images 25 published by Rotovision SA
Rue du Bugnon 7
CH-1299 Crans-Près-Céligny
Switzerland

Exhibitions and Events Manager
Harriet Booth
T +44 (0)20 7739 8901

Book design
Atelier Works

Production in Singapore by ProVision Pte. Ltd
T +65 334 7720
F +65 334 7721

Association of Illustrators
81 Leonard Street
London EC2A 4QS
T +44 (0)20 7613 4328
F +44 (0)20 7613 4417
E info@a-o-illustrators.demon.co.uk
W www.aoi.co.uk

Rotovision SA
Editorial and Sales Office
Sheridan House
112/116A Western Road
Hove BN3 1DD
England
T +44 (0)1273 72 72 68
F +44 (0)1273 72 72 69
E sales@rotovision.com
W www.rotovision.com

Acknowledgements
We are grateful for the support of many organisations
and individuals who contributed to the Images Exhibition
and Annual as follows:

All our judges for applying their expertise to the difficult
task of selecting this year's work

The Royal College of Art for hosting the
Images 25 Exhibition

Pentagram Design Ltd and Waterstone's Booksellers
for their kind support of Images 25

Atelier Works for the design of this annual

Katherina Manolessou for her illustrations in this annual

Nicole Harman, Gary French, Jane Ralls and Becky Moss
at RotoVision for the production of Images 25

Robin Heighway-Bury for the use of his illustration
on the Call for Entries form

AOI Managing Council
Francis Blake, Michael Bramman, Derek Brazell,
Stuart Briers, Joanne Davies, Adam Graff,
James Marsh and Ali Pellatt

Finers Stephens Innocent for their legal advice

Events and Exhibitions Manager
Emily Glass (up to August 2000)

AOI Manager
Samantha Taylor (up to July 2000)

All our volunteers for their dedicated and invaluable
assistance with the competition and exhibition.

contents

about the AOI

The AOI was established in 1973 to advance and protect illustrators' rights and encourage professional standards. The AOI is a non-profit making trade association dedicated to its members' professional interests and the promotion of illustration.

Members consist primarily of freelance illustrators as well as agents, clients, students and lecturers. The AOI is run by an administrative staff responsible to a Council of Management.

As the only body to represent illustrators and campaign for their rights in the UK, the AOI has successfully increased the standing of illustration as a profession and improved the commercial and ethical conditions of employment for illustrators.

Campaigning

The AOI is a member of the British Copyright Council and the Creators Copyright Coalition. It helped set up the secondary rights arm of DACS, the UK visual arts collecting society.

The AOI was responsible for establishing the right of illustrators to retain ownership of their artwork and continues to campaign against loss of copyright control, bad contracts and exploitative practices. We will expose companies who consistently abuse illustrators' rights.

Information and support services

Portfolio Advice

Members are entitled to a discounted annual consultation with the AOI's portfolio consultant. Objective advice is given on portfolio presentation and content, suitable illustration markets and agents.

Journal

The AOI Journal (Illustrator) is distributed bi-monthly to members, keeping them informed about exhibitions, competitions, campaigns and activities in the profession.

Hotline Advice

Members have access to a special Hotline number if they need advice about pricing commissions, copyright and ethics problems.

Publications

The AOI publishes Rights: The Illustrator's Guide to Professional Practice, a comprehensive guide to the law for illustrators. It provides detailed advice on how to protect against exploitative practices and contains a model contract for illustrators to use. We also produce Survive: The Illustrator's Guide to a Professional Career which is a comprehensive practical guide to beginning and continuing a career as a professional illustrator. Survive includes information about marketing, ethics, agents and a guide to fees. These publications are available to members at reduced rates.

Client Directories

The AOI currently has three illustration client directories which are only available for purchase by members. The Editorial Directory has details of over 100 contacts in the newspaper and magazine industries. The Publishing Directory is a comprehensive list of important contacts in book publishing. The Advertising Directory has details of over 200 contacts from the world of advertising.

Business Advice

Members are entitled to a free consultation with the AOI Chartered Accountant, who can advise on accounting, National Insurance, tax, VAT and book-keeping.

Regional Groups

The contact details of regional representatives are available to members who organise social activities for regional members and provide an important support network.

Discounts

Members receive discounts on a range of services, including a number of art material suppliers nationwide.

Legal Advice

Full members receive advice on ethics and contractual problems, copyright and moral right disputes.

Return of Artwork Stickers

Available to AOI members only. These stickers help safeguard the return of artwork.

Students and New Illustrators

Our seminars and events, combined with the many services we offer, can provide practical support to illustrators in the early stages of their career.

Events

The AOI runs an annual programme of events which include one day seminars, evening lectures and thematic exhibitions. These include talks by leading illustrators as well as representatives from all areas of the illustration field, and cover such subjects as children's book illustration, aspects of professional practice, new technologies and illustrators' agents. AOI members are entitled to discounted tickets. To request further information or a membership application form please telephone +44 (0)20 7613 4328

Website

Visit our website at www.aoi.co.uk for details of the Association's activities, including samples from current and past journals, details of forthcoming events, the AOI's history and on-line gallery.

Patrons

Glen Baxter
Peter Blake
Quentin Blake
Raymond Briggs
Chloe Cheese
Carolyn Gowdy
Brian Grimwood
John Hegarty
David Hughes
Shirely Hughes
Sue Huntley
Donna Muir
Ian Pollock
Gary Powell
Tony Ross
Ronald Searle
Paul Slater
Ralph Steadman
Simon Stern
Peter Till
Janet Woolley

foreword

The last 25 years has been tumultuous for the profession of illustration and the AOI continues to strive to be both an anchor and guiding light in a choppy sea of change. The publication Images has become a beacon of sorts fulfilling a unique and pivotal role in celebrating and promoting British Illustration. Certainly a ubiquitous presence in the offices of some of the most respected advertising agencies, design groups and publishing houses nationally is testimony to Images' value to the industry. It stands out from the rest, from some ersatz and anodyne publications as a 'source' book with a difference. Images alone can proudly substantiate the claim of being the BEST of British illustration.

This year witnessed a collaborative endeavour between the AOI and SAA to attract a maximum number of illustrators to submit work for consideration, a process culminating in the highest number of aspiring entries in 6 years. From this increased entry our selected panel of respected judges, drawn broadly from the profession, have applied knowledge and insight to ensure Images 25 emerges as a most meritorious collection representing exemplary standards within the diversity of contemporary practice.

Images will be referred to by leading clients and commissioners, with 4,000 copies distributed nationally, and virtual publication on the World Wide Web ensuring an international audience. It will be valued by students and academics as a catalogue of quality which documents some of the best images of a new century and viewed by illustrators as a benchmark for excellence. The book will facilitate the launching of new careers, help to nurture some tentative beginnings and endorse established practice.

Source books generally have been criticised adversely by some sections of the design press. To consider Images, however, with such deference belies the integrity which has engineered its creation and conceals the genuine worth it holds. One cannot deny that this is a source, yes, this is the source of entertainment, stimulation, information, creativity and delight which illustration can constitute. You may want to add your own superlatives to this list.

When technological, cultural, social and financial imperatives continue to redefine and reshape the landscape of the profession, placing multifarious obstacles in the path of its practitioners, this collection affirms the strength of individuals to embrace both change and uncertainty with ingenuity and flair. It is clear from Images 25 that British illustration continues to be extant, gaining fresh momentum as it evolves.

Our publication respects practitioners as both pioneers of innovation and invention and guardians of the traditions of creative, intellectual and aesthetic excellence. Applaud the illustrators herein, together with the thoughtful commissioning which has allowed them to demonstrate their power and the intelligence invested in what is here presented as the best.

As the line at the top says …Forward

images 16

Exhibition only

25 years of Images

Simon Stern

AOI Patron

At the beginning of the 70s, though colour offset lithography had already ushered in the wealth of adventurous children's illustration that we now take for granted, the rest of the illustration market was confined to realistic work on paperbacks and in women's magazines, (usually featuring semi-clad females) and a tiny quantity of more stylised work, most of it in black and white in the Radio Times. That was about it.

So when, in 1973, a small group of illustrators and agents got together to inaugurate the Association of Illustrators, chief among their aims was to expand the market for illustration. By 1975 the AOI's bi-monthly Journal had started to include a substantial amount of imagery, and in 1976 the first jury selected Association of Illustrators Annual of Illustration was published. It was a heroic achievement; then, as now, the product of huge amounts of work and angst for those who created it: a good deal of angst, too, for those who failed to get in. Every year the AOI tried to make sure its juries were well balanced; every year came passionate complaints from a few of the unsuccessful. Since only one entry got in for every ten submitted, the offended always outnumbered the delighted by a good margin.

The annual fell on fertile soil. The design industry was ready for new ideas and art directors seized on the new imagery, both the mainstream and the more adventurous. Except for Booth Clibborn's 'European Illustration' there was no other illustration annual around. In those happy days clients actually bought their copy, and entry costs for the illustrator were nominal.

There have been two name changes over the years. Annuals 4 & 5 were re-christened 'The Best of British Illustration', but Edward Booth Clibborn threatened to sue, so the name was changed to 'Images', a name that has stuck ever since.

In other fields, too, the AOI was making progress. Clients no longer assumed they owned the artwork they commissioned. The legal niceties of licencing and copyright were sorted out, at least in theory. A huge battle with the print unions was fought and won under the long reign of Joyce Kirkland, the AOI's first full-time administrator. The 'radical committee' arrived on the scene in 1981, and caused a huge rumpus. Under its influence the work of Ian Pollock, George Snow, Andrej Klimowski and others was seen as the new wave in illustration. The AOI acquired a gallery near Goodge Street, the magazine went into colour, business was booming (remember 'big bang'?) and illustration had arrived.

Then the AOI became the victim of its own success. Illustration's new high profile spawned illustration courses in the colleges and a flood of new people on the market. Two major sponsors, Benson & Hedges and the Readers Digest, withdrew their support. New illustration agencies sprang up, quite a few started by ex AOI administrators, so that many more artists had agents to represent them and felt less need to belong to the AOI. The 1992 recession hit. When it was over computers had come on the scene, and the days when illustration was the new fashionable happening thing were over.

The AOI's existence had also made possible the advent of Contact, the first of the paid space annuals. Contact: Illustrators '85 had a mere 26 pages of illustration in it, but it grew. Though the artists had to pay to get in, it had two great advantages: it was sent to clients free, and from the illustrator's point of view you could, once you'd paid your money, be sure of getting in.

So Images had to follow suit. It, too, was sent out free, and charged the illustrator for entry, albeit less than half as much as Contact. Today, though no longer the only all British annual around, Images continues its important role as the only jury selected annual, providing a showcase in which illustrators can be sure of rubbing shoulders with the best, and commissioners can see the best. For the artists who submit their work to the judgment of their peers, Images is the benchmark.

As for the AOI, though it has had to pull in its horns since the 80s, it is still going strong. The big battle now is over intellectual property, a battle being fought side by side with photographers and journalists not just in the UK, but worldwide. By plugging into this network of creator organisations of every kind, we are able to add our voice in government and in Europe to those resisting the corporate takeover of the ownership of copyright in imagery.

The magazine re-launch and the AOI's evolving web-site, on which a fuller history of the AOI can be found, (www.aoi.co.uk) show that it is still on the move. Looking back at how things were when the AOI started it seems to me that it has achieved an enormous amount, and my bet is both the AOI and Images will be going strong another twenty five years from now.

the future of illustration

Harry Lyon Smith

Illustrators' Agent

To consider the styles and fashions into the future is the most difficult thing of all. We will see the usual retro styles coming round in fashion, but whatever the style the market will use highly skilled and creative illustrators who are both professional, good to deal with and progressive in their work.

I very confidently base any thoughts that I may have in this piece on the one over riding belief that illustrators will be playing as an important, if not greater, role in the worlds' media in 25 years time as today.

The real question is what will constitute an illustration? We are already seeing hybrid images that float between illustration, animation, computer graphics, model making and photography. These images are being created principally on computer systems that have now become affordable and software that is of a standard that can be used commercially by the majority. This is only going to evolve and embrace more illustrators. There will be just as many individual styles and techniques. Illustrators will be as confident working on screen as they were with brush in hand, as many are already. The market is and will demand animation and 3D imagery in nearly all styles along with quicker delivery.

We need to consider, as the basis of all thoughts on the future, where illustration will appear. For about the last 250 years, illustration has enjoyed print as its main platform, in fact it was this technology that really gave rise to our genre.

Will this remain our platform when screen use is accelerating so fast? We have come to a fork in the road as I see it. Over the last year or so our agency has seen a significant rise in commissions for use in New Media and it is set to grow.

Things will really change when two technologies arise: firstly, the merging of the web and television. This is just around the corner and within 5 years the majority of the population will have a Web/TV in their homes and offices. This will mean that web sites become more like channels as we know on TV, and every one of those will need visual content. Some of the content will be film and studio. However there are going to be millions of channels requiring illustrated images in all forms.

Secondly, the development and distribution of wireless broadband technology. This is already advanced and we will be seeing this easily within 10 years. The important thing about this is that we will all have our own highly portable real-time 'tablet' (for want of a better word). This tablet will be our complete communication tool. It will be our PC, Web/TV, phone, e-mailer, we will be able to type on it, write on it, dictate to it, read our books, newspapers and magazines on it. And we will probably have several of them, one for the office/work, one for home, one for school, one for holidays and reading in the bath etc. They will all hold the same info and have the same functions, but will be differently designed depending on the use, i.e. waterproof, or flexible, leather-bound etc.

How often, if this is the future, will our work be reproduced on paper? Less and less I would suggest. When everything is so portable, when memory is not ever an issue and processing power is real-time, will we need many of the reference books, the educational books, the picture books to be printed, let alone the newspapers and magazines?

There will be, for the current living generations, a printed requirement. Print output may well rise up until the time that the 'tablet' is both affordable and taken up by most of the population.

How do we exploit all the changes ahead rather than feel threatened and swamped by them? Well it is an attitude of mind as much as anything, new technology and a changing way of life is happening and will continue at an ever increasing pace. To turn our back on it is to jeopardise our futures so we must embrace it and use it. Leading illustrators in the future, much as they have always been, will never rest on their laurels. Perhaps this has traditionally been as much to do with continually evolving one's style and perfecting techniques. Now with technology giving us what it does they will seek out the latest developments and harness them to their own creativity, building on what they do and taking them on to new levels. The boundaries for the majority of illustrators are being taken down giving them access to a whole new market on the screen.

The marketing of our work is changing rapidly. The web allows a truly international audience and what with e-mail and cheap international calls it is now not an issue to think beyond our shores. This applies to us going to the rest of the world, but it also means the rest of the world is available to our traditional markets. Clients are losing their fear of international commissioning to the extent that where you live will be a complete irrelevance from now on. One of our busiest artists moved to Australia 2 years ago and has more work now from the UK than ever before. This is a liberty that technology has given us and it may as well be taken advantage of.

Our agency currently enjoys over 50% of inquiries involving our website. This has changed from zero in just 3 years. Each month we see this gradually building and with it a lesser use of portfolios. I can only assume that in not many years from now traditional portfolios will become somewhat redundant. We place as much importance updating online portfolios as on the traditional. This has meant a very heavy investment in technology, personnel and training to achieve and maintain it. This is not a process that we will see diminish, increasing our investment year on year, learning new ways to market ourselves on the net and create the best possible platform for our artists. This has not meant a reduction in printed promotion yet, it may be increasing. However this is bound to change in the longer term, as people's first point of call becomes the web, rather than the bookshelf. The marketing challenge will be to get commissioners to find your website.

Stock image sales are perfect for the web and I am sure that we will see an increasing availability of stock illustration. However it must not take over from bespoke commissions. If we allow too greater proliferation of stock and cheap prices we will be saying to our clients that we would rather they bought stock than commissioned us. This could lead to our industry starving itself and drying up in many quarters. It is beginning to happen in some instances and we have all heard how some photographers have been put out of business as stock proliferates in their industry. It is our duty to take a long-term view on this and manage our stock resources responsibly.

One of the greatest evolutions that I see coming to our practice is the involvement of the art director/designer in the commissioning and creating process. Illustration has been thought by a sizeable part of the market as a bit risky, because clients had to wait until the final delivery to see if the illustrator had recreated their mind's eye. These days are going as clients are already able to see, and get involved in the process via e-mails. In the future real time invited access to the artist's screen along with a webcam chat will complete this involvement. This will put us on a par with the photographer's Polaroid, and should see new clients come our way.

Again our agency has seen a marked move from the days when changes had to be sent back to the artist, this never happens now as the client will have seen the work before it left on an e-mail. Rejected work, which painfully happened from time to time, seems to be a thing of the past. And it is all because clients are so much better informed on who and what they are commissioning and being that much more involved in the process.

In summary, if an e-year equates to 7 normal business years then being asked to reveal the next 25 is to consider the next 6 generations of illustration and how it will be used in the technology that will be available to us. Challenging and highly speculative but there are some happenings and that can give one a steer.

I believe the future is very rosy. It is changing fast and there sadly will be casualties along the way. But it is a future where the illustrator will become a key supplier of visual content in New Media to a much greater extent than we have ever seen in the role to date. The work will be much more widely seen and appreciated, giving a greater acknowledgement and public awareness to the genre. Illustrators will be consulted and play a fundamental role in the direction and production of content, be it TV, websites, presentations, publishing, ads and graphics.

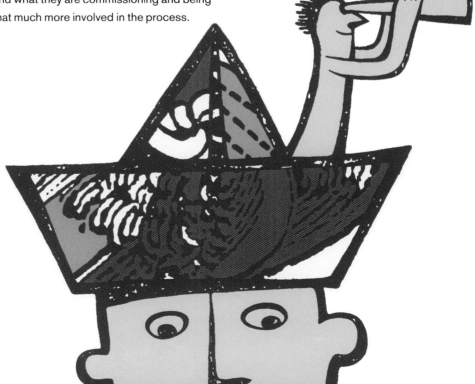

judges of **images**

4

23

20

12

28

29

24

22

21

15

8

10

17

18

25

13

Advertising	Design	Editorial	Children's and General books	Student	Unpublished
1 Colin Barker Art Buyer, GGT Direct	**6 Mike Dempsey** Designer, CDT Design	**11 Frazer Hudson** Illustrator	**16 Paul Wearing** Illustrator	**22 Jill Calder** Illustrator	**27 Vanessa Dell** Illustrator and illustrators' agent
2 Clare Mackie Illustrator	**7 Claire Fletcher** Illustrator	**12 Andrew Kingham** Illustrator	**17 Joe Whitlock Blundell** Production Director, Folio Society	**23 Nelly Dimitranova** Illustrator	**28 Anne Magill** Illustrator
3 James Marsh Illustrator	**8 Quentin Newark** Director, Atelier	**13 Debbie Lush** Illustrator	**18 Katherine Baxter** Illustrator	**24 Andrew Foster** Illustrator	**29 Ashley Potter** Illustrator
4 Henry Obasi Illustrator	**9 Mark Oliver** Illustrator	**14 Courtney Murphy Price** Art Director, The Independant Sunday Review	**19 Lizzie Harper** Illustrator	**25 Barry Robinson** Design & Security Print Director, Royal Mail	**30 Gary Powell** Senior Lecturer, University of Brighton
5 Pat Scovell Head of Art Buying Mc Cann Erickson	**10 Reggie Pedro** Illustrator	**15 Patrick Myles** Art Director, ETP Ltd	**20 Alison Jay** Illustrator	**26 Brian Webb** Creative Director, Trickett & Webb	**31 Samantha Wilson** Illustrator
			21 Mike Jolley Art Director, Templar Publishing		

About the illustrations

M Medium
B Brief
C Commissioned by
F Firm

Advertising
Gold award winner

Russell Cobb
G The Times Feed Your
Mind Campaign
'Padlock'

M Acrylic

B Relaunch The Times as
a knowledge provider
and increase loyalty

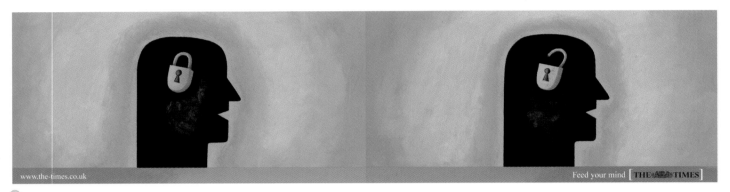

C Chris Hodgekiss
Pip Bishop

F Rainey Kelly Cambell
Roalfe
Y&R

'Acorn'
'World'
'Tin Opener'

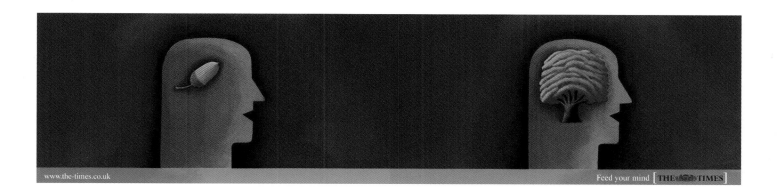

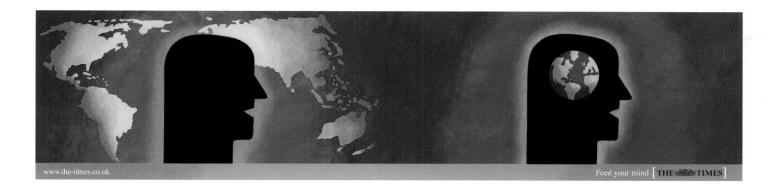

Lo Cole
Edinburgh Festival
Fringe Programme
Cover

M Photoshop

B To convey all aspects
of fringe festival in
one integral image
incorporating copy

Turinna Gren
Tempo Tissues

M Computer generated

B By using this
antibacterial tissue,
which also contains
aloe vera, you can
maintain an active
life even if you have
a cold.

Peter Grundy
Electronic Shamrock

M Illustrator 8

B Design a shamrock
to copyline 'We'll get
you there on time'
(press ad)

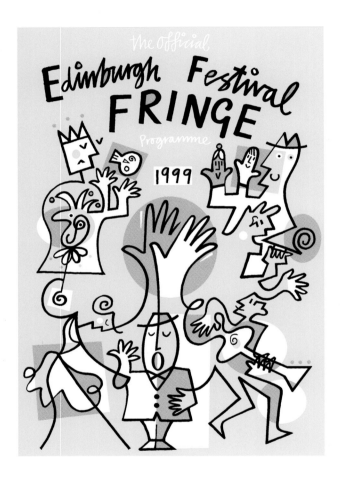

C Lee Southey
F The National Magazine Company Ltd

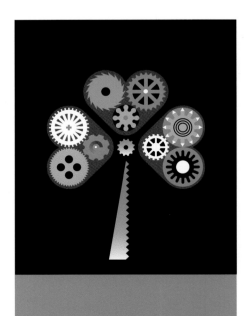

C Emma Davies
F Crombie Anderson

C Cara Devenish
F Abbott Mead Vickers

Matilda Harrison
The Wolf After Granny

M Acrylic

B To produce an
illustration of the wolf
from Little Red Riding
Hood after he's eaten
the grandma. It was
to look like a classical,
almost stereotypical
children's book
illustration

Paul Hess
Gold Lowest Cows

M Watercolour

B To follow art director's
brief for a press
campaign

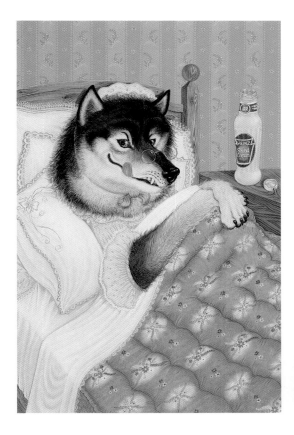

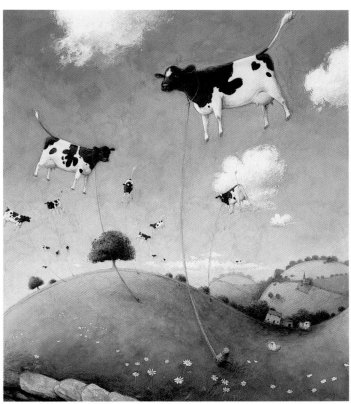

C Sarah Lane
F Leo Burnett

C Ray Brennan
F D'Arcy

Frazer Hudson
Free Your Mind
M Digital
B Illustrate the caption
'Free your mind'.
Featuring the same
character in 5 press
advertisements,
'Declare your
independence',
'Millennium',
'Shorten your day',
'Make your own rules'

David Humphries
Sunbather
M Collage
B Depict a character
indulging in a typical
holiday activity in a
domestic environment

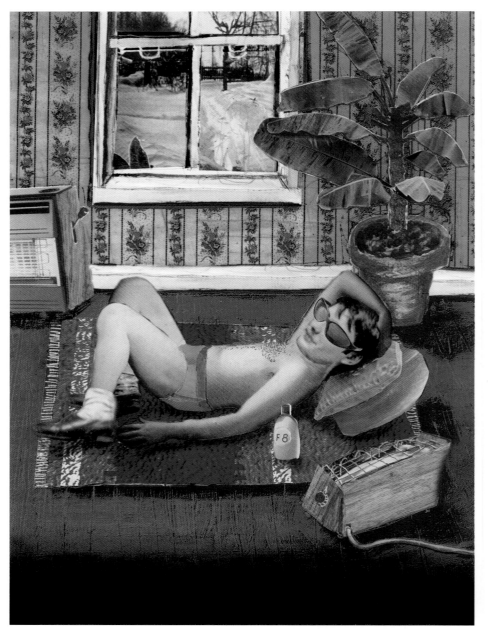

C Mark Lane
F Grange Advertising

C Clare Delafons
F TBWA London

Andrew Kingham
Are You Doing Your
Bit? Turn Off The Light!

M Metal

B Part of a government
sponsored campaign
to persuade people to
use less of the earth's
natural resources

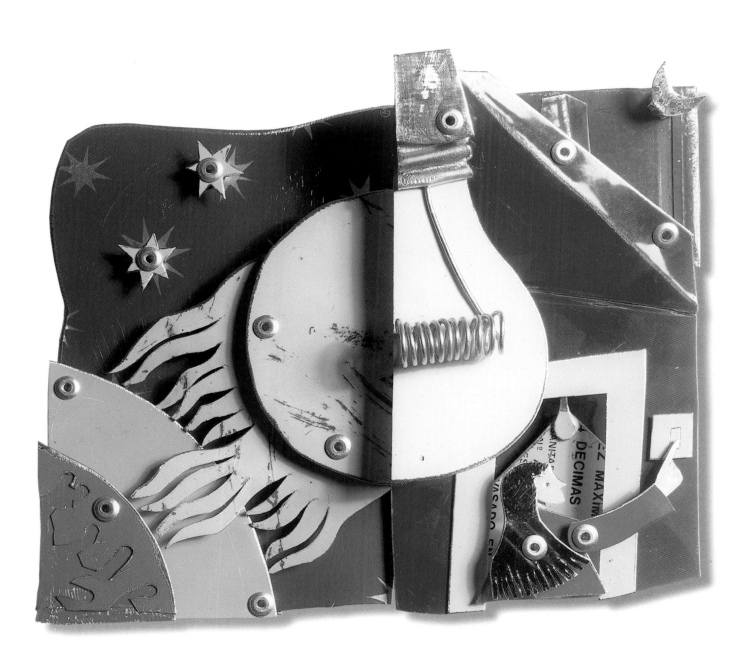

James Marsh
0-60 in 12 seconds

M Acrylic on Canvas and
Photoshop collage

B To illustrate page of
a flip book, one half
toy horse, thee other
half racehorse

Lydia Monks
Playground

M Mixed media

B To illustrate some
groups of children in a
playground, showing
that the children who
gave their friends
Mars Bars were
more popular

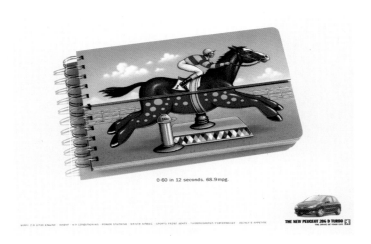

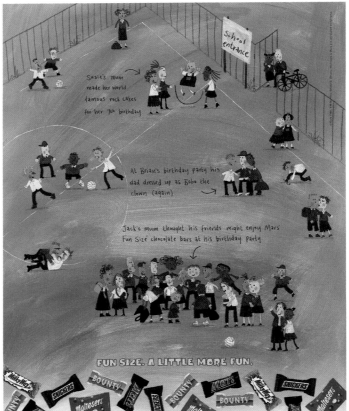

C Andy Mackay
F RSCG Euro

C Abbott Mead Vickers

Ali Pellatt

Tom from Tottenham

M Mixed media

B To portray designer Tom as an archetypical web programmer/interactive designer – a cool techno freak

Michaela from Manchester

M Mixed media

B To portray Michaela as an archetypical e-commerce person – style conscious, slick and hard-edged

Linda from Luton

M Mixed media

B To portray Linda as an archetypical networker in the e-office environment – sweet, friendly, young, intelligent

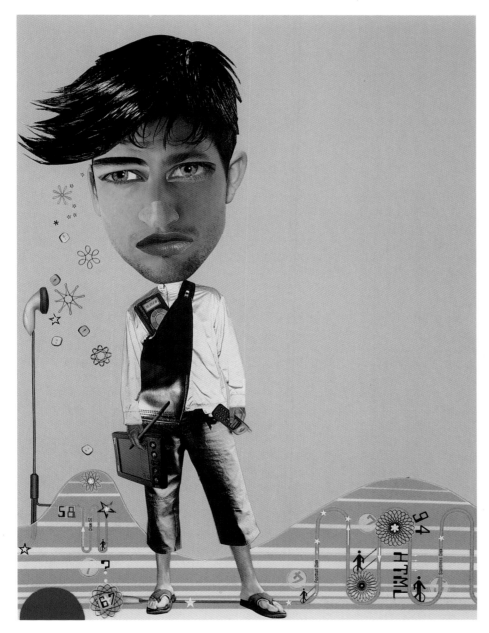

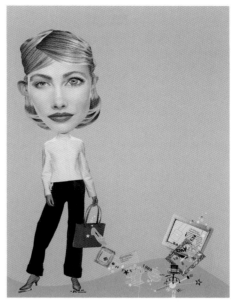

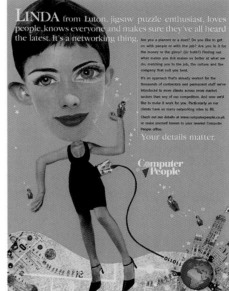

C Barkers

Ian Pollock
Cruel Britannia
M Watercolour, ink
 and gouache
B Poster campaign for
 The London Dungeon.
 4 sheet poster on
 London Underground
 on behalf of The
 London Dungeon.

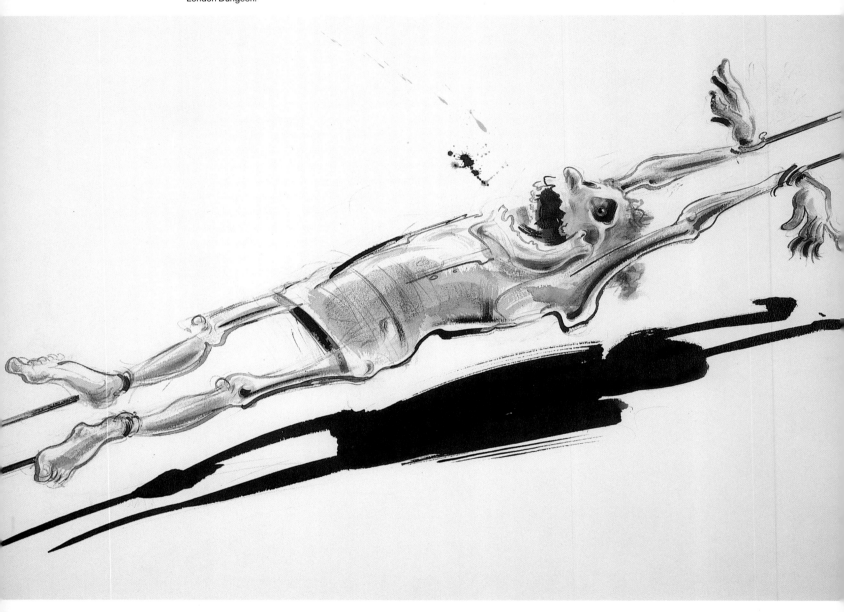

C Rob Hammond
F The Real Adventure

Shonagh Rae

Bubbles

M Mixed media

B Illustrate a woman relaxing after a shopping trip and showing how she has taken advantage of a money saving opportunity using her NatWest card

Desert Island

M Mixed media

B Communicate what creams can become reality if you're resourceful. Who needs posh hotels? Sleeping under the stars is for people with more sense than money

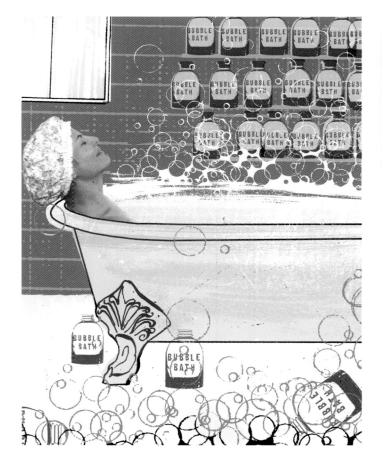

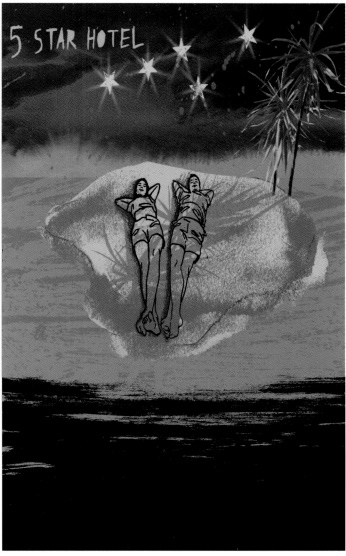

C Julia Fisher
F TBWA

C Rachel Sharman
F TBWA

Brett Ryder
Headaches Removed

M Mixed media
B Illustrate how the
 NatWest graduate
 package removes
 financial headaches

Karen Selby
I Didn't Know I Cared

M Pen and ink
B Indulge yourself at
 the Liberty sale

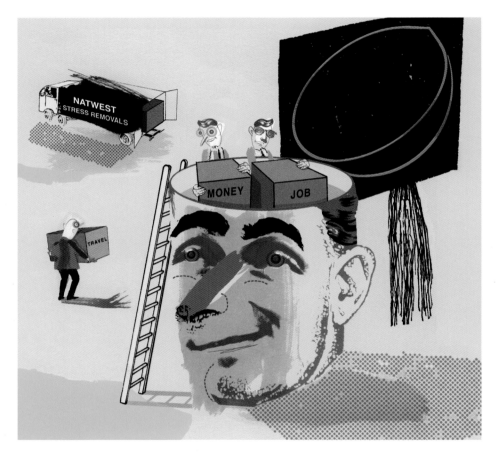

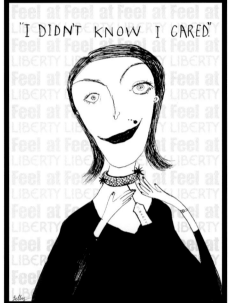

C Alastair Hutchinson
F TBWA

C Clare Delafons
F TBWA London

Peter Suart
Feer Gynt
M Watercolour and pen
B Fublicity material
for the play

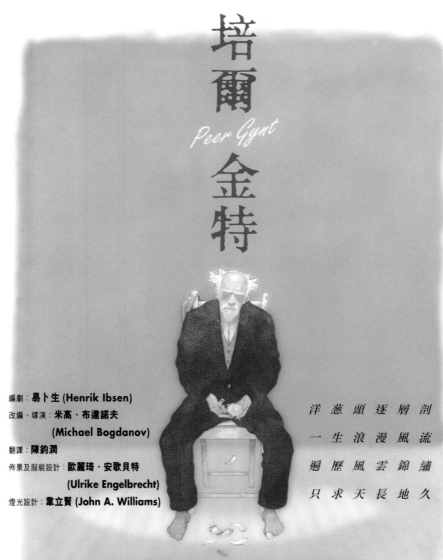

C Ada Kwan
F Hong Kong
Repertory Theatre

Mark Thomas
Natwest Loans
are Child's Play

M Brush line (Indian ink)
and liquid acrylics

B Pastiche of 1950's
girl's comic-style
paper dolls – to work
if actually cut out and
made up! This was
one of a series of 4
ads (all in slightly
differing styles)

Bob Venables
St Terry of East
Grinstead

M Alkyd

B To paint a Gothic
stained glass window,
but with a modern
view of Guinness
advertising campaign
in press

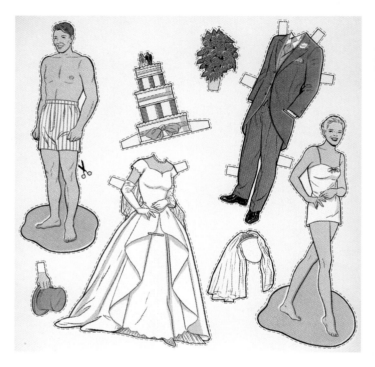

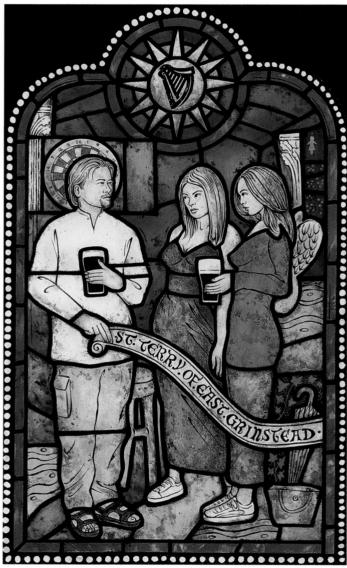

C Gavin McGrath
F TBWA

C Amanda Goonetilleke
F Abbot Mead Vickers

Holly Warburton
Take-away

M Mixed media

B Create an image
of a woman with a
bowl of noodles on a
background depicting
China to suggest an
icon of Madonna

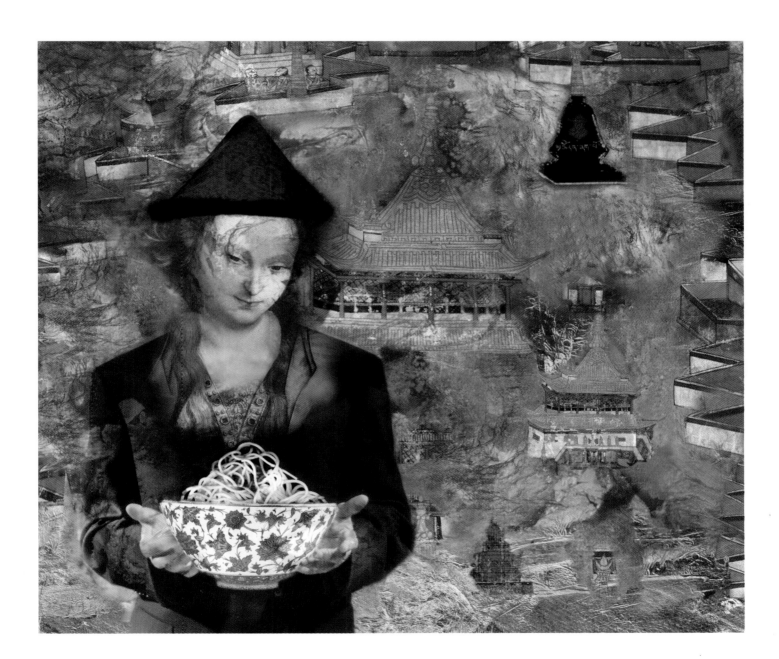

C Julia Fisher

F TBWA

Paul Wearing

Doing anything good
for the millennium?

M Digital

B For a below line
campaign advertising
a government charity
initiative. Conveying
the idea of giving,
avoiding imagery
normally associated
with third world
charities

For the millennium,
why not sow your oats?

For the millennium,
why not organise a
few drinks
somewhere hot?

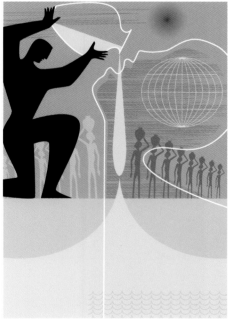

C Kit Marr

F HPT Brand Response

Chris West

B Bombay Sapphire Campaign

M Oil

B Create a range of six postcards for P.O.S. presentat on based on Bombay Sapphire's interpretation of great artists and their styles

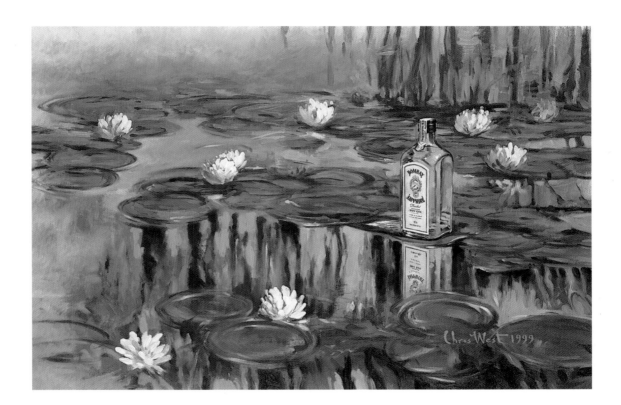

C B D London

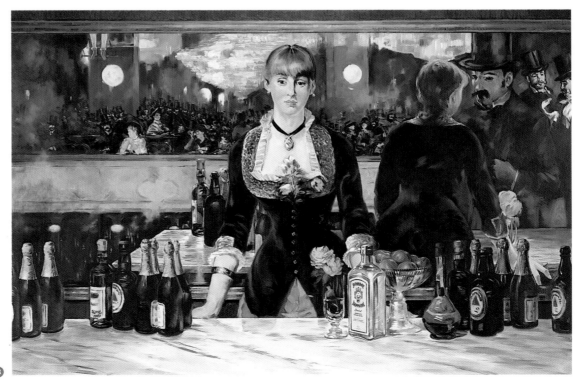

Ian Whadcock

S Volkswagen Golf '25 Years of Refinement

M Digital

B To illustrate VW Golf's Mk1-4 in respect of advances in suspension technology – for use as spoof set of stamps in press ads

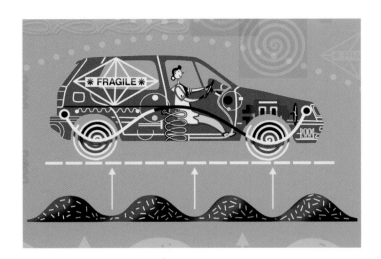

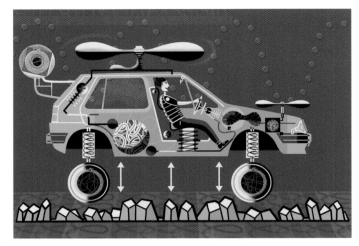

C Grant Parker

F BMP DDB

Design
Gold award winner

Ian Whadcock

G Transcend

M Digital

B The illustration is part of a sequence of 8 images for Rockwell Electronic Commerce Limited. The brief was to illustrate Telecommunications Call Centre solutions for small to medium sized businesses

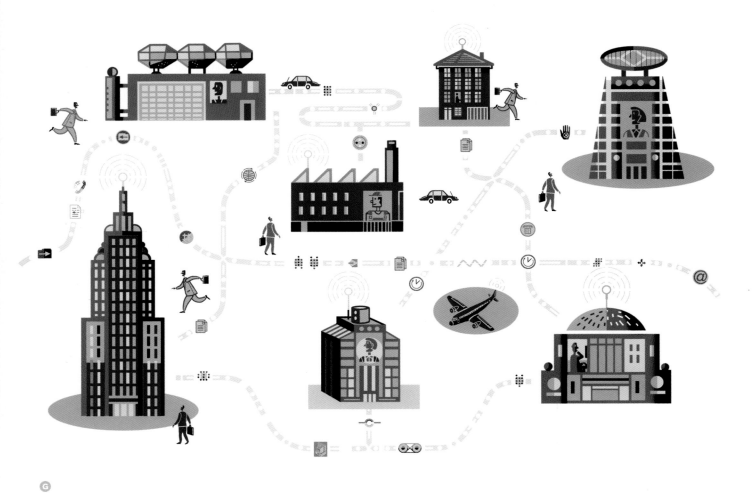

G

C Jon Grover

F Kysen

Stephen Bliss

Silhouette Stripes

M Black ink, gouache, collage and Illustrator 6

B Produce an image for T-shirt and catalogue usage

Swinger Perfume

M Black ink, gouache, collage and Illustrator 6

B Create a fake perfume bottle as a pop icon for use on T-shirts and posters

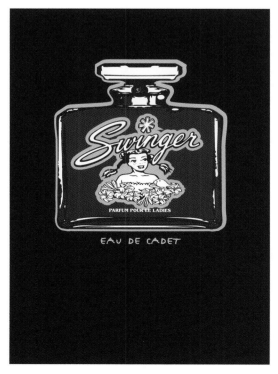

C Jeremy Joseph

F De-lux

Izhar Cohen

Flight of the Imagination
M Water colour
B Saison calendar: a celebration of the end of a century and a start of a millennium

Tall Story
M Water colour
B Saison calendar: a celebration of the end of a century and a start of a millennium

Milking
M Digital
B Wiseman's Dairy Annual Report

Transportation of Milk
M Digital
B Wiseman's Dairy Annual Report

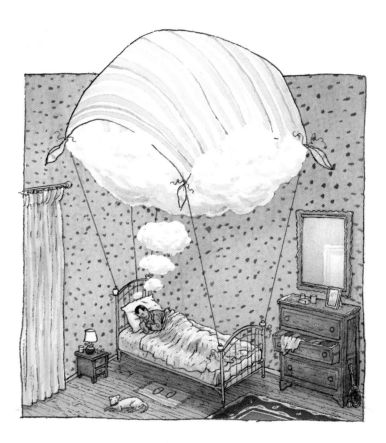

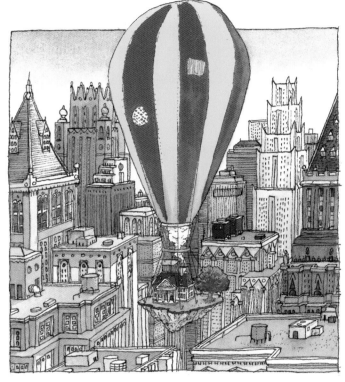

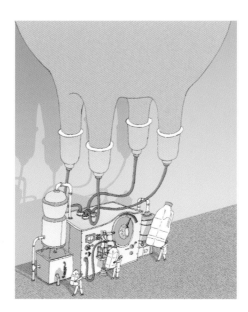

C Cate Studwell
F The Tayburn Group

C Cate Studwell
F The Tayburn Group

Andrew Davidson

Forging Partnerships

M Gouache

B To illustrate a poster, for a poster site, to be placed in a photograph of a railway relevant site, for Railtrack's annual report

Green for Go

M Gouache

B To illustrate a poster, for a poster site, to be placed in a photograph of a railway relevant site, for Railtrack's annual report

Ⓢ Robert the Bruce Millennium Stamps

M Wood engraving

B To illustrate Robert the Bruce and the Battle of Bannockburn. To be seen as one of four stamps in The Soldiers tale, part of The Royal Mail's millennium stamp programme

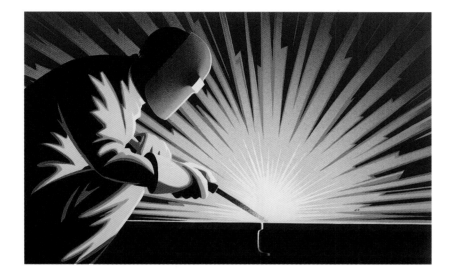

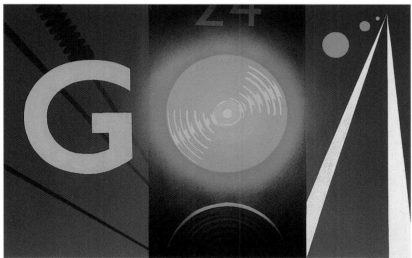

C David Stocks

F SAS

C Mike Dempsey

F CDT

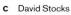

Red Dot
Global

M Mixed media
B Produce 6 A4 colour
 images (plus 16 spot
 illustrations) depicting
 the terms global,
 innovative, powerful,
 committed, focused
 and future for Dresdner
 Kleinwort Bensons
 annual report

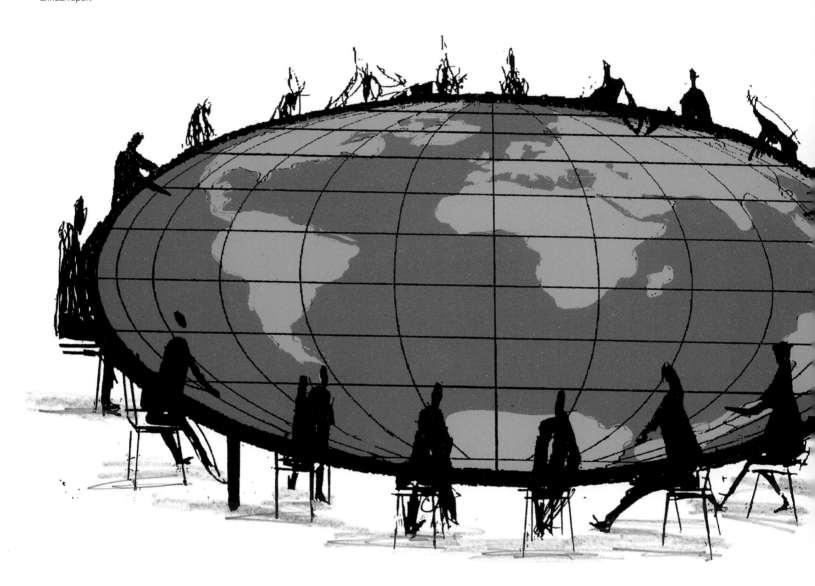

C Andrew Gorman
F Radley Yelder

Colin Elgie
Rocket

M Powermac G4 using
Adobe Illustrator 8
and Photoshop 5.5

B To illustrate the idea
of a company being
poised to take off and
achieve greater profits
for an annual report

Max Ellis
Clockwork King

M Digital

B Produced as part
of a range of
greetings cards

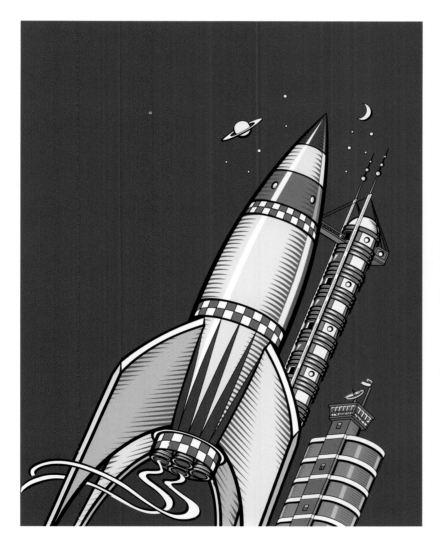

C Mike Higgs

F Talkvisual

C Dan and Lucy Good

F Lightweight Designs

Michael Gillette
Trendspotting
M Digital
B Depict the importance of seeing future trends, an article in Atticus, published by WPP Group plc

Christopher Gilvan-Cartwright
Proms 99
Catalogue Cover
M Collage
B To produce a contemporary, stylish image which incorporates the shape of the Albert Hall, sums up the Proms, can be rearranged for other merchandise

Peter Grundy
B Poster for Moet & Chandon
M Illustrator 8
B Ten international artists chosen to produce an image for a limited edition of posters celebrating Moet & Chandon

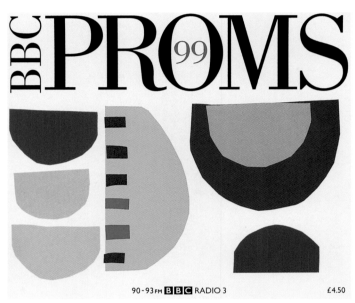

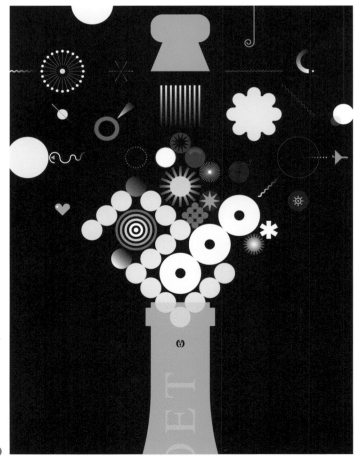

C David Freeman
F Enterprise IG

C Kate Finch
F BBC

C Patrick Amsellem
F Moet & Chandon

Martin Haake

Hope against Hype

M Gouache and collage

B Depict how to evaluate
the effectiveness of
pharmaceutical
advertising, an article
in Atticus, published
by WPP Group Plc

Dovetail Bus

M Collage on paper

B Create an image for a
party invitation for the
opening of dovetail
furniture shop

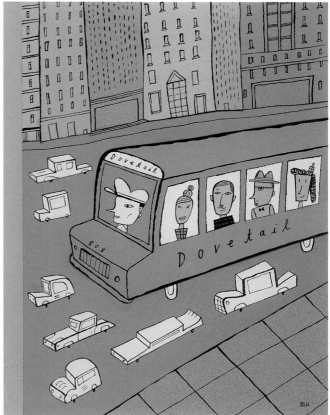

C David Freeman

F Enterprise IG

C Andy Ewan

F Design Narrative

Jonny Hannah

Apparently Simple
Duck

M Ink

B Depict concept for
article in Issues on how
incredibly complex
organisations are
having to manage
their brand so that it
appears very simple

Well I Woke Up This
Morning....

M Ink

B Depict concept of
'singing the blues'
for cover of Issues
Compendium

Brent Hardy-Smith

Snowball

M Watercolour

B Give us a hand this
Christmas. Christmas
card for Age Concern

C Tom Crew
F Enterprise IG

C Helen Meake
F Age Concern

David Holmes
The Fourth Room

M Watercolour

B To illustrate the benefits
of visiting the Fourth
Room Consultancy

Peter Horridge
Marine

M Black ink

B Produce an image
of a calligraphic
galleon to be used
in a brochure for a
solicitors specialising
in marine law (one
of 4 images for
different areas)

C Robert Maude

C Stewart Fallowfield
F The Art Department

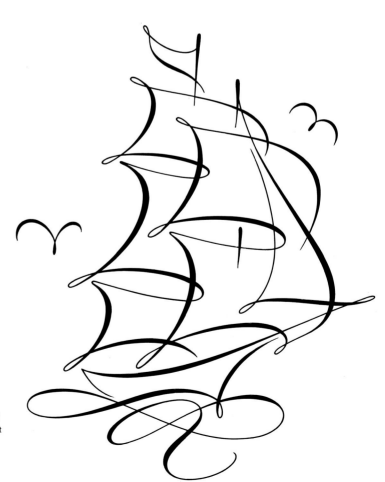

David Hughes
Website Cat

M Mixed media

B To supply an illustration to advertise Central Illustration Agency website

Matt Johnson
Can Do

M Digital

B Depict that tin cans don't have to be a uniform shape, an article in Atticus, published by WPP Group plc

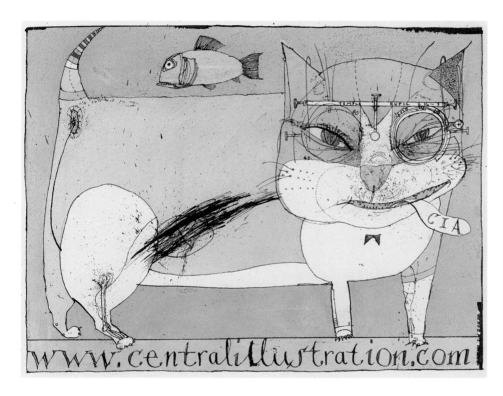

C Brian Grimwood
F CIA

C David Freeman
F Enterprise IG

Satoshi Kambayashi
Datamart Shopping

M Line and wash

B Data Management using data warehouses and datamarts

Ricca Kawai
Medicine Animals

M Ink

B Animals to reflect efficacious of medicine on child's body

C Dominic Finnigan

F Spy Design

C Pentagram Design

Andrew Kingham
Zollverein Comes
to Life
M Metal
B Poster to show
regeneration of
industrial region
in Germany

Neil Leslie
Stirling University
Prospectus
M Computer assisted

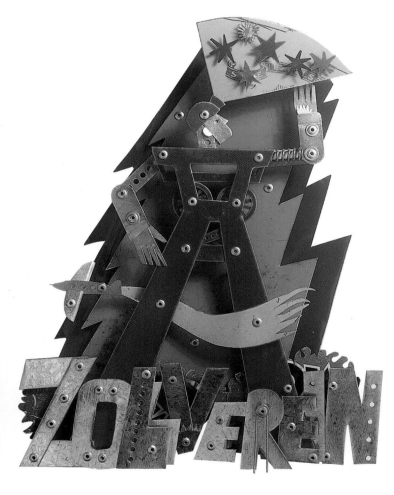

C Mick Dean
F Pure Design

Patrick MacAllister

Quest Game/
Box Lid

M Photoshop

B To illustrate a
children's game
for the national
curriculum

Quest Game/Card

M Photoshop

B To use a different
character for each
type of question

Quest Game/
Boards

M Photoshop

B Each board has a
down/up movement
with 24 jumps i.e. dive
for buried treasure,
fish/bubbles are the
down jumps

C Shelia Ebbutt
F B.E.A.M.

James Marsh
The Almighty Dollar
M Acrylic on Canvas
B To produce an image
for a report on the
American dollar and
how it is revered

John McFaul
A cowboy...
M Computer generated
B One in a series of six
brainteaser postcards
to be sent to Nortel
clients. The illustration
had to give a flavour to
the question

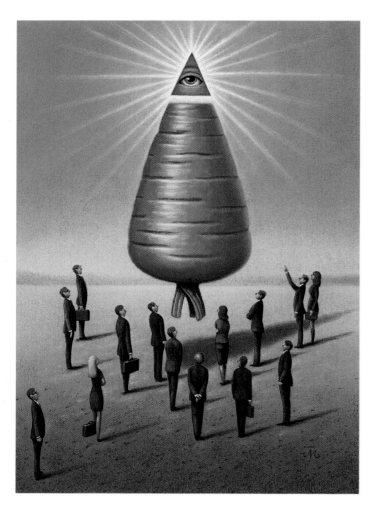

C John Robertson
Design
F Bank Director USA

C David Russell
F The Republic

Mark Moran
2 Heads

M Acrylic

B To produce an image
based on knowledge
is power

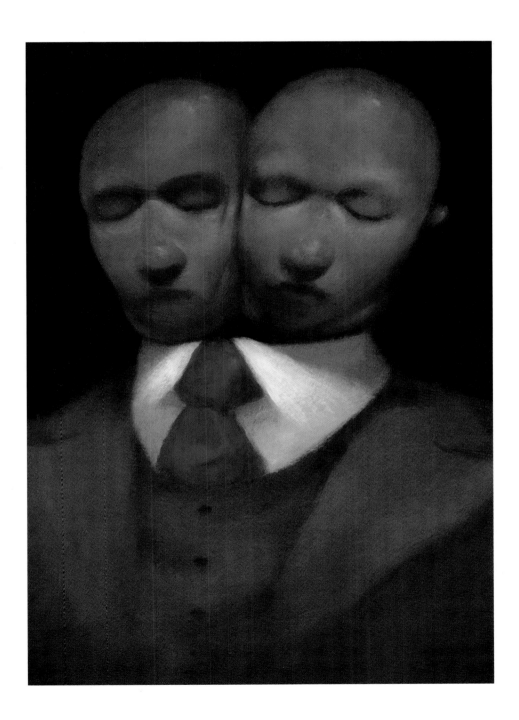

C Chris Rudd
F GMM & ICA

Mark Oliver
Sherbet Fountain
Fruitang
Black Jack

M Gouache

B Part of a range of
sweet packaging for
'Bassetts & Beyond'

C Pip Dale
F Wickens Tutt
Southgate

Garry Parsons

Faces in P aces

Collection

M Acrylic

M Acrylic

B Self-promotional

B Self-promotional

Ian Pollock

Third World Debt –
Christian Aid

M Ink

B Christian Aid
campaign A5
postcard to cancel
Third World Debt

C Richard Swingler

F Christian Aid

Paul Powis
Castlemorton

M Acrylic

B To produce a
landscape painting
suitable for silkscreen

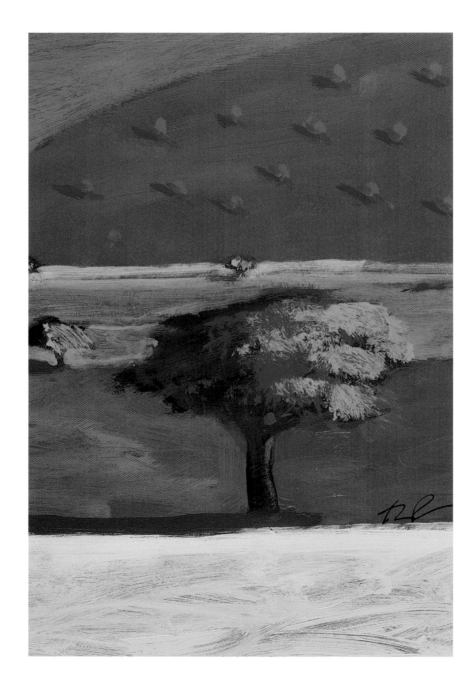

C Glyn Washington
F Washington Green

Nik Ramage

Arts 'n' Crafts

M 3-D and photography

B Illustrate commissioned
poem for the arts and
crafts presentation
pack for the May
2000 stamp issue

**Matthew
Richardson**

January – New Dawn

M Mixed media, digital
assemblage

B To illustrate a page
for Adobes 2000
calendar

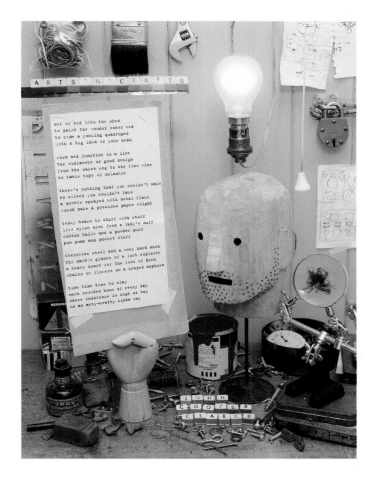

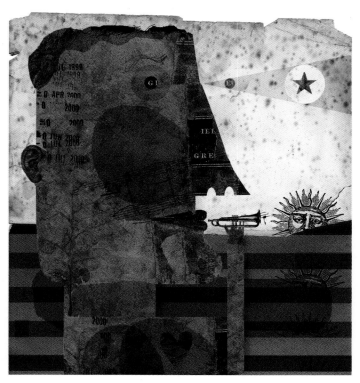

C Sarah Moffat

F Turner Duckworth

C Paul Hiscock

F Adobe

Andy Smith
Big Orange World
M Digital
B Depict concept for
article on issues in
the globalisation and
localisation of brands

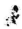

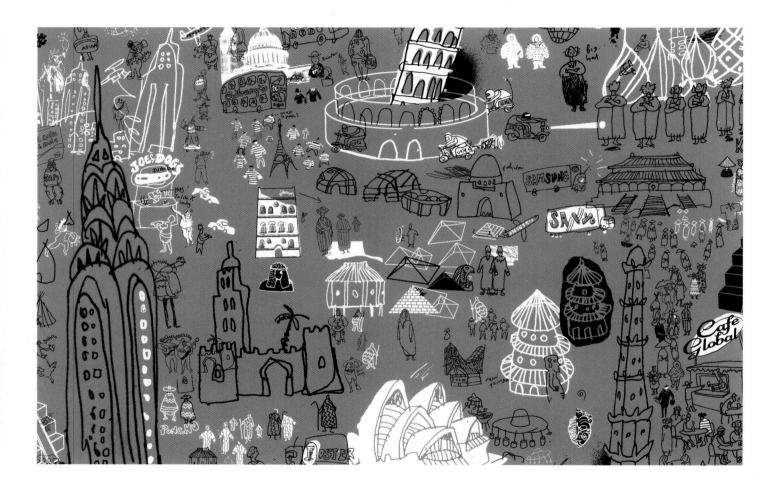

Simon Stern
Publishing Industry
Consolidation

M Watercolour and ink

B Cross ownership of
newspapers and
publishing consumable
manufacturers. For
Fuji Trade Magazine

Brian Sweet
Colour Predictions

M Gouache

B Produce poster image

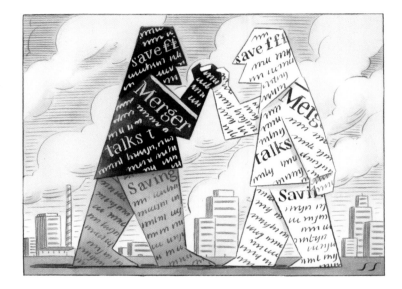

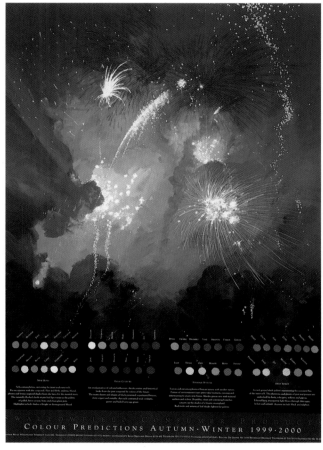

C Paul Hiscock

F Paul Hiscock
Associates

C Jack Gardener

F Swallowfield

Russell Walker
Piciaso

M Ink and photoshop

B A title page illustration
to promote the
Illustration Agency in
a design directory

Tony Watson
The Hollow Man

M Brush, ink and
watercolour

B A series of 1930s
detective stories
on cassette. The
illustration is from
the cassette sleeve

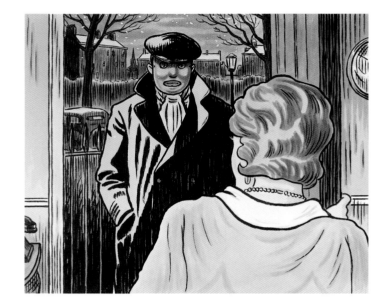

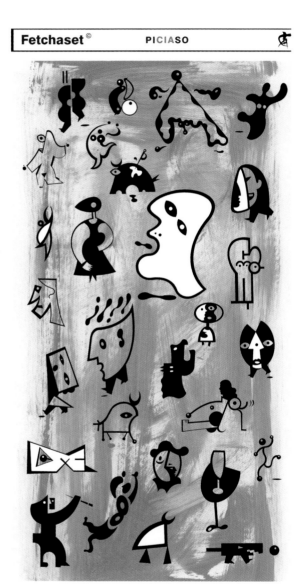

C Brian Grimwood
F Central Illustration
Agency

C Matt Bookman
F BBC Radio
Collection

Paul Wearing

3 Centuries in the US

M Digital

B Illustrate the growth
and change in racial
mix of the USA's
population that has
occurred in the last
three centuries

Spirit Song

M Digital

B Produce a portrait of
jazz pianist Kenny
Barron that conveys
the african inspiration
behind the music
contained on the album

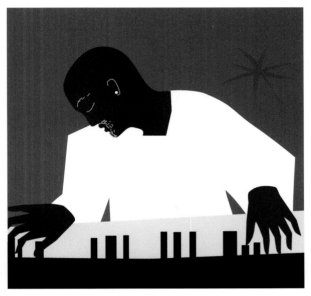

C Raquel Miqueli

F Miqueli Design

C Hollis King

F Verve Records

Mark Wilkinson
The Wicker Man

M Digital

B Commissioned for
band – 'Iron Maiden'
as wraparound image
for CD, picture disc
and posters. Idea was
to use pagan imagery
of burning wicker man

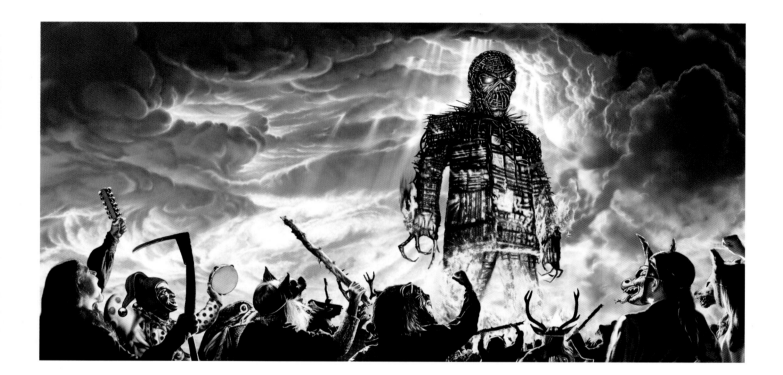

C Dave Pattenden
F Sanctuary Music
Management

Editorial
Gold award winner

Frazer Hudson
G Correct Eating
Posture
M Digital
B Illustrate an article
about correct eating
posture: 'Quick fix
meals and soft chairs
can be detrimental to
your health. So it can
pay to correct your
posture and savour
your food'

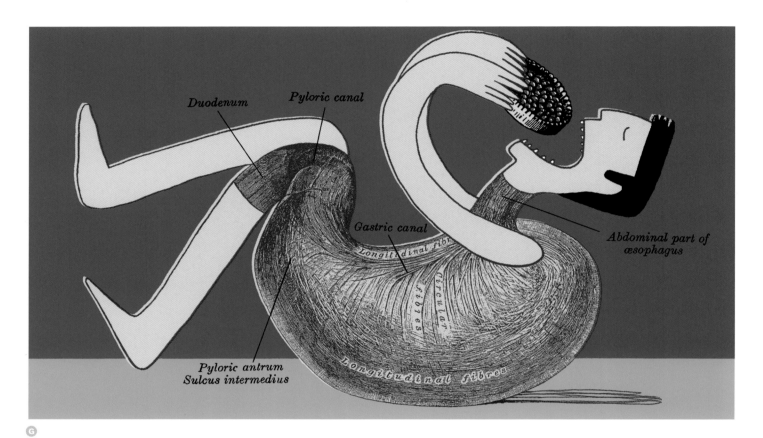

G

Andrew Baker
Who Owns Whom

M Computer assisted

B To produce cover
artwork for Design
Week. The cover
story looked at the
ownership of leading
design groups

Simon Bartram
In the Heart of the Sea

M Acrylics

B In 1819 the whale
ship 'Essex' sank after
an unprecedented
attack by an enraged
sperm whale. Survivors
escaped on one of the
ship's small boats

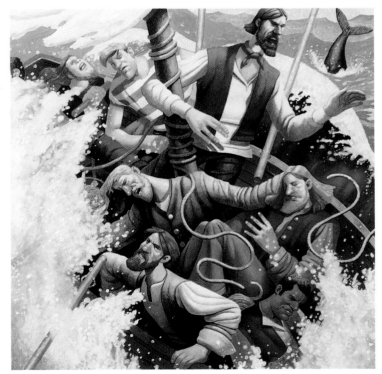

C Ivan Cottrell

F Centaur Publishing

C Caroline Sallis

F Radio Times

Paul Bateman
Moving

M Collage

B Illustrate article
about moving house
and the amount of
belongings we collect
which need packing

Paul Blow
Dictionary

M Acrylic

B To illustrate Melvyn
Braggs radio series
'The Routes of English'

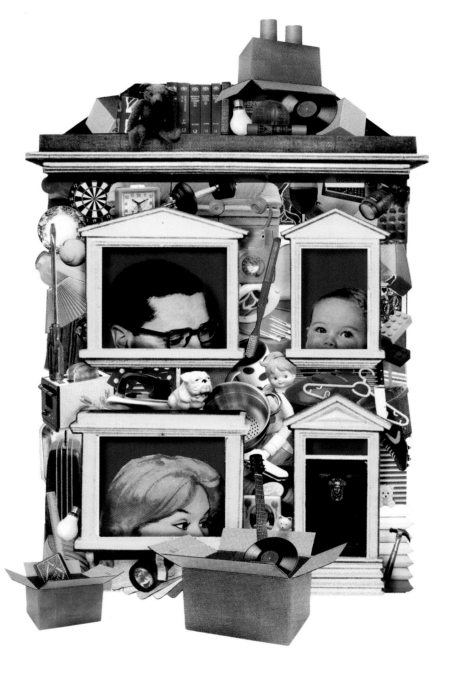

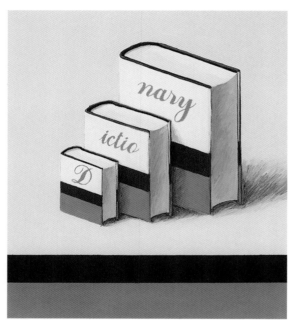

C David Riley

F The Daily Telegraph

C Tracey Gardiner

F Radio Times –
Worldwide

RadioTimes
The best thing on tv.

John Bradley
Self Defence

M Ink

B Illustrate self defence
for an ongoing series
reviewing net sites for
Net Magazine

C Anthony Johnson

F Net Magazine

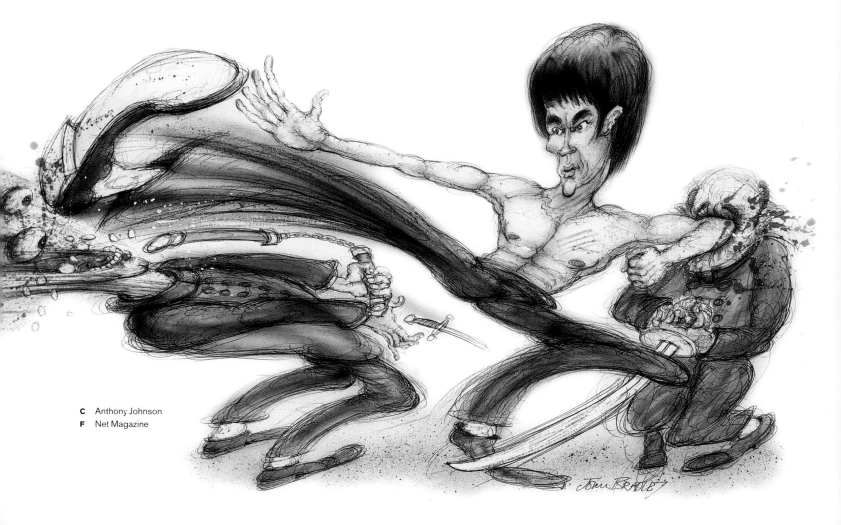

Michael Bramman
Day of the Dead
M Acrylic
B Illustrate Mexican
 Festival

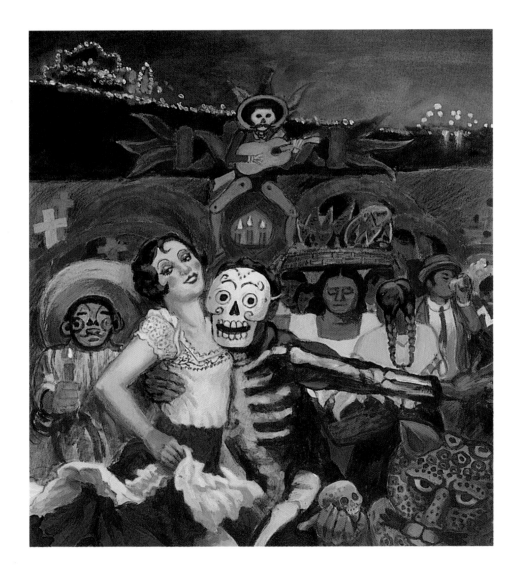

C Jan Burnaby-Davis
 Christine Walker
F The Sunday Times

Stuart Briers

Internet Flower

M Digital

B To depict the fight
against legislation
which is threatening
to restrict the growth
of the internet

Intellectual Property

M Digital

B To illustrate article
about ownership of
ideas posted on the
Internet and the
copyright abuses,
which can occur

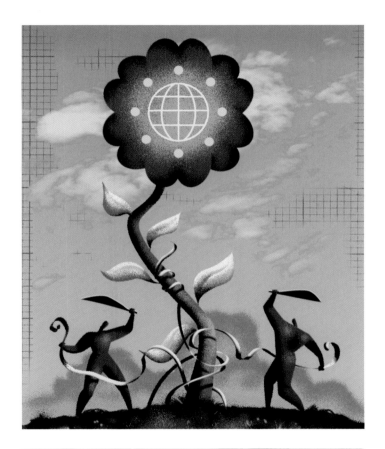

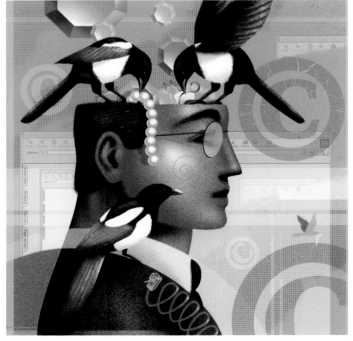

C Mark Montgomery

F I.E.E.E Spectrum

C Mitch Shostak

F Shostak Studios

Bill Butcher

Dressing a New
Economic Model

M Mixed media

B To illustrate Japan's
commitment to free
market capitalism
from its 50 years
of democracy

Insurance and the Net

M Mixed media

B To illustrate the
rather dull subject
of insurance and
the web

Virtual Seeing

M Mixed media

B To illustrate a
computer programme
which enables the
viewer to build an
imaginary world

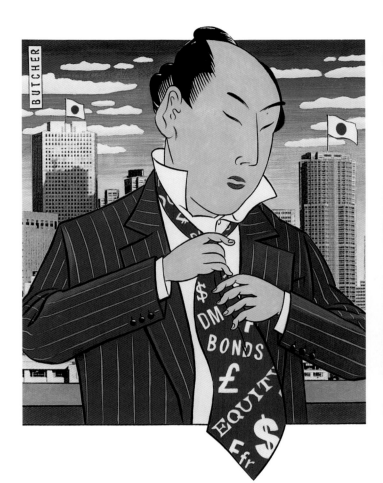

C Tony Mullins

F Connectis Magazine

C Vick Keegan

F The Guardian

It's Behind You

M Mixed media

B To illustrate front
cover of a magazine
showing a clue to a
murder mystery

Facts and Friction

M Mixed media

B To illustrate the
suspicion which
organisations have
when dealing with
the media

C John Tennant

F Express Newspapers

C Jane Davies

F Tempest magazine

Brian Cairns
The Dope on Silicon

M Acrylic

B Article discussing new
techniques in viewing,
mapping and analysing
silicon chip design

Chandra
Not Known at
This Address!

M Acrylic on canvas

B Special report:
companies supplying
mailing lists are
encouraged to update
and weed-out
inaccurate data from
their lists to ensure
users don't miss their
intended target

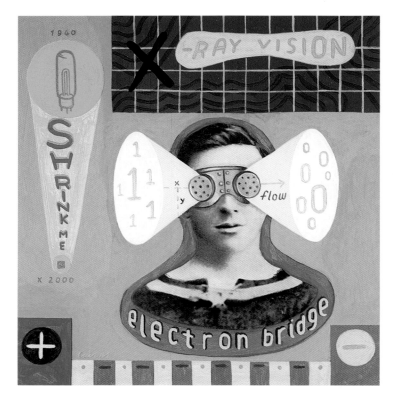

C Alison Lawn
F New Scientist

C Ken George
F Marketing Week

Jill Calder

Holiday in China

M Acrylic, ink

B To illustrate the
columnists holiday to
China, where she was
caught up in a security
scare after the Chinese
Embassy was bombed
by the USA

Grace Jones

M Acrylic, ink and paint

B To illustrate a fashion
article about a catwalk
show in which Grace
Jones modelled

C Angus Bremner
F Scotland on Sunday

C Angus Bremner
F Scotland on Sunday

Russell Cobb
All Work and No Play
M Acrylic
B Illustrate article –
'All work and no play'

Sarah Coleman
Think Again,
Think Paper
M Paper, foamboard
B Cover image for Arjo
Wiggins' Raw
Material magazine, in
which the illustrator
was the subject of a
feature on those in
love with paper

C Patrick Myles
F FX Magazine

C DML Marketing
for Arjo Wiggins
Fine Papers

Jonathan Cusick
Anorexia

M Acrylics

B To accompany
an account by
a teenager of
her struggle
with anorexia

Cyrus Deboo
The Cost of
Spending a Penny

M Digital

B To illustrate a short story
about having to pay to
use public lavatories
in central London

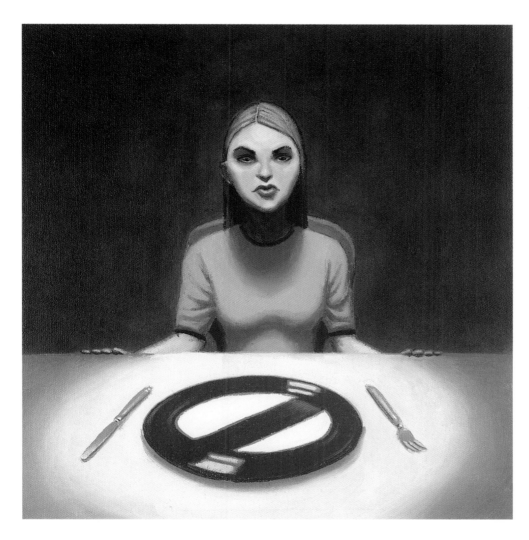

C Emily Moore

F The Guardian

C Gary Cook

F The Financial Times

Marion Deuchars
Waking Nightmare
M Digital
B Reaching for sleeping
 pills can lead to
 problems even
 worse than insomnia.
 Long-term use can
 lead to tolerance,
 withdrawal problems
 and addiction

Nick Dewar
Taurus Starsign
M Acrylic
B Illustrate the star sign

C Laura Hall
F Radio Times

C Jason Arbuckle
F Red

Philip Disley

The Oscars

M Gouache, ink and photoshop

B Illustrate a piece on the Oscars

Love at first bite

M Ink and photoshop

B Produce a cover for a book review concerning the diaries of Sylvia Plath

Doctored Livingstone

M Ink and gouache

B Produce a cover for 'The Observer Sunday Review' on the subject of 'Snogging Ken'. A play based on the plot to smear Ken's campaign for mayor

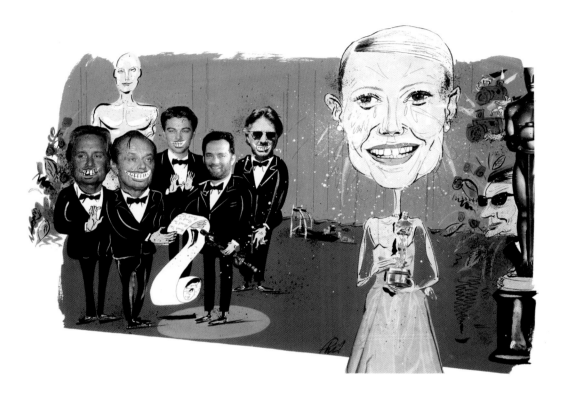

C Lisa Clark

F Financial Times

C Courtney Murphy Price

F Independent

C Gary Phillips

F The Observer

Jovan Djordjevic
Drop the Pilot

M Photocopy, montage,
watercolour, digital

B The advent of handheld
digital communication
equipment/computers

Pete Ellis
Richard Ingram

M Ink and acrylic

B Illustrate Richard
Ingram playing
the piano for BBC
Music magazine

C Martin Stanley
F Microscope

C Simon Morris
F BBC Music magazine

Andrew Foley

Castaway 2000	Untitled
M Acrylic	**M** Acrylic
B Illustrate the TV criticism of 'Castaway 2000', concentrating on the volatile central character Ray Bowers	**B** Illustrate a radio review – 'Storylines'. Radio drama wherein an Irish author tells his life story

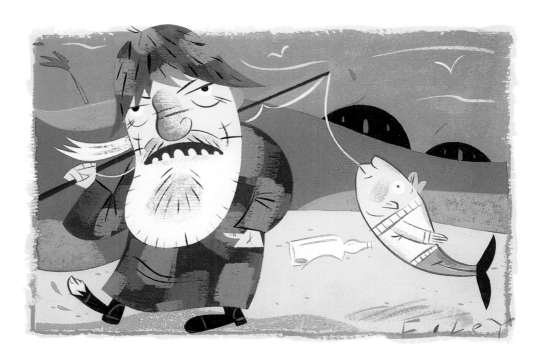

C The Scotland on Sunday	**C** The Scotland on Sunday

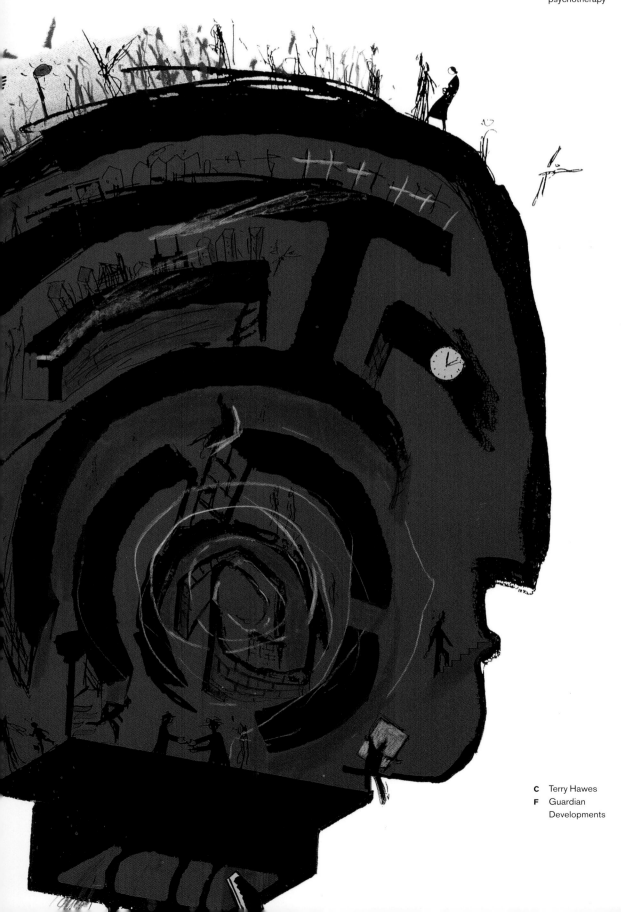

Andrew Foster
Mending Your Head
M Mixed media
B To communicate
a generic image
about mental
health/demystify
psychotherapy

C Terry Hawes
F Guardian
Developments

Carolyn Gowdy
The Resurrection

M Mixed media

B Mary Magdalen visits
Christ's tomb in the
garden only discover it
is empty. In a moment
she will learn of his
miraculous resurrection.
Illustration for
Handel's oratorio
'The Resurrection'

Geoff Grandfield
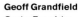 On the Eve of the
Millennium

M Pastel

B As the century
ends, a view of old
neighbourhood,
figures wandering,
discovering their
past through gypsy
knowledge, Millennium
Dome rises like new
sun/dawn

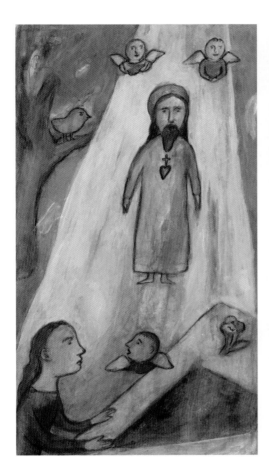

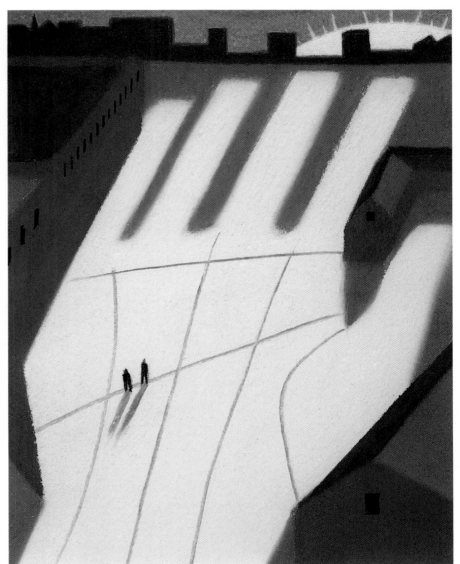

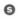

C Tracey Gardiner
F Radio Times
Magazine

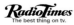

C Tracey Gardiner
F Radio Times

Peter Grundy
Icons for
Bloomberg Mag
M Illustrator 8
B Create a series of
special feature icons
to appear in the
magazine on a
regular basis

C Frank Tagariello
F Bloomberg Magazine

Martin Haake
Brazil 500

M Paper collage

B Create an image that
shows Brazil's 500th
birthday and the
millennium party
in Rio de Janeiro

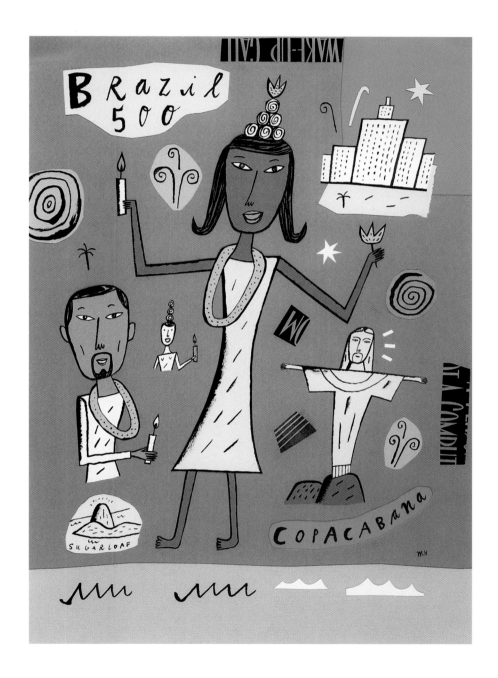

C George Walker
F Axon Publishing

Matilda Harrison

Noah's Ark

M Acrylic

B To devise a complex themed visual puzzle that illustrates 25 letters of the alphabet, the viewer then has to find the 26th

The Circus

M Acrylic

B To devise a complex themed visual puzzle that illustrates 25 letters of the alphabet, the viewer then has to find the 26th

Radio Times Christmas Cover

M Acrylic

B To produce a gentle, generally appealing image which incorporates traditional elements and the past, whilst looking forward to the new millennium

Is the Kennel Club going to the dogs?

M Acrylic

B To illustrate an article criticising the role of the Kennel Club

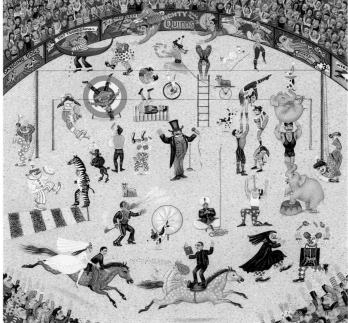

C John Tenent
F Express

C John Tenent
F Express

C Laura Hall
F Radio Times, BBC Worldwide Ltd

C Michael Lyons
F Country Life

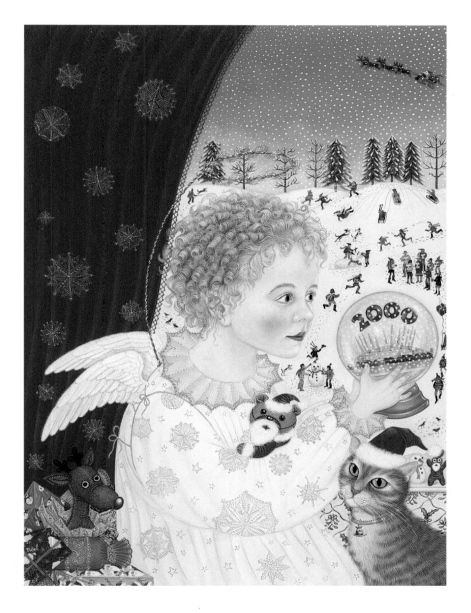

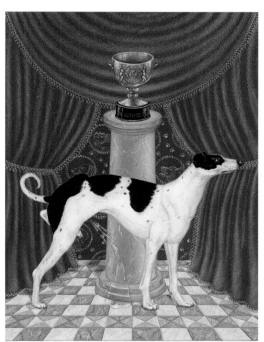

Kevin Hauff

Defence Tactics

M Mixed media

B Anti computer virus designers produce regular updates for the consumer to shield themselves against attack from aggressive new viruses

Monsignor Quixote

M Mixed media

B An innocent village priest is accompanied by an ex communist mayor, his 'Sancho Panza', to witness the temptation and realities of modern day Spain

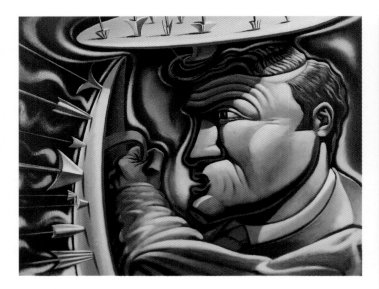

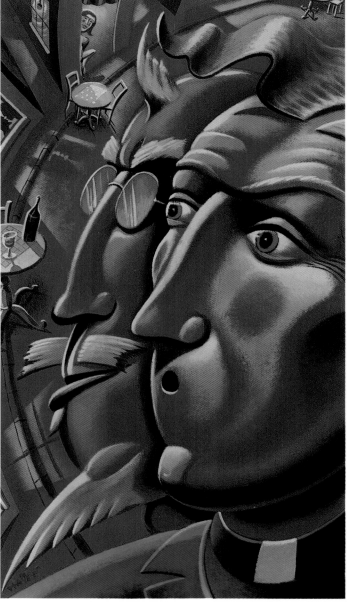

C Hazel Bennington

F PC Magazine

C Tracey Gardiner

F Radio Times

**Robin
Heighway-Bury**
Toxic

M Ink and digital

B To illustrate an article
on a detoxifying diet
and lifestyle

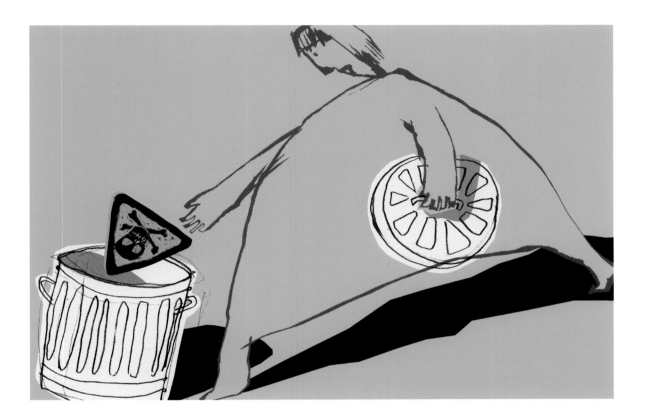

C Wayne Ford
F Observer, Life

Matthew Herring

Routes to the Market	E-commerce
M Silkscreen and collage	**M** Silkscreen and collage
B Article discussed distribution of goods and targeting customers	**B** Use of E-commerce shopping on the internet etc...

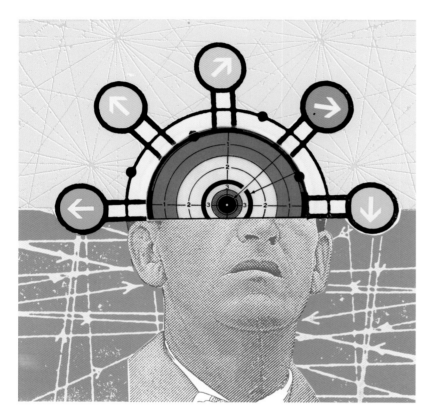

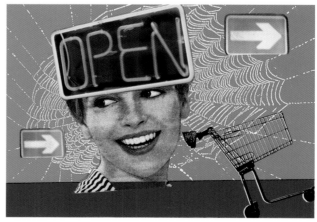

C Martin Stanley **C** Martin Stanley

F Microscope Magazine **F** Microscope Magazine

Marian Hill

Garden Centre

M Collage

B To illustrate an article
by Adam Caplin for
Gardens illustrated
about the development
of the garden centre

B Who ate all the pies?

M Collage

B To illustrate an article
by Bill Knott for
Waitrose Food
Illustrated about the
demise of the old
fashioned pub food

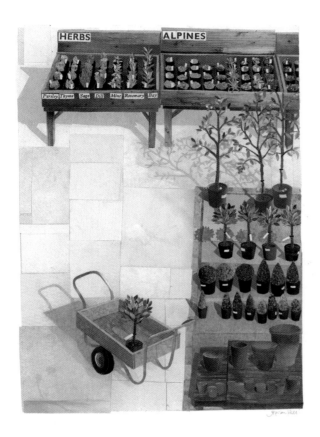

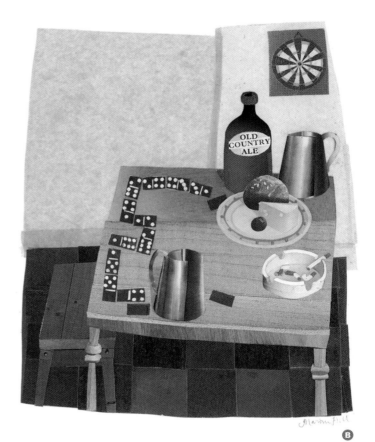

C Hannah Atwell

F Gardens Illustrated
Magazine

C Jane Collins

F Waitrose Food
Illustrated Magazine

Angela J Hogg

That Sinking Feeling

M Mixed media

B To illustrate an article
about the problems of
saving British coastal
wetlands and bird
sanctuaries against
continuing rising tides

Salmon

M Mixed media

B To illustrate a short story
about an adolescent
romance set around
a Scottish loch

C Colin Brewster
F New Scientist

C Jonathan
Bulstrope-Whitelocke
F Sunday Express
Magazine

Frazer Hudson

G Correct Eating
Posture

M Digital

B Illustrate an article
about correct eating
posture: 'Quick fix
meals and soft chairs
can be detrimental to
your health. So it can
pay to correct your
posture and savour
your food'

Wine on the Web

M Digital

B Illustrate the increasing
number of wine sales
made using the internet

C Wayne Ford

F The Observer, Life

**Marie-Hélène
Jeeves**
Rugby World Cup

M Mixed media

B Radio coverage of the
Wales vs Argentina
match during the
Rugby World Cup

C Jonathan Christie
F Radio Times

Matt Johnson
Head Hunters

M Mixed media/digital

B To show how
companies were
using computers to
identify idea workers

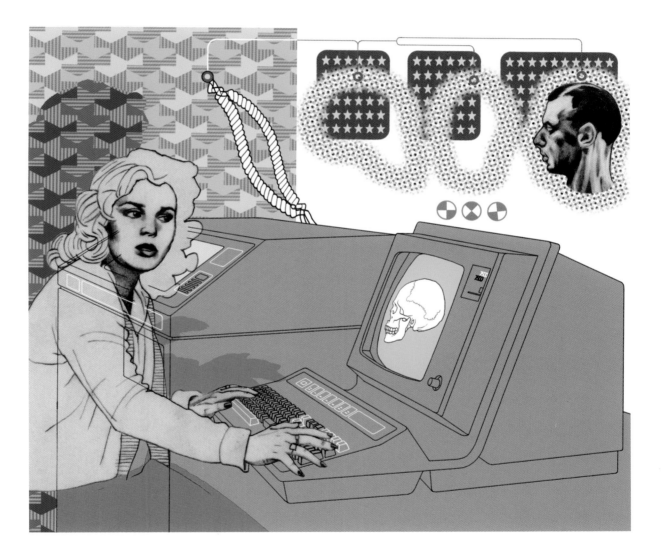

C Linda Rennell
F Martin Leech
Publications

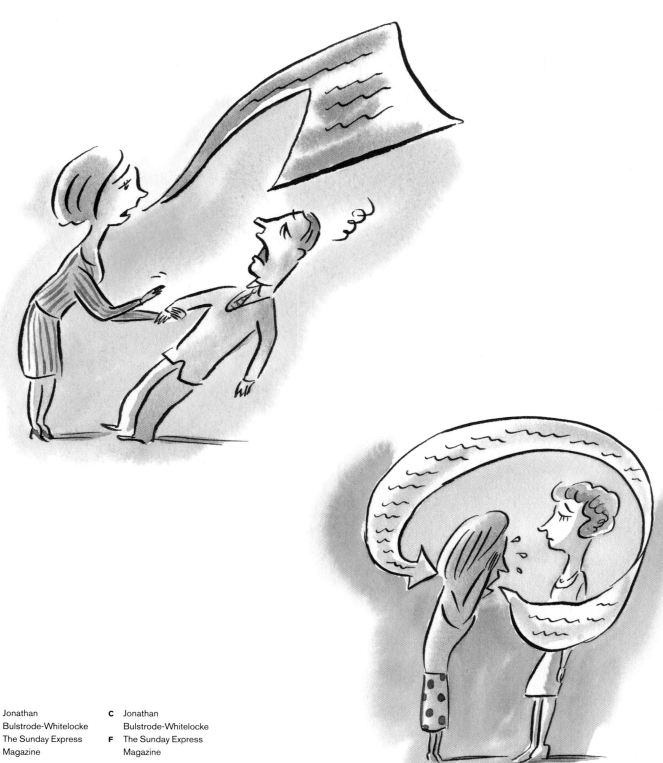

**Satoshi
Kambayashi**
Difficult Words
(Dismissal)

Difficult Words
(Feeling Hurt)

M Line and wash

M Line and wash

B To illustrate a difficult
situation where you
have to fire someone

B To illustrate a situation
where you have to tell
your friend they've
upset you

C Jonathan
Bulstrode-Whitelocke

C Jonathan
Bulstrode-Whitelocke

F The Sunday Express
Magazine

F The Sunday Express
Magazine

Gary Kaye
DJ Deity

M Collage, gouache, pencil

B The rise of the once humble DJ to the position of deity as dance music hijacked the mainstream charts

Andrzej Klimowski
Generation X-rated

M Paper montage

B To accompany article about the death of PC, by Brett Easton Ellis

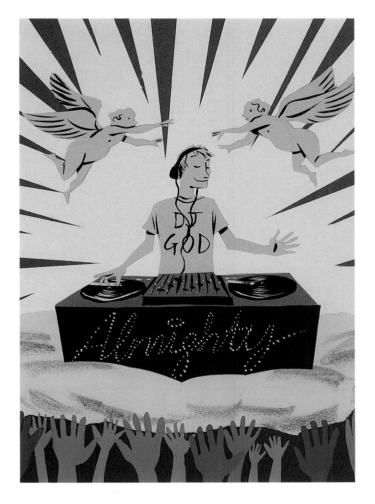

C Roger Tredre
F Viewpoint magazine

C Geoff Waring
F Red

Henning Löhlein

Job Application	E-Christmas	Piggy Bank	Bang Bang
M Mixed media	**M** Mixed media	**M** Acrylic	**M** Acrylic
B To illustrate article about more and more women applying for work abroad around the globe	**B** The first Christmas with internet in full swing to illustrate article in 'Online' – The Guardian	**B** Bad times follow good times, the economic cycle	**B** To illustrate a short story about an elderly lady who dresses up in cowboy gear

C Frau Tessenyi	**C** The Guardian	**C** Frau Kraus	**C** John Whitelocke
F 'Freundin'		**F** Börse Online	**F** The Sunday Express

Frank Love
Rheingold
M G4 Powermac –
Photoshop 5
B To accompany a radio
listing for a radio
broadcast of the opera

Tiffany Lynch
Zodiac Natural
Remedies
M Acrylic
B To illustrate the 12
horoscope signs
and their associated
natural health remedies

C Caroline Sallis
F Radio Times –
BBC Worldwide

C Emma Williams
F IPC Magazines

RadioTimes
The best thing on tv.

Tim Marrs

Flash Bastards

M Digital and mixed media

B William Randolph Hearst. Showing his rise to a fortune, and new editorial style and attitude. (News News)

Marked for Life

M Digital and mixed media

B Short story. A woman coming to terms with mid life and a celebration of past memories centred around May Day celebrations, rekindling a love

Holiday from Hell

M Digital and mixed media

B Writing a book after a holiday nightmare – John Harding's account of experiences inspiring a best-selling blockbuster

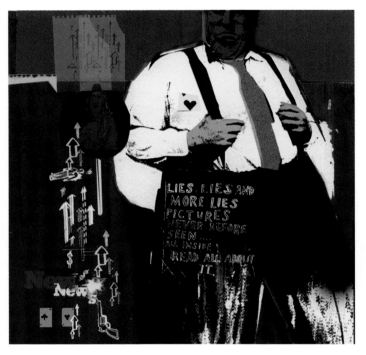

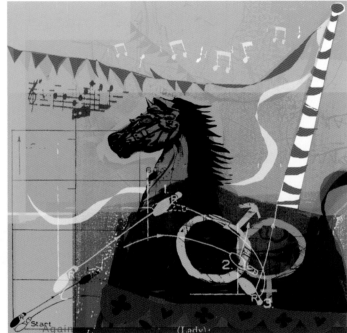

C Taren Automatic
F Pil Magazine

C Jessica Reiter
F You Magazine, Mail on Sunday

C Mitch Davies
F Thomas Cook Magazine

James Marsh

Yen Behaving Badly

M Acrylic on Canvas

B Open Brief to
illustrate feature
article about the
Japanese economy

An Island in the Mind

M Acrylic on Canvas

B A feature for the travel
section: a writer visits
Dominica to find the
spirit of the novelist
Jean Rhys

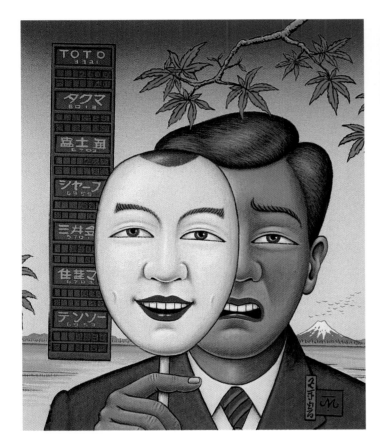

C Tom Reynolds

F Sunday Times
Magazine

C Vicky Jones

F Telegraph

Jan Martin

Encounters with
Aliens No.1

Encounters with
Aliens No.3

M Collage

B A series of images
depicting encounters
between humans
and aliens – anytime,
anywhere – to
accompany
submissions by
new writers based
on this theme

C Debbie Taylor

F Mslexia Publications

C Debbie Taylor

F Mslexia Publications

Roger McGough:
Word Games Master

M Collage

B An image depicting
poet Roger McGough
playing with words
to accompany an
interview with him

Cash at any cost:
Corporate Profit vs.
Public Welfare

M Collage

B To depict a fatcat
trying to squeeze
money out of the
government – article
on the desire to
safeguard profits at
the expense of
environmental and
safety concerns

Is it safe to trade on
the net?

M Collage

B A dodgy-looking
character making off
with credit cards from
a broken computer –
for an article on
internet security

C Tony Sigley

F The Big Issue
South West

C Tony Sigley

F The Big Issue
South West

C Paul McIntyre
(Internet Investor)

F Future Publishing Ltd

Daren Mason
Copy Snatchers

M Mixed media

B To provide an image
about foreign
journalists selecting
stories from UK press
and sending back
home, with their view
of the British

C Tracey Gardiner
F Radio Times

Finger Print

M Mixed media

B Doctors using thumb
 scanners to identify
 themselves to gain
 access to patients
 records

C Lucy Holloway
F Health Serv ce Journal

Belle Mellor

Mobile Etiquette	Rain or Shine	Growth Restriction	Stolen Identity
M Pen and ink	**M** Pen and ink	**M** Pen and ink	**M** Pen and ink
B Etiquette when using mobile phone	**B** Coping with global climate changes	**B** Increased tax burdens stunting growth of the small businesses	**B** The ease with which private personal details may be accessed and used

C Sue Vega	**C** Dexter Tiranti	**C** Jane Moss	**C** Sue Vega
F The Economist	**F** New Internationalist	**F** Director	**F** The Economist

José Luis Merino
Gemini Starsign

M Illustrator

B Illustrate starsign

Lydia Monks
Birds

M Mixed media

B To illustrate a reader's
letter. The reader
wanted to know which
car was the most
likely to 'pull the birds'

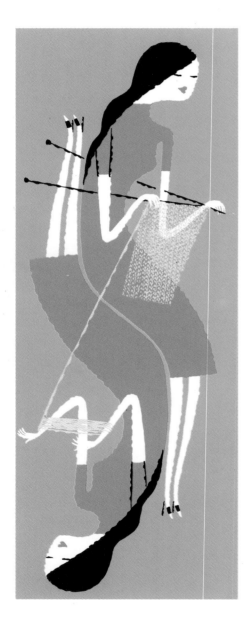

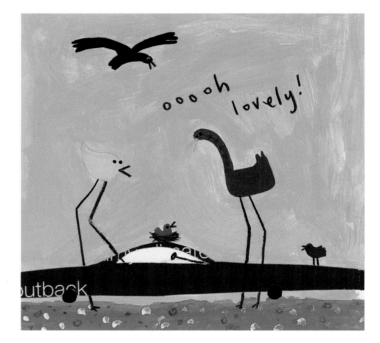

C Jason Arbuckle

F Red

C Hayley Nard

F Top Gear

Mark Moran

8 Way Servers		Dour
M Acrylic		**M** Acrylic
B Illustrate an article about 8 way servers and how they can process vast amounts of data		**B** Illustrate an article about how Scots are seen as dour, but behind the myth is a history of contradictions

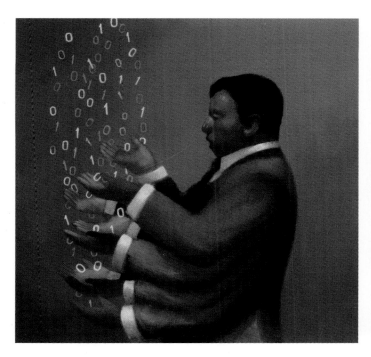
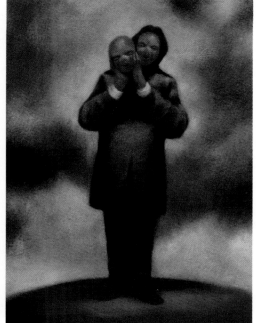

C Hazel Bennington
F PC Magazine

C Angus Bremner
F Scotland on Sunday

Simon Pemberton

Tragic Tree	Rottweiler.com
M Mixed media	**M** Mixed media
B 'E-commerce doesn't work' – late delivery of Christmas trees bought over the internet	**B** Short story about a home with the largest TV the writer has ever seen, constantly connected to dangerous dogs web-sites

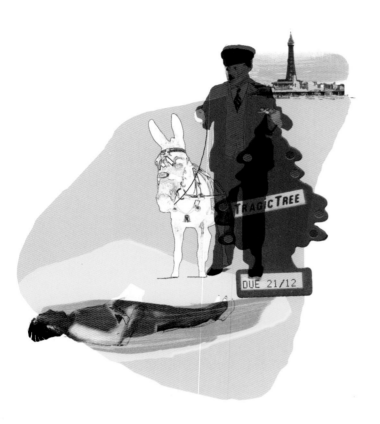

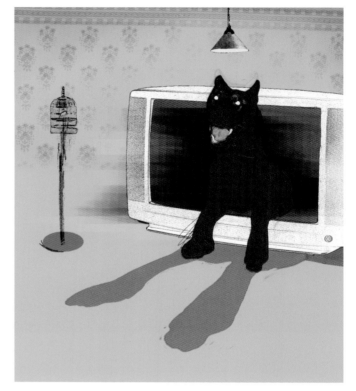

C Paul McIntyre	**C** Jane Bernstein
F Future Publishing	**F** BBC Ariel Magazine

Cock Crowing

M Mixed media

B To illustrate short
story where the writer
is forced to listen to a
salesman at a party ,
talk about himself all
night, as he dreams
about playing his
Rubik's cube

Super Fast Processors

M Mixed media

B To illustrate feature
on next generation of
super fast computer
processors that will
far outpace all the
competition

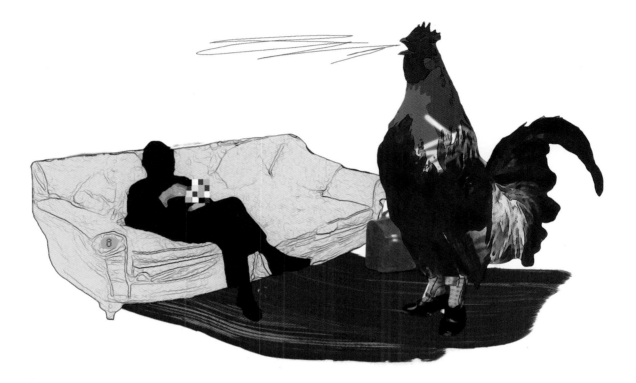

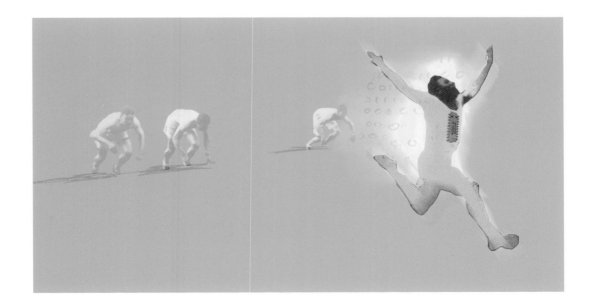

C Gary Cock
F Financial Times
'The Business
Magazine'

C David Grant
F Digit Magazine

Ingram Pinn
To the Core

M Ink and watercolour

B To illustrate an article about cutting back bank services and replacing them with cash machines

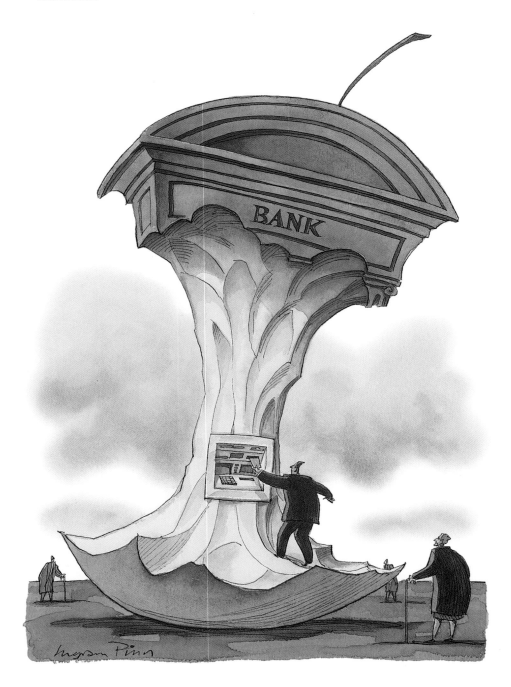

BANK

C Andy Chappin
F Financial Times

Ian Pollock
Artscene Millennium
Cover – The birth
of Christ

M Collage, watercolour,
ink and gouache

B Image for the
Millennium issue
of Artscene

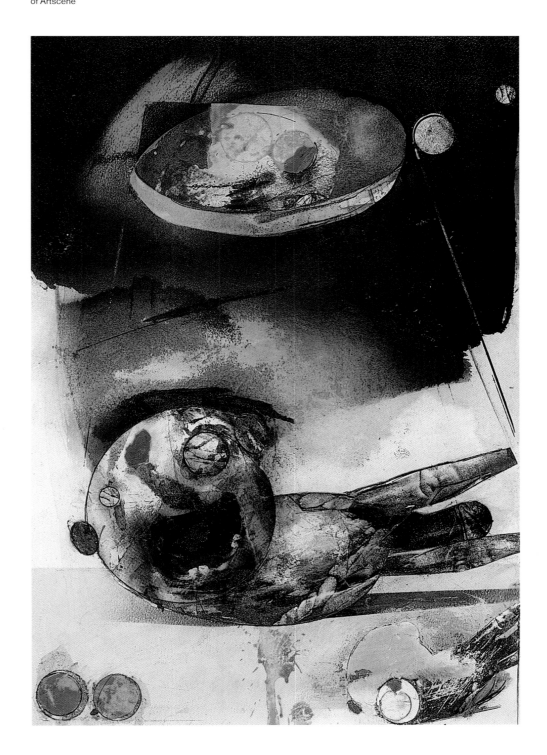

C Vic Allen
F Artscene

Paul Price
Firewire

M Computer assisted

B Illustrate article about
firewires, hacking and
internet madness for
'Internet Works'
magazine

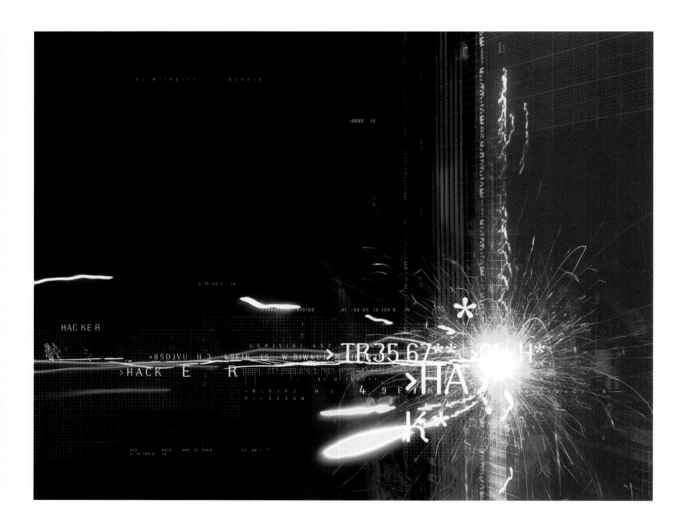

C Paul McIntyre
F Future Publishing

Demetrios Psillos

Alexandra Palace
Classic Motor Show

M Acrylic on paper

B To bring an artist
eye look at life, on a
regular weekly basis.
Open brief. 'Watch
this space' is a regular
section in the Times
magazine which
appears every week

Portrait of Anne
Widdecombe

M Acrylic and collage
on card

B To bring an artist
eye look at life, on a
regular weekly basis.
Open brief. 'Watch
this space' is a regular
section in the Times
magazine which
appears every week

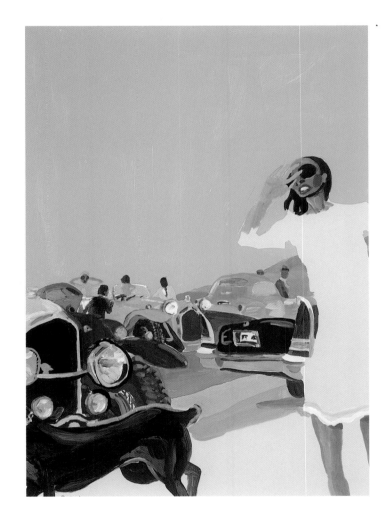

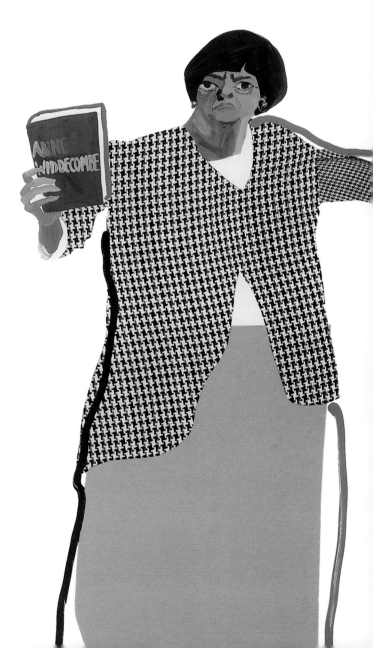

C Chris Hitchcock

F The Times Magazine

C Chris Hitchcock

F The Times Magazine

Jonathan Satchell
Going Underground

M Digital

B Front cover portraying
 the question mark
 over the financing
 of the London
 Underground system

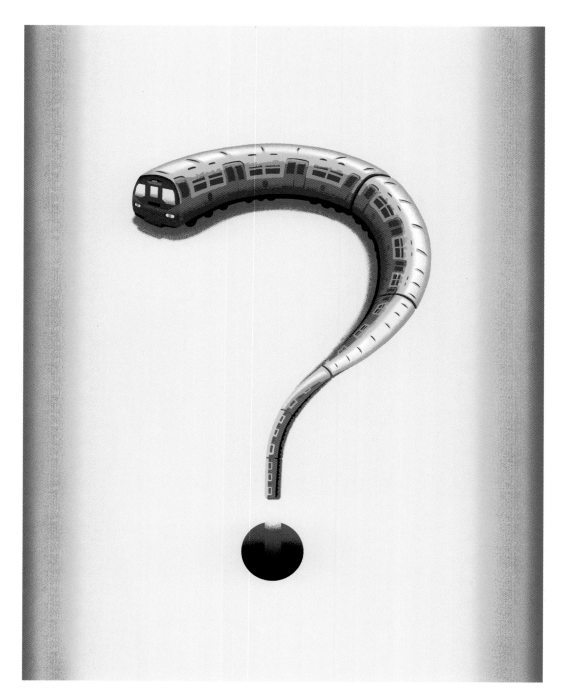

C Paul Hiscock
F Paul Hiscock
 Associates

Michael Sheehy

Mobile World

M Watercolour and ink

B To depict how new
mobile phone
technology affects
all our lives

East Timor

M Indian ink

B Cover illustration:
elections were
disrupted by violence
in East Timor in an
attempt to defy the
democratic process

C Christine Jacquemart

F Enjeux Adroit

C Robert Carey

F The Tablet

Paul Slater

Daughters of Britannia

M Acrylic

B British diplomacy
through the
experiences of
women abroad. In
thirties Moscow,
when conditions were
bad, Marie-Noele
Kelly kept a chicken
coop in her residence

Jonathan Meades:
Feeding Time

M Acrylic

B To interpret
Jonathan's unique
words with Paul's
unparalleled style

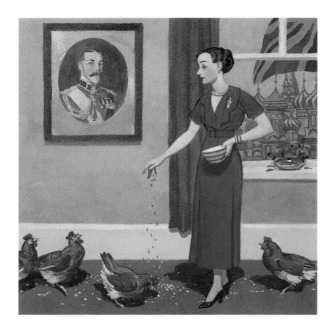

C Caroline Sallis
F Radio Times

C Graham Ball
F The Times Magazine

Alastair Taylor
Strong Stuff
M Acrylic
B Wire column –
 about the increasing
 alcoholic strength
 of modern wines

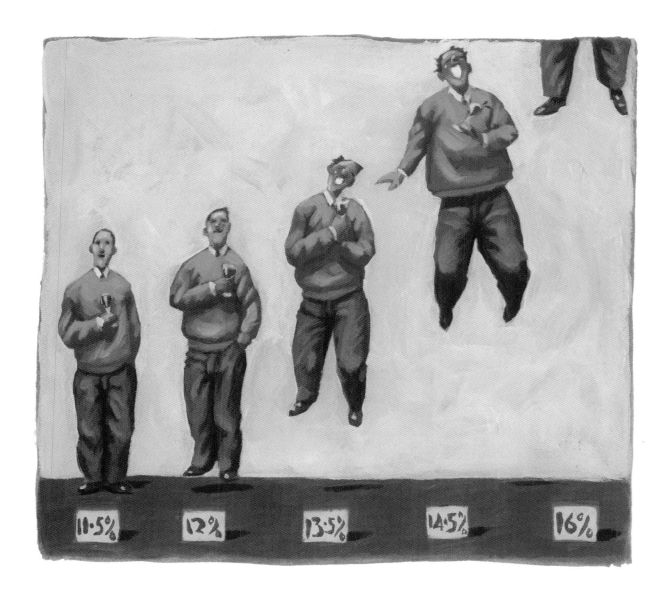

C Peter Balstow
F Sunday Times

Nancy Tolford
Galileo's Daughter

M Digital

B Review of the book by
best-selling author
Dava Sobel

Oyvind Torseter
Fight the Future

M Computer generated
drawing

B To illustrate an article
in Flag Magazine
about technology
and communication

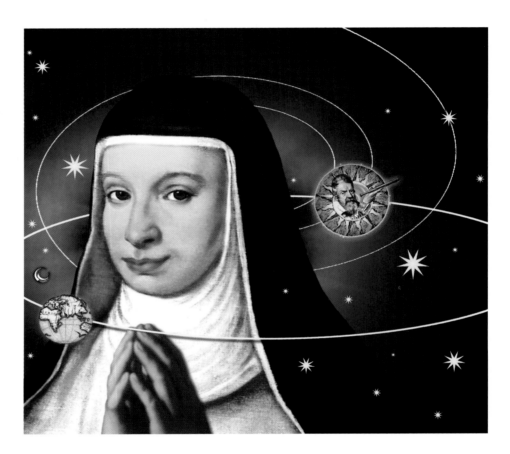

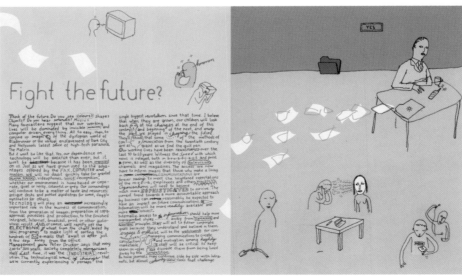

C John Morris

F The Saturday
Telegraph

C Flag Magazine

Paul Wearing
Climber

M Digital

B Illustrate article about
a mountaineer who
survived extreme
conditions by mentally
picturing home base

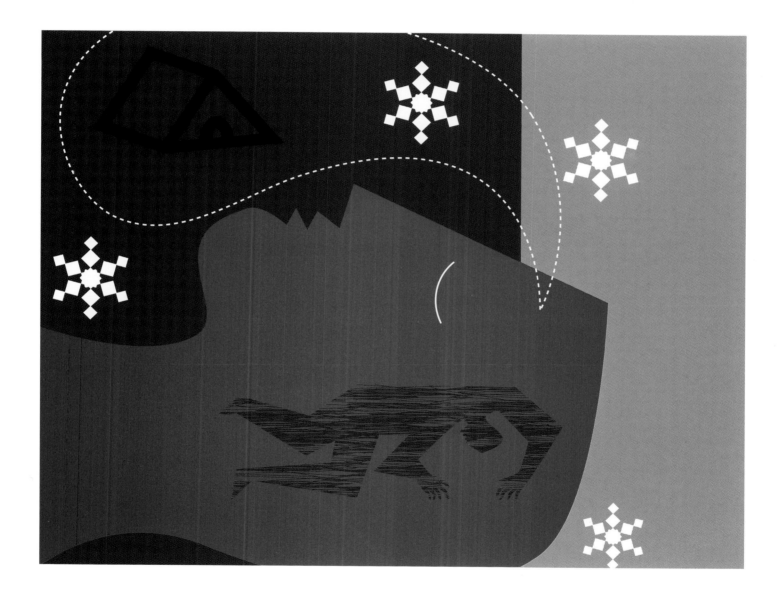

C Deborah George
F New Scientist

Janet Woolley

Going Global
Travel Special

M Photomontage

B To illustrate an article
about major airline
companies engulfing
all other airline
companies

Guess Who's
Coming to Dinner

M Photomontage

B To illustrate a
humorous fiction
article about
ex-girlfriends

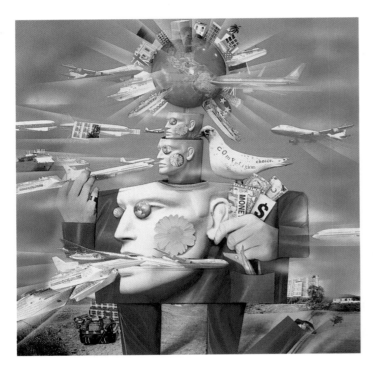

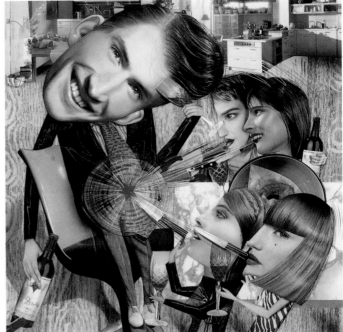

C Time Magazine

C Playboy Magazine

Childrens books
Gold award winner

Sara Fanelli
G 'Dear Diary' – The
 Insect Costume Party
M Collage
B Children's book about
 the events of one day
 seen and told through
 the diaries of 7
 different characters

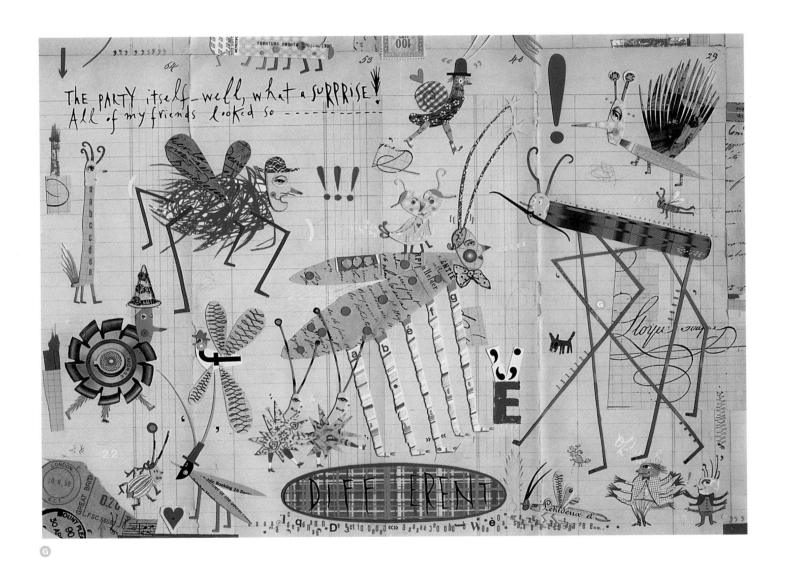

C Walker Books

**John
Bendall-Brunello**
Puppy Finds a Friend

M Watercolour and
coloured pencil

B Illustrate a 24 page
(dual language) book
all about a puppy who
can't find a friend to
play with in the farm!

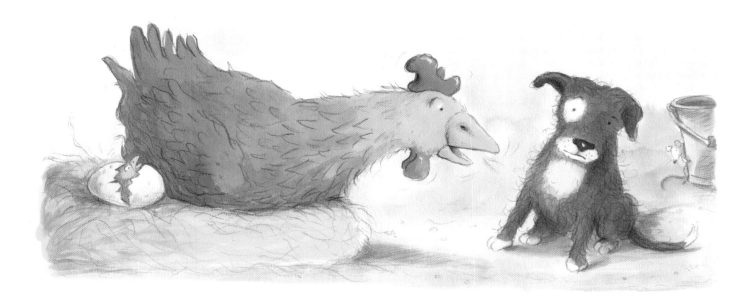

Christian Birmingham
Wombat Goes Walkabout

M Pastel

B Portrait of wombat

Jo Davies
All my animals have shrunk in size

M Gouache

B To illustrate 'Mr Betts and Mr Potts' by Rod Hull. Published by Barefoot books

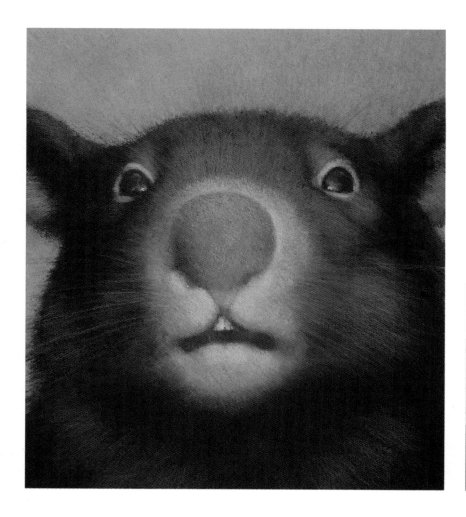

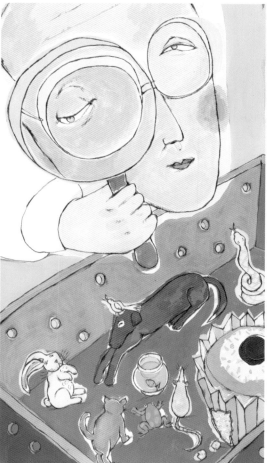

C S Stericke

C Tessa Strickland

F Barefoot Books

Sara Fanelli

G 'Dear Diary' – The
Insect Costume Party

'Dear Diary' – The
Firefly's Diary

M Collage

B Children's book about
the events of one day
seen and told through
the diaries of 7
different characters

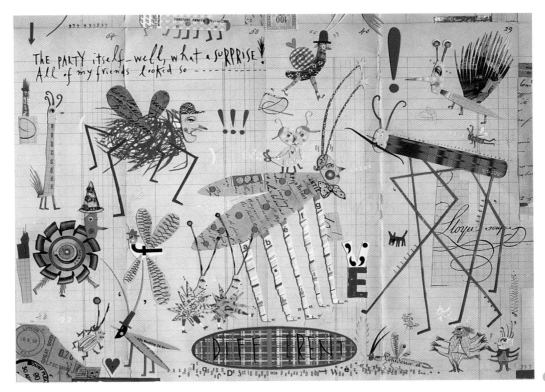

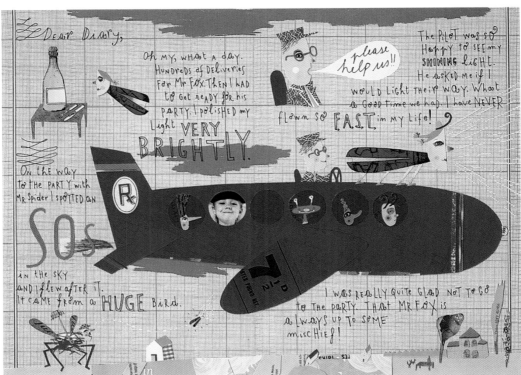

C Walker Books

Christopher Gilvan-Cartwright

Robbie the Rocket

M Acrylic

B To illustrate a children's story of an adventure in space

Robbie the Rocket – Explosion

B Becoming Me

M Acrylic

B Illustrate for ages 4 and up about a story of creation, a book about realisation and connection to all things

Amanda Hall

Little Darkness

M Watercolour inks and pencil crayon

B First piece of artwork for 'The Stolen Sun' my own forthcoming picture book, based on Inuit themes, contracted by Francis Lincoln. Work in progress

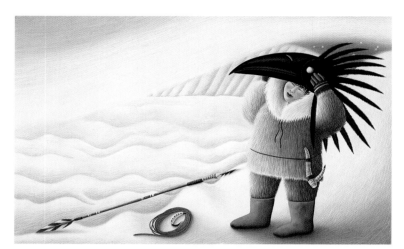

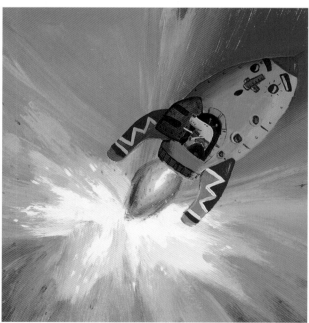

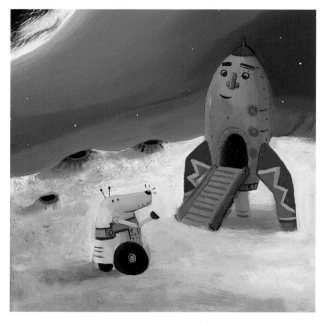

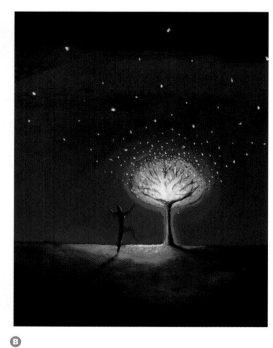

C Emma Percival

F Brilliant Books

C Sarah Slack, Cathy Fishgrund

F Frances Lincoln

C Janetta Otter-Barry

F Frances Lincon

Paul Hess

Once there was
a Hoodie

M Watercolour

B To illustrate the text
of 'Once there was
a Hoodie' by Sam
McBratney. A hoodie
being a somewhat
dim but friendly
creature that roams
the countryside once
every 100 years
looking for a mate

Karin Littlewood

Swallow Journey

M Watercolour and
gouache

B A story following the
adventure of Blue, a
young swallow as he
leaves cold northern
Europe, eventually
arriving in South Africa

Katherine Lodge

Shoe Shoe Baby
in Bed

M Acrylic and gouache

B This piece is from the
book 'Shoe Shoe
Baby'. It is the second
to last spread where
she goes to sleep

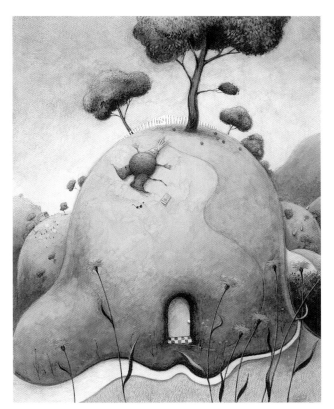

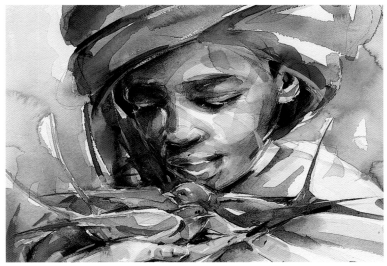

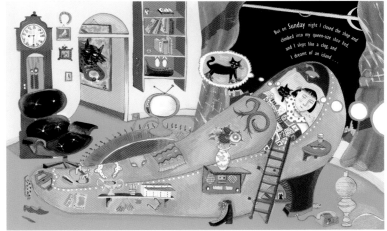

C Kay Barnham

F MacDonald Young
Books

C Tim Foster,
Anna McQuinn

F Zero to Ten

C Paula Burgess

F David & Charles

Brigitte McDonald

Posh Pets – Rabbit

M Watercolour and gouache

B Create an illustration of a posh pet at an expensive vet's surgery to accompany the text 'would you let your pet see the very best vet.'

Julie Monks

The Houseminders

M Oil on paper

B To illustrate a story by Ian Wybrow

S The Birds Came Swooping

M Oil on paper

B To illustrate a story by Ian Wybrow

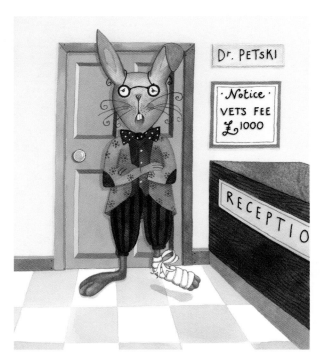

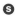

C Lara Stapleton

F Ladybird Books

C Kate Burns

F Hodder Children's Books

Lydia Monks

'Madeleine Drove and
Drove and Drove...'

M Mixed media

B To illustrate a story
about a pig who
works in the city.
In this spread, she
has had enough,
and drives to the
countryside

Food

M Mixed media

B To illustrate a title page
for the food section in
'The Puffin Book of
Sniggeringly Silly Stuff'

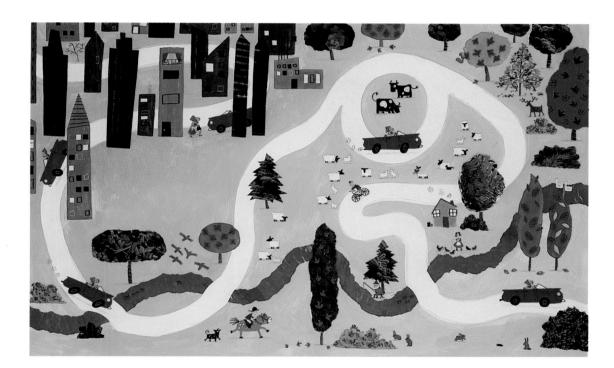

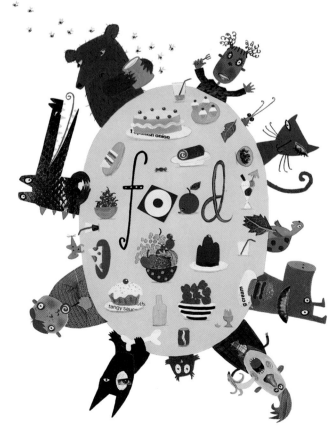

C Anna Wilson

F Macmillan's
Children's Books

C Amanda Clifford

F Puffin Books

Philip Nicholson
Alice in Cyberspace

M Computer generated

B To create a cast of
crazy, lively, colourful
characters for 'Alice in
Cyberspace' – target
age group 7-11

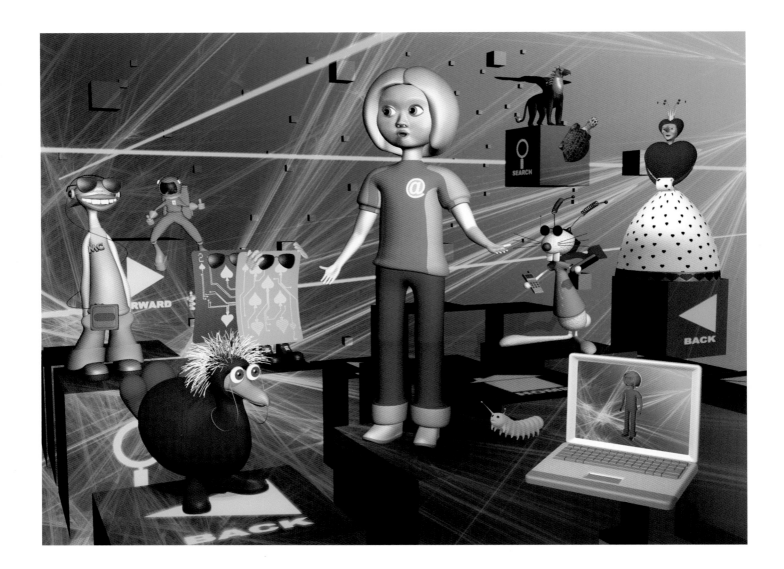

C Annette Searle-Rogers
F BBC Educational
Publishing

Garry Parsons
Billy Grufston

M Acrylic

B Self promotional
work based on the
story 'The Three Billy
Goats Gruff'

David Roberts
I'm Not Scared of
the Monster

M Pen and ink and
watercolour

B To illustrate a book of
poems for children
compiled by Tony
Bradman entitled
'Here Come the
Heebie Jeebies and
Other Scary Poems',
about the fears
children have

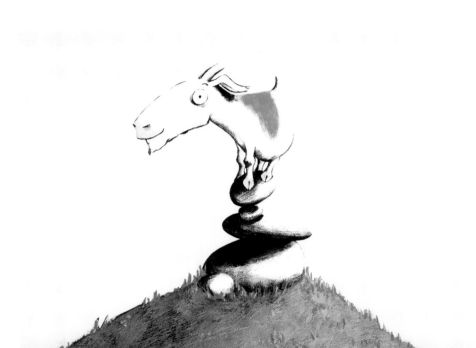

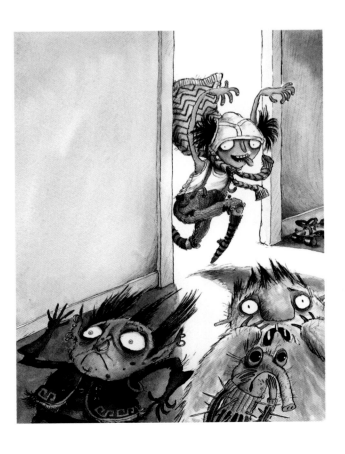

Anne Sharp
Safari

M Acrylic

B Double page spread
for 3-D panorama in
safari pop up book

Sue Shields
Will's Dream

M Coloured pencil and
watercolour

B Pictures for a history/
reading book for Key
Stage One. How
William came to
defeat Harold at
Hastings

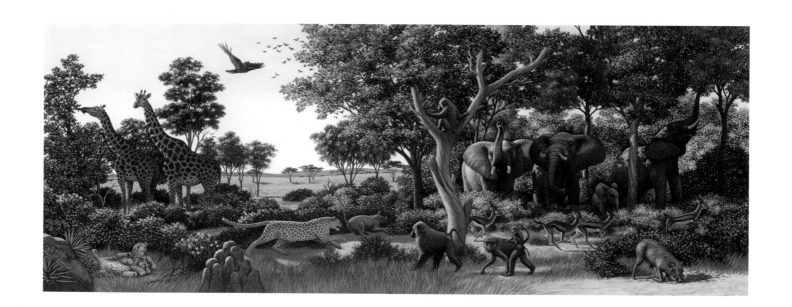

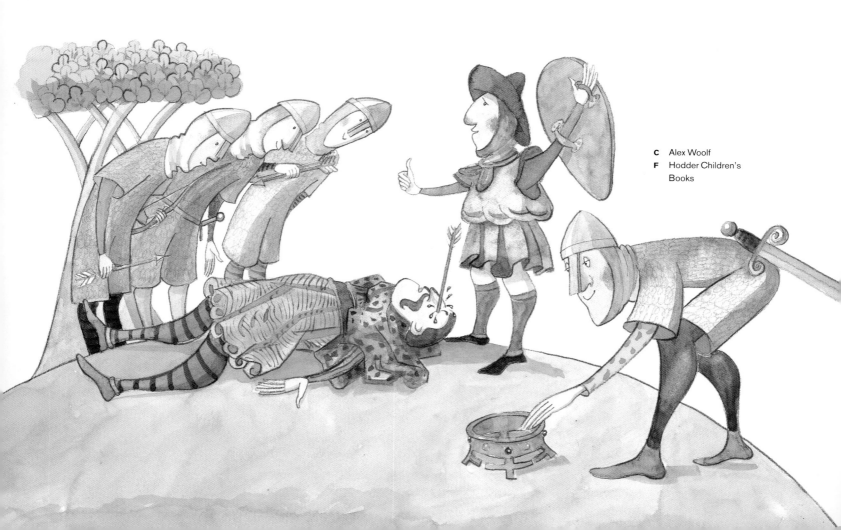

C Alex Woolf
F Hodder Children's
Books

Meilo So

Treasury of Poetry

M Watercolour

B For spread on summer
– June, July and August

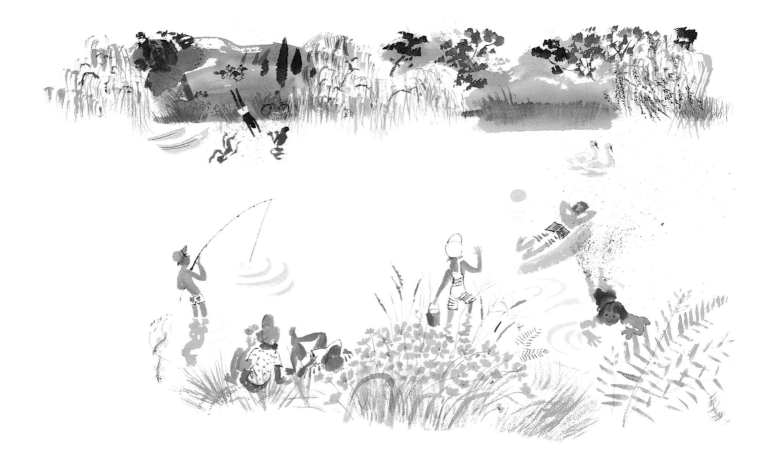

**Stephen
Waterhouse**
'Engines, Engines'
A colourful counting
book – written by
Lisa Bruce

M Acrylic

B To produce illustrations
for a 32 page book
about a counting
journey across
various scenes and
landscapes of India

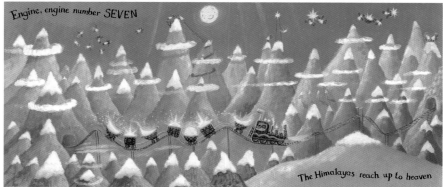

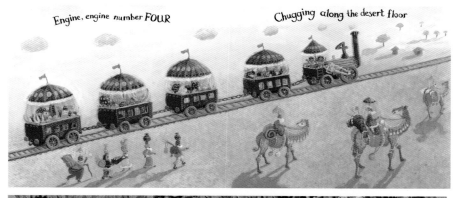

C Emma Matthewson
F Bloomsbury
Children's Books

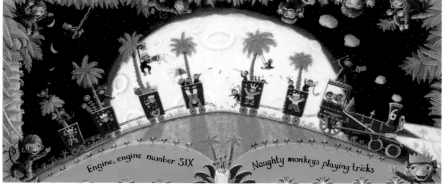

Bee Willey
The Animals Wishes
(cover)

M Mixed medium

B Cover for a Native
American tale of the
maker and the animals
he creates. To show
the Maker, animals
and convey a Native
American feel

C Johnathan Williams
F Heinemann

Anne Wilson

The Lord's Prayer –
But deliver us form Evil

M Mixed media

B To illustrate 'The
Lord's Prayer'
including all inside
pages and cover

The Lord's Prayer –
For Ever and Ever

M Mixed media

B To illustrate 'The
Lord's Prayer'
including all inside
pages and cover

C Del Tucker/Janet Sungsby

F Tucker-Sungsby
Children's Books

General books
Gold award winner

Geoff Grandfield
G The Handmaid's Tale
M Pastels
B Audio cassette
 sleeve cover image
 of Margaret
 Atwood's novel
 'The Handmaid's Tale'

G

C Matt Bookman
F BBC
 Radio Collection

BBC RADIO COLLECTION

Andrew Baker
Leading Lights

M Computer assisted

B To produce cover for
Design Week. The
issue focused on
the year's winners of
Design Week awards

Paul Bateman
Law for Business
Students

M Collage

B Create a collage in
the style of Monty
Python on the theme
of law and business,
for the study book
'Law for Business
Students'

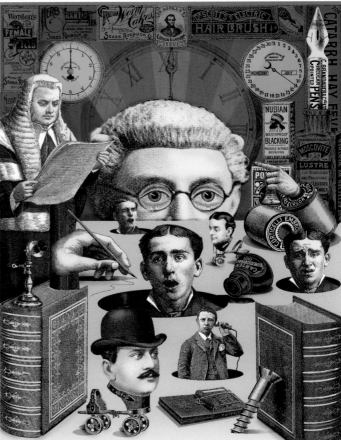

C Ivan Cottrell
F Centaur Publishing

C Kevin Ancient
F Addison Wesley
Longman

Brigid Collins
The Therapeutic
Garden

M Watercolour and
Japanese paper

B To provide a decorative
and appealing
illustration for a book
which covers not only
gardening but also
suggesting healing
and philosophy (plus
black and white inside
illustrations)

Paul Cox
Home Truths

M Watercolour and ink

B To produce an
illustration for the
cover of 'Home
Truths' by David
Lodge, conveying a
situation involving
the principal
characters in
the book

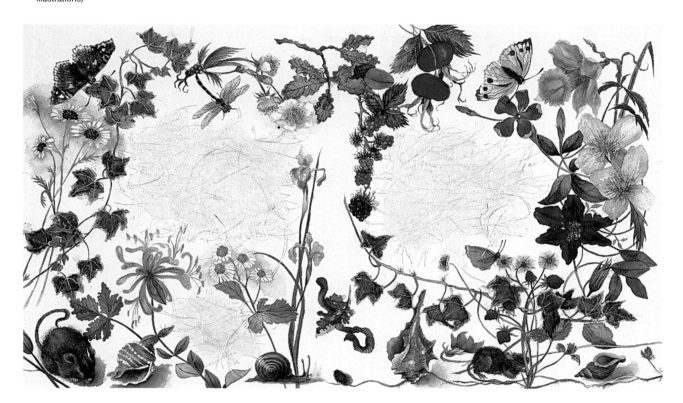

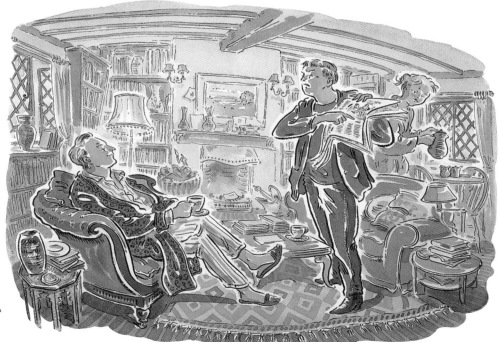

C Julia Lloyd
F Transworld

C Roseanne Sera
F Penguin Books USA

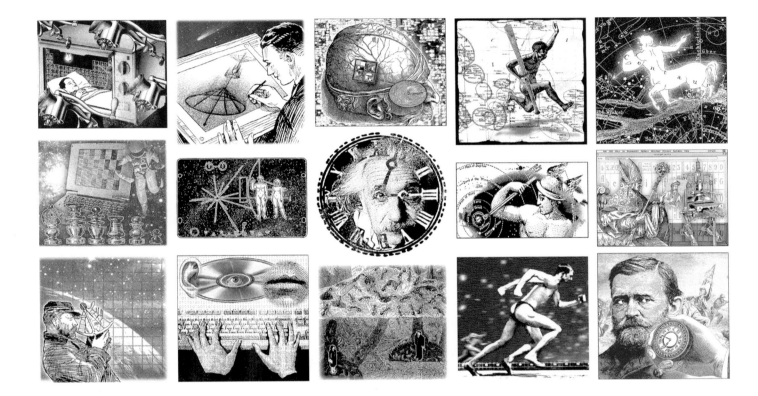

Jovan Djordjevic

The Giant Leap

M Pen, ink, photocopy, montage, digital

B Mankind's quest for space travel/ exploration and future colonisation of the solar system

C Lorraine Jerram

F Headline

Max Ellis
The Koln

M Digital

B The image was
 produced using
 drawings by diver
 John Liddiard for use
 as an accurate dive
 plan, part of a series
 of British wrecks

Carl Ellis
In the Swim
(Issue 39 'Wildlife of
Britain' magazine)

M Watercolour

B Life studies of Perch

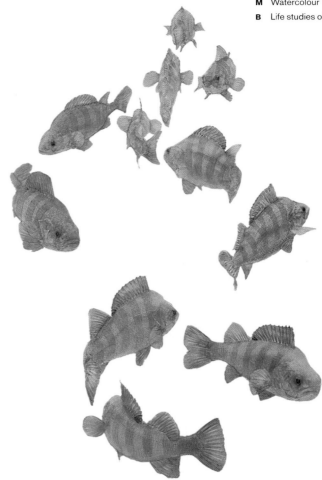

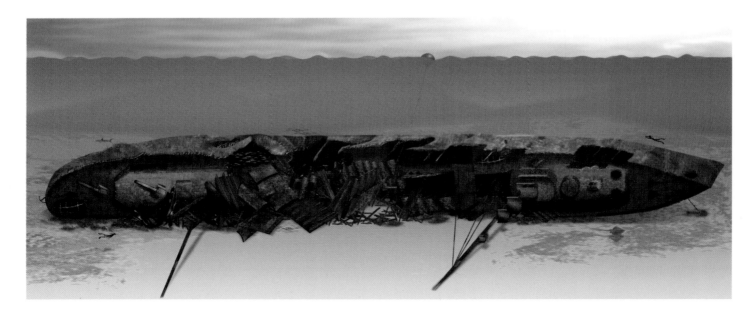

C Tami Levinson

F Diver Magazine

Sara Fanelli

	Last Things	Homework
M	Collage	M Collage
B	Book cover for novel by Jenny Offill	B Book cover for novel by Suneeta Peres Da Costa

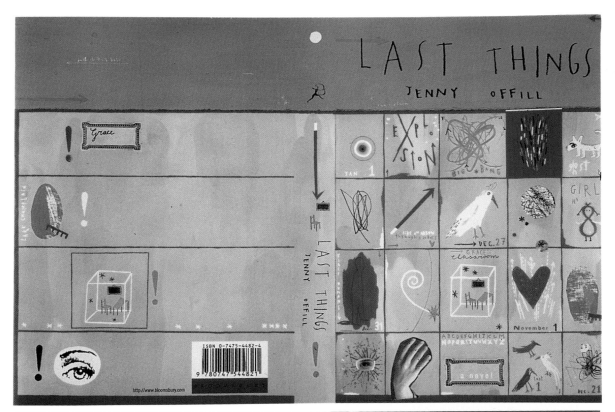

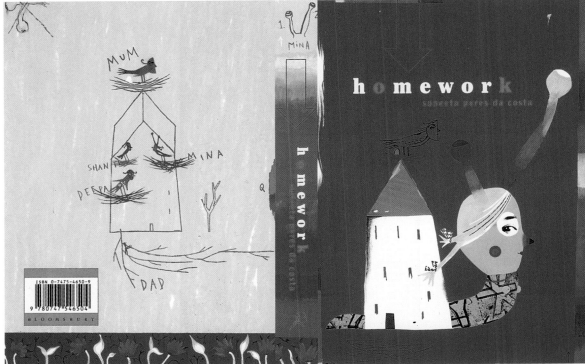

C William Webb
F Bloomsbury

Jason Ford
Brighton Rock

M Gouache

B Audio cassette sleeve
cover image of
Graham Greene's
novel 'Brighton Rock'

Geoff Grandfield
 The Handmaid's Tale

M Pastels

B Audio cassette
sleeve cover image
of Margaret
Atwood's novel
'The Handmaid's Tale'

C Matt Bookman
F BBC Radio Collection

C Matt Bookman
F BBC Radio Collection

BBC RADIO COLLECTION

BBC RADIO COLLECTION

David Hitch
PG Wodehouse:
Thank you, Jeeves

M Acrylic

B One of a series of
paperback covers for
PG Wodehouse novels

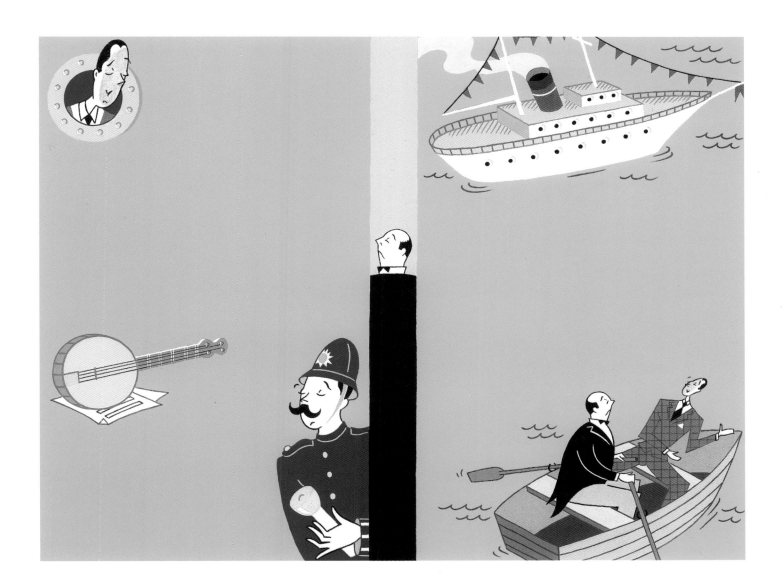

C Alice Wright

F Penguin Books

Peter Malone

B Song of Solomon
(Old Testament)

M Gouache

B Image for the book
'Gardens of the
Imagination'
Published by
Chronicle Books

Rappaccini's
Daughter
Nathaniel Hawthorne

M Gouache

B Image for the book
'Gardens of the
Imagination'
Published by
Chronicle Books

Garden of Eden
(Old Testament)

M Gouache

B Image for the book
'Gardens of the
Imagination'
Published by
Chronicle Books

Paradise Lost
John Milton

M Gouache

B Image for the book
'Gardens of the
Imagination'
Published by
Chronicle Books

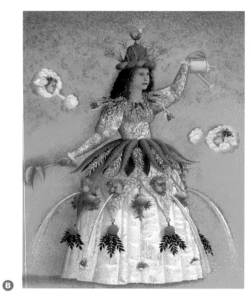
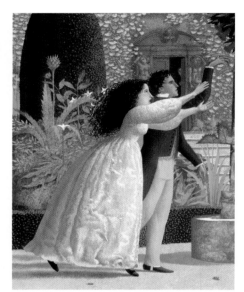
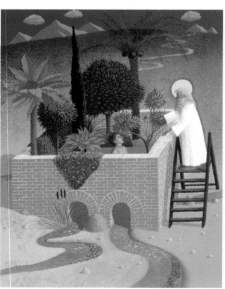
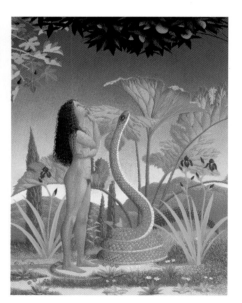

C C Herter

F Chronicle Books

**Matthew
Richardson**
Winter in Volcano

M Mixed media,
transfer print

B To illustrate the book
'Winter in Volcano'
which centres on the
escapades of a 'hip'
college lecturer in
1970's Hawaii

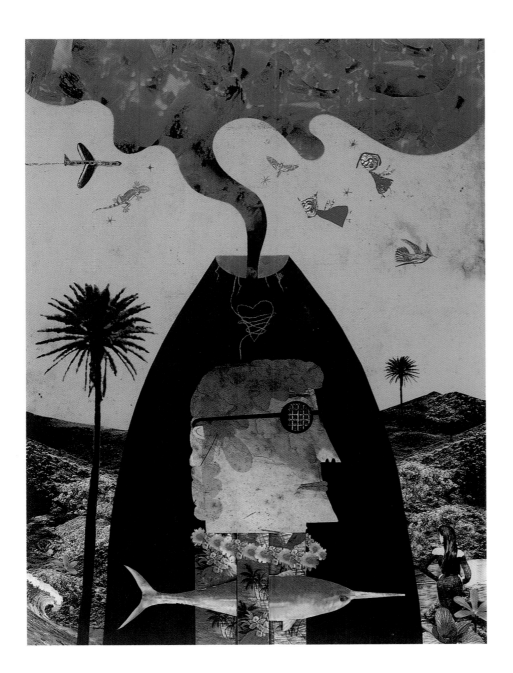

C Jeremy Butcher
F Random House

David Rooney
Lorna Doone –
Lorna Comes Home

M Scraper board

B To illustrate R D
Blackmore's novel
'Lorna Doone'

Lorna Comes Home

London

John Saves Sheep

John Breaking Rock

S Harvest

C Joe Whitlock Blundell
F The Folio Society

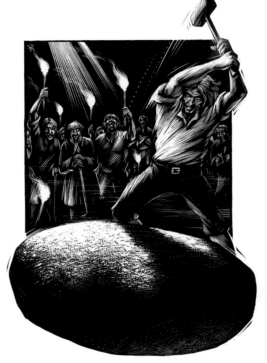
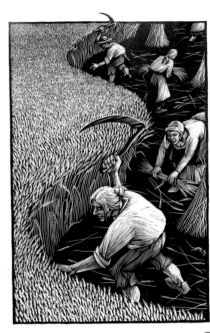

Rachel Ross
Three Men on a Plane,
Published by
Faber and Faber

M Acrylic

B To produce an image
showing some of the
characters going about
their daily business in
the neighbourhood in
which this humorous
book is set

Alex Williamson
Spies

M Silkscreen print

B Commissioned
illustration (used on
cover) as one of thirty
produced to illustrate
Orwell's '1984'

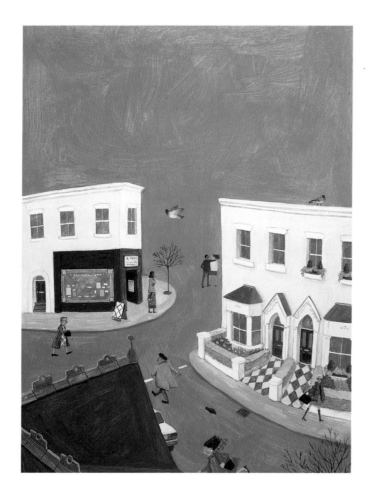

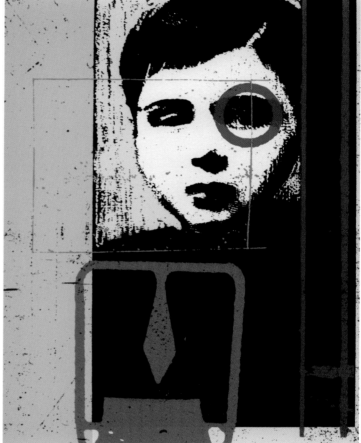

C Tiago Figueiredo
F Pentagram

C Caz Hildebrand
F Random House
Publishing

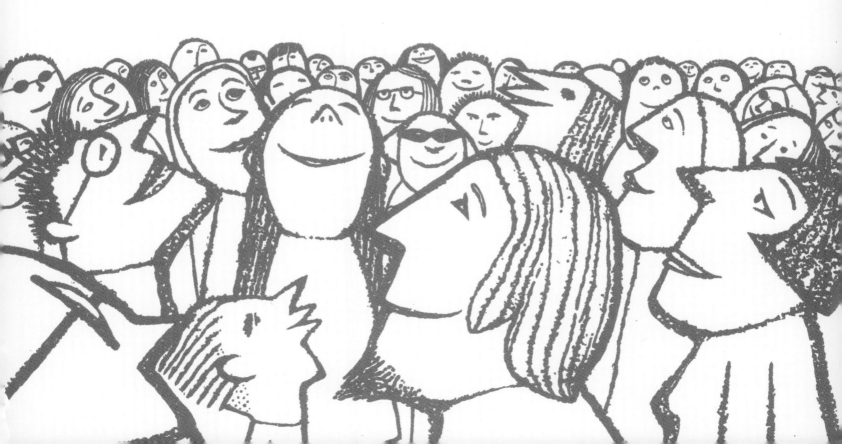

Student
Gold award winner

Joanne Hayman
G Suburbia
M Screenprint and
 computer
B To illustrate the
 negative side of
 suburbia evident in
 contemporary culture

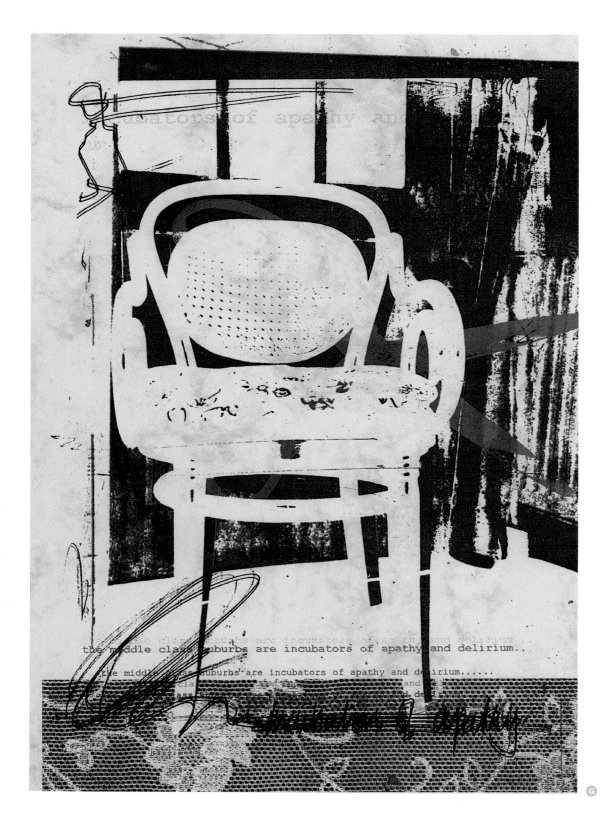

Honor Ayres

Walk in the Park

M Mixed media

B Illustrated to portray
a variety of everyday
people walking
their dogs

Hats

M Mixed media

B Illustrated for a
poem about hats

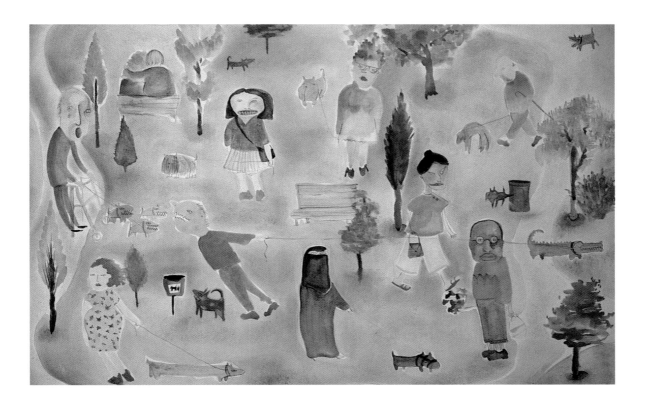

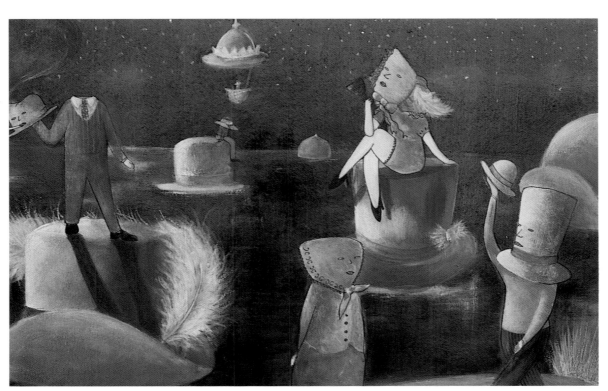

Camilla H Bache
The Moleman
M Screenprint
B John Irving's 'A
 Widow for One Year':
 'The moleman's job
 was hunting little girls.'

Sarah Ballard
Romeo and Juliet
M Mixed media
B To design a book
 jacket for William
 Shakespeare's
 'Romeo and Juliet'

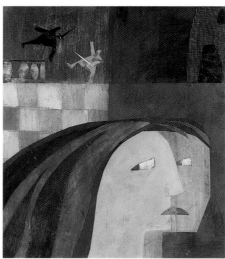

**Alexander
Paul Bennett**

Deer Spine

M Watercolour

B Illustration to show
articulation of a
deer spine

Gurnard Dissection

M Watercolour

B Image to depict
realistically and
clearly the main
organs of a Gurnard

Alex O'Brien

Anatomy of a
Cockerel

M Gouache

B To produce a realistic
and detailed study
from any section of
the anatomy, giving
a precise medical
viewpoint in a medium
of your choice

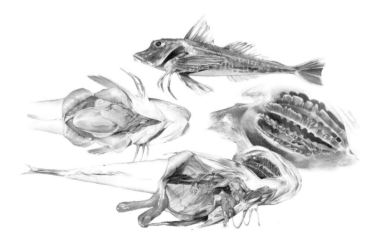

David Bimson
The World According
to Garp
M Gouache
B Book jacket for 'The
World According to
Garp' by John Irving

Sally-Ann Brady
New Year's Eve
M Acrylic
B To produce a four-
frame sequential
narrative, illustrating
an event from the
Christmas and
New Year vacation

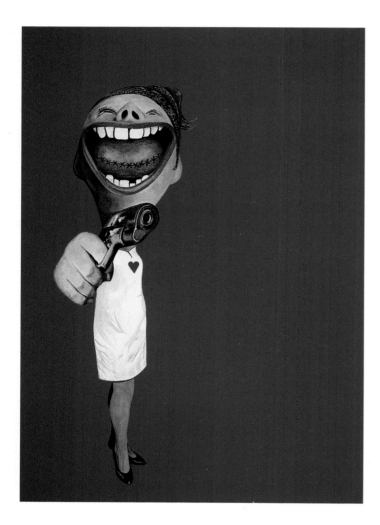

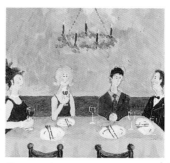

9·00 pm

midnight

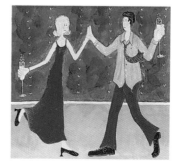

3.00 am

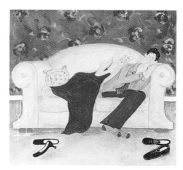

3·15 am

Eddie Bridge

Sergio

M Screenprint

B Alternative book
cover illustration for
Christopher Frayling's
biography of Italian film
director, Sergio Leone

Stephen Calcutt

Entertainment Bird

M Mixed media

B Illustrate alternative
aspects of
animal abuse

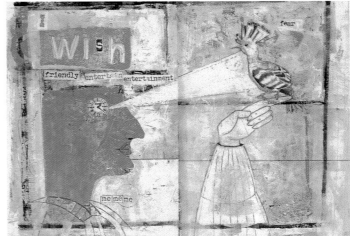

Charlotte Canty
Noah and Cinderella

M Mixed media

B 'Who would you have a one 2 one with?' choose 2 characters, fictional or real-life and describe how they would communicate

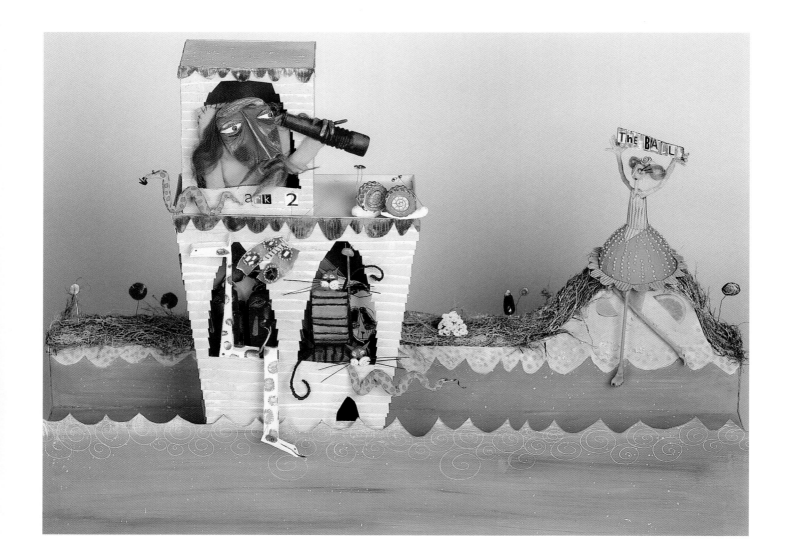

Ben Carter

Sexual Perversity
in New York

M Mixed media –
pencil/colouring
pencil and tipex pen

B 'New York Short
Stories' (story about
a pervert who has
travelled to New York
to represent Toys 'R'
Us and a teddy bear
collection)

Don't Play God with
my Genes

M Mixed media – etching
and pencil work

B Newspaper article
about transplanting
genes from one
species to another
i.e. humans and pigs
being genetically
engineered

Destroying the Total
Stock of Biodiversity

M Mixed media –
pencil/colouring
pencil and tipex pen

B Environmental issues:
people in powerful
positions manipulating
and carelessly
destroying valuable
habitats beyond repair

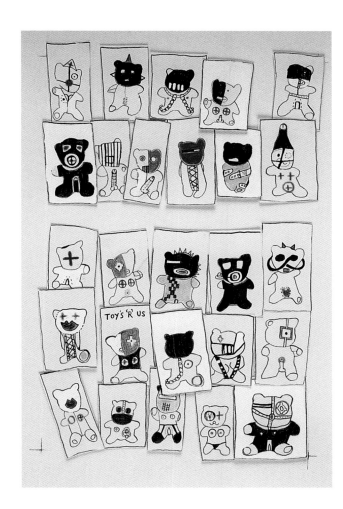

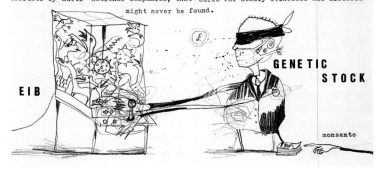

Carolyn Carter

India	Pink Town	Untitled
M Charcoal and acrylic	**M** Printing and Indian ink	**M** Indian ink and mixed media
B Self-promotional	**B** Self-promotional	**B** Ideas around the love of reading – of being engrossed in a book

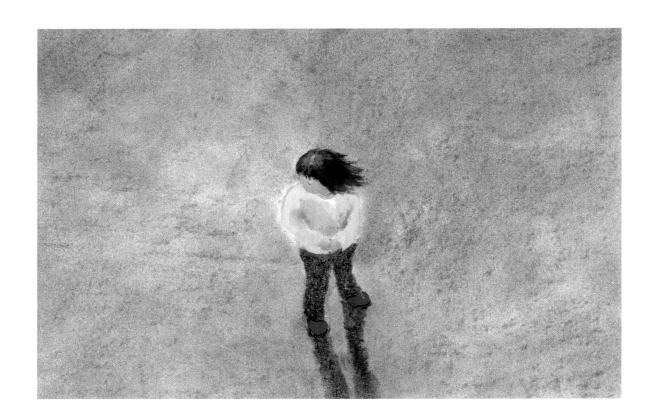

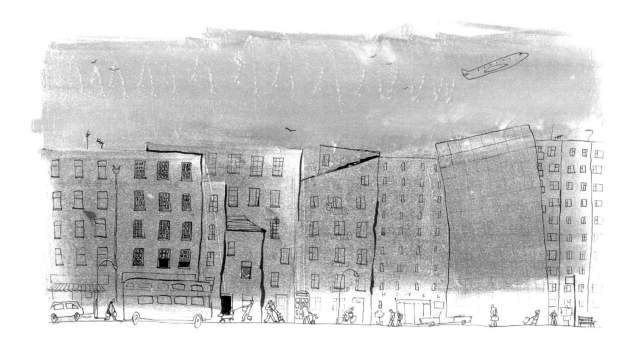

Helen Carter
Canine Couture

M Film ink, collage
and Adobe
Photoshop

B The increasing
obsession and
popularity of designer
wear, available for our
four-legged friends

Ben Challenor
The Trade Centre

M Mixed media

B A fold out information
guide of personal
accounts from
New York

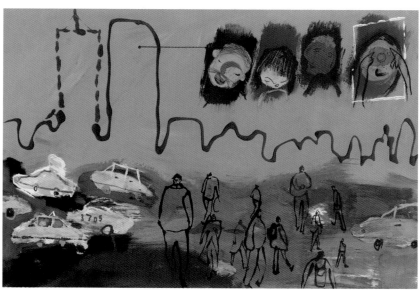

Ian Chamberlain
Nights at the Circus

M Mixed media and collage

B Self-initiated project inspired by the book 'Nights at the Circus' by Angela Carter

Shirley Chiang
Chickens

M Watercolour and felt tip pen on paper

B To produce a picture that showed a sequence with chickens

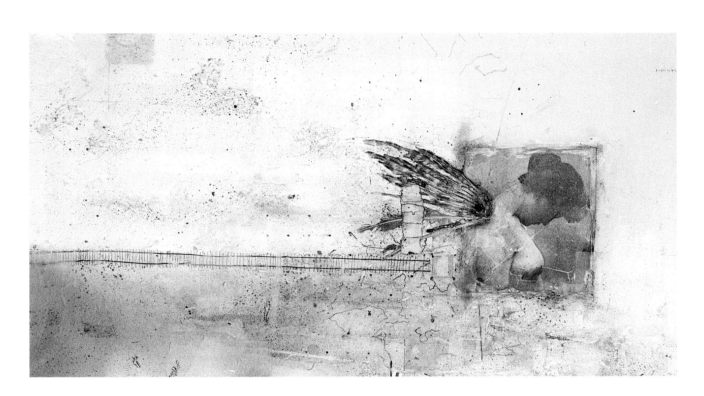

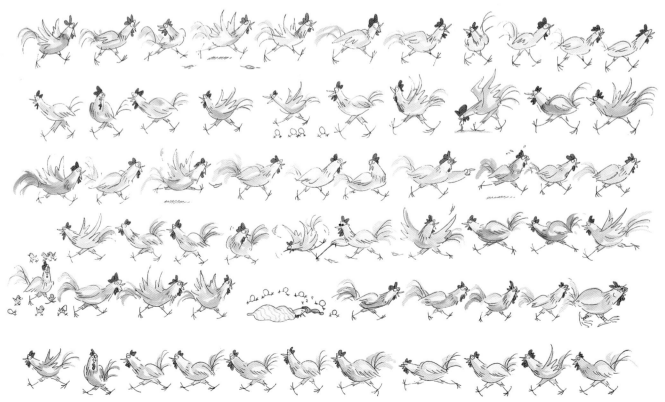

Joanna Clinch
After the Transplant

M Photomontage

B To surmise a response
to organ transplantation
based on personal
experiences

Elizabeth Cooper
Guide to Planting a Tub

M Gouache and
watercolour

B To produce a step-by-
step guide to planting
a tub for a garden

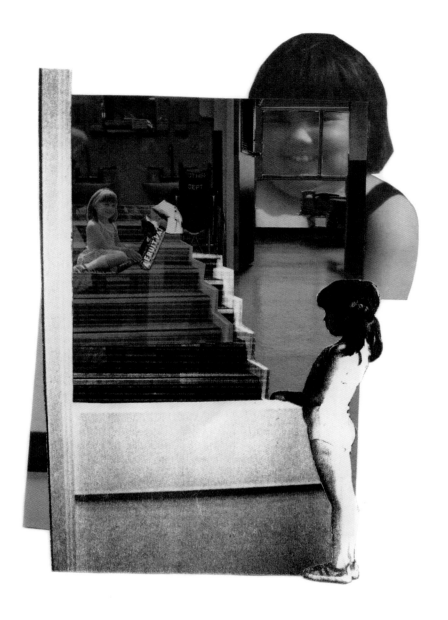

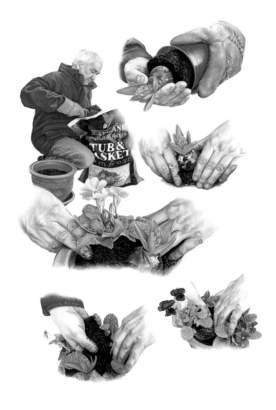

Mark Crane
Subway

M Mixed media and digital

B To design an image
illustrating the
problems of
communication
within a city

Kate Cunningham
Terrifying Teddy

M Mixed media

B To take an every day
object and transform
it into something else

Richard Dale
Snow Bunting

M Acrylic

B Without limitations
on subject matter,
produce a professional
quality illustration within
a four week deadline

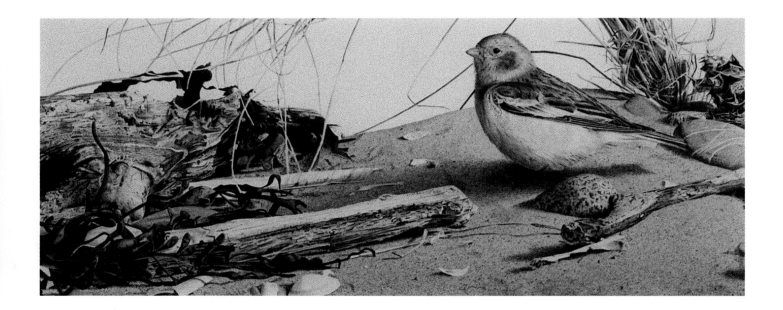

James de la Rue
Untitled

M Pen and ink

B From an original story
'Night of the Tooth',
entered in MacMillan's
Books Student
Competition

Pietrochiodo

M Watercolour and ink

B Self-directed brief
illustrating scenes
from 'The Cloven
Viscount', a short
story by Italo Calvino.
Made during the
second year of degree

**Susan
Duxbury-Hibbert**
A Night in
Granny's Room

M Pastels and ink

B To illustrate a poem
about the onset of
night in a strange room,
and the child's comfort
from the candle which
remains bright

Edward Eaves
Waterstone's
Piccadilly

M Wood, wire and
acrylic paint

B An automated
window display
for Waterstone's
flagship bookstore
on Piccadilly

Sylvia Gwen Eglington

Raising the Wheel

M Watercolour

B To illustrate the impact of buildings or structures on the urban landscape

Jody Elston

Road Rage

M Acrylics – China-graph

B Wrath – Part of a self-promotional project in which I produced a set of postcards based around modern interpretations of the 'Seven Deadly Sins'

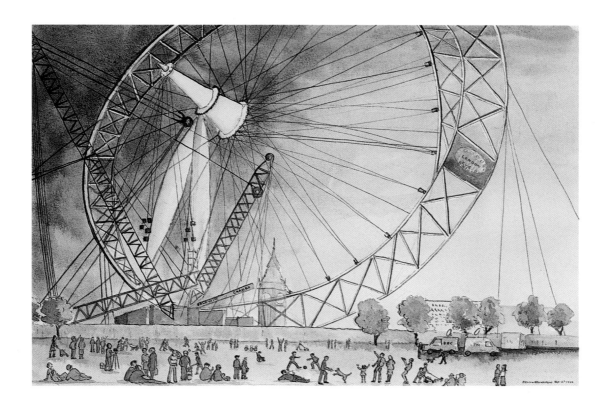

Rebecca Finn
Boy-Eating Plant
M Pen and digital
B Kids guide to London
Kew Gardens

Lydia Evans
Feeding the Pigeons
M Collage
B To create an image
loosely based on
the theme London
for a historical ES
Magazine cover

Dancing King
M Gouache and collage
B To create a character
for a children's book
and produce 3
illustrations showing
that character from
different views and
in different activities

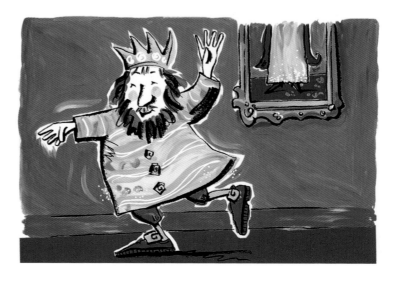

Adam French
Grey Squirrel
Study Sheet

M Acrylic

B A study sheet showing
the behavioural aspects
of the grey squirrel

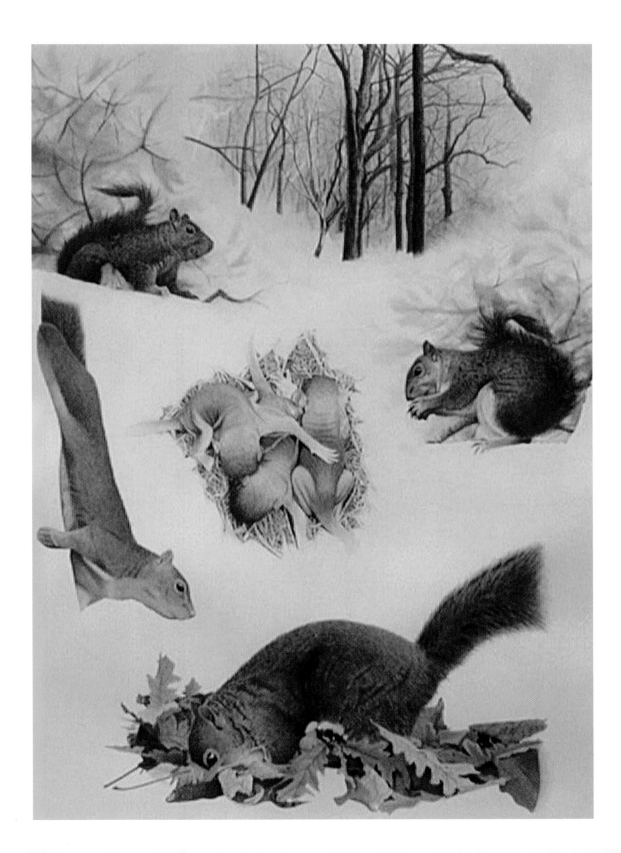

Tina Gander
The Life's Work
of Lowry
M Mixed media
B To illustrate the physical
and mental being of
the artist Lowry.
College project to
develop character
representation from
life drawing

Lizze Gardiner
Pigeons at Trafalgar
M Pen and Photoshop
B To create a series of
illustrations portraying
some of London's
more diverse areas

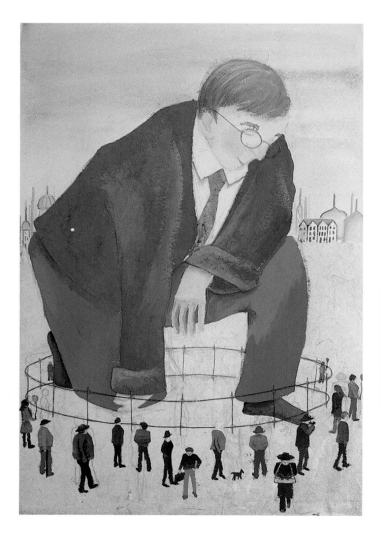

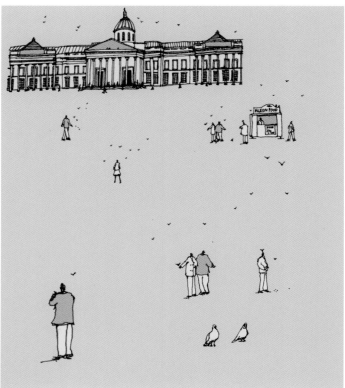

Alison Gee
Still Life of Game

M Acrylic

B To produce an
illustration to a
professional standard
for commercial use
within a 4 week
deadline

**Lyndsey Louise
Godden**
Plastic Surgery

M Acrylic and collage

B An exploration of the
critical opinions of
women regarding their
own gender, and how
these opinions act
to reinforce society
representations of
negative female
archetypes

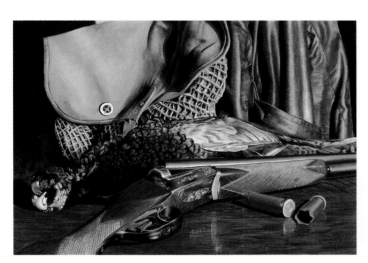

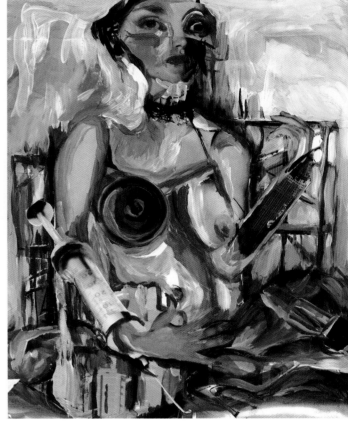

Willi Gray

Enter Strange
Creatures

M Collage, paint
and digital

B Personal project:
from a series of
images to illustrate
Shakespeare's 'The
Tempest'. Strange
spirits carrying a
banquet

Ariel

M Collage, paint
and digital

B Personal project:
from a series of
images to illustrate
Shakespeare's 'The
Tempest'. Ariel alights
in the form of a harpy
making the imaginary
banquet vanish

S Caliban

M Collage, paint
and digital

B Personal project:
from a series of
images to illustrate
Shakespeare's 'The
Tempest'. Caliban in
front of his cave

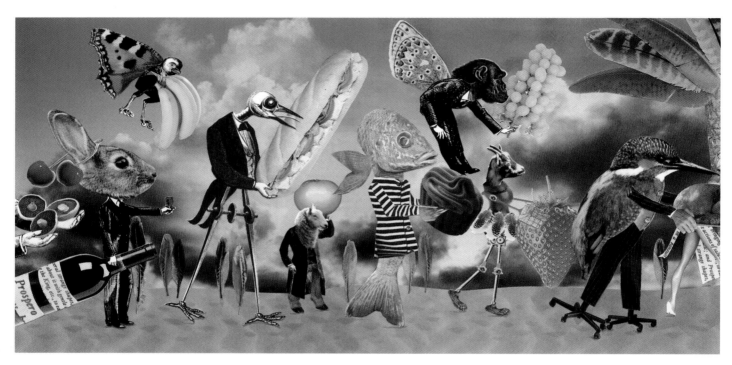

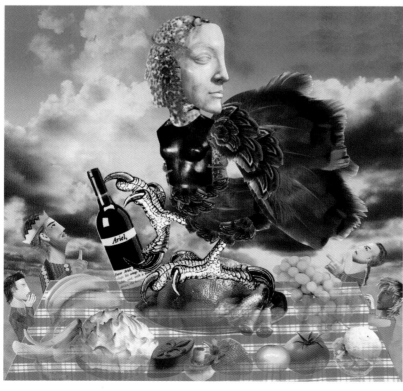

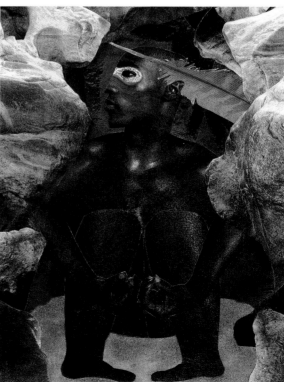

S

Joanne Hayman

G Suburbia

M Screenprint and computer

B Illustrate the negative side of suburbia evident in contemporary culture

Polly Holt

B Personal Demons

M Modelmaking combined with computer manipulation

B A selection of domesticated demons from a humourous anthropological alphabet book for adults and children written by the artist

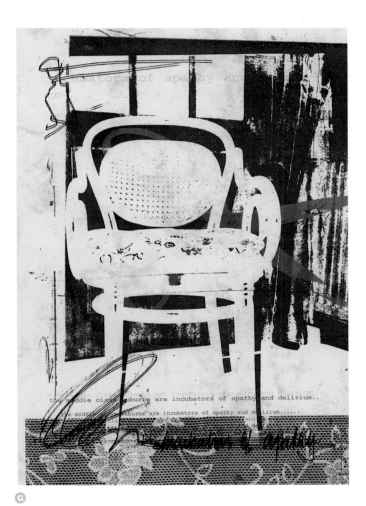

G

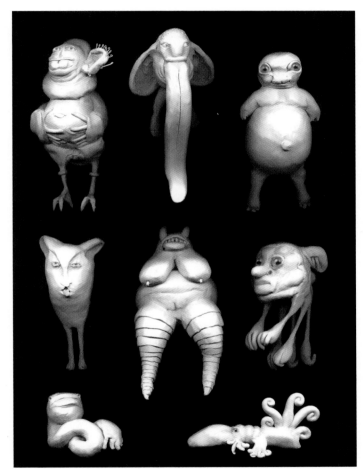

B

James Hood
Echo and Narcissus
or As Ricky looks
into the bottom of
his teacup he sees
something he really
likes the look of

M Oil paint, spray paint
and Photoshop

B One of a threesome
of images, 'Modern
Day Myths'

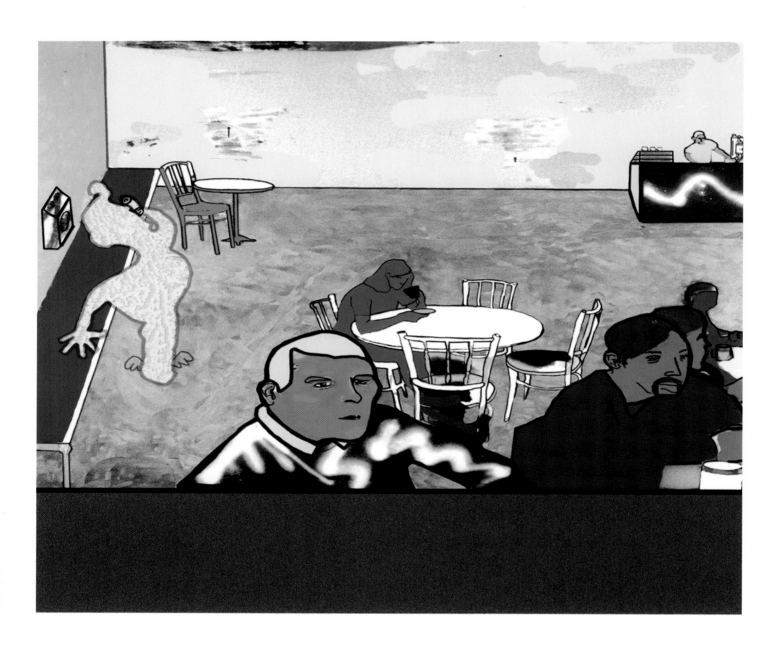

Jasmine Hughes
Organic Honey

M Mixed media

B Degree project work.
To accompany an
article in Vegetarian
magazine about the
benefits of organic
gardening

Brett Humphries
Ivy

M Acrylic and gouache

B To dynamically illustrate
the growth habit of ivy

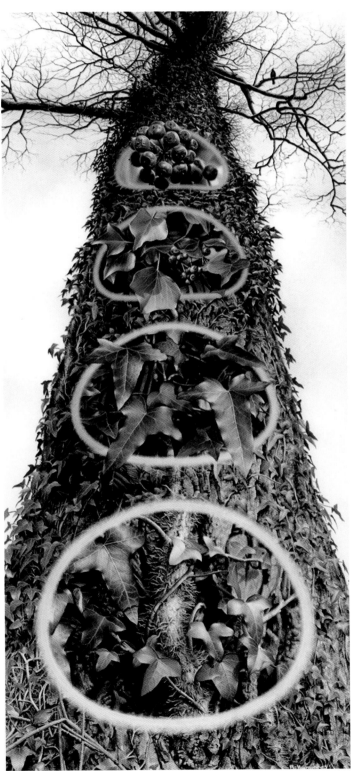

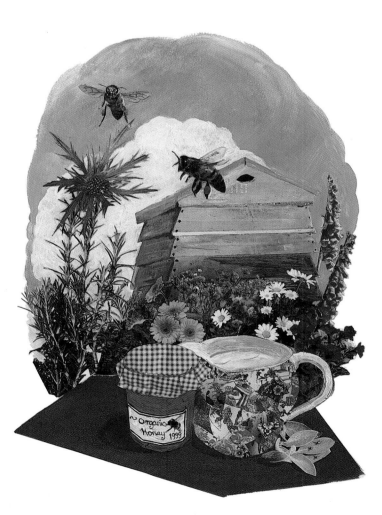

172

Ian Jarvis
Maggot Feeds from
Cash-starved Shade

M Pencil on chalk and
computer manipulation

B One of a series of
images depicting the
peculiar vital essence
of the people of London
and her suburbs

Masako Kuwahara

Leader

M Acrylic, Ink, collage
 and pencil

B To illustrate the poem
 by Roger McGaugh

Where am I?

M Acrylic, collage
 and pencil

B Self-promotional – to
 illustrate Alice in the
 Wonderland

Nightmare

M Acrylic, ink, collage
 and pencil

B Self-promotional – to
 illustrate Alice in the
 Wonderland

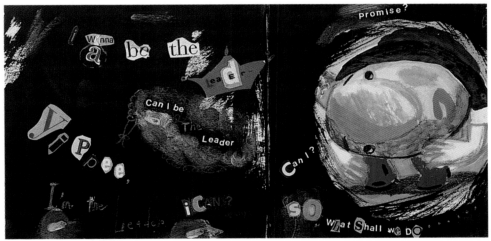

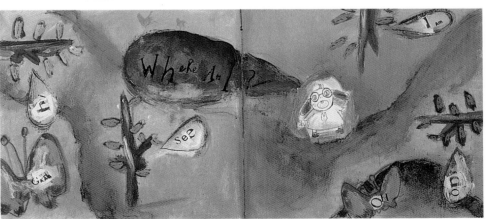

Matt Johnson
Untitled

M Mixed media/digital

B Reflection on
contemporary
socio-sexual mores

Paul Laidler
Insectophobia

M Mixed media

B Past and present
making alternate
futures is the main
theme. Seen here as
an archeological
artefact describing a
psychological ailment.
From an unknown
civilisation

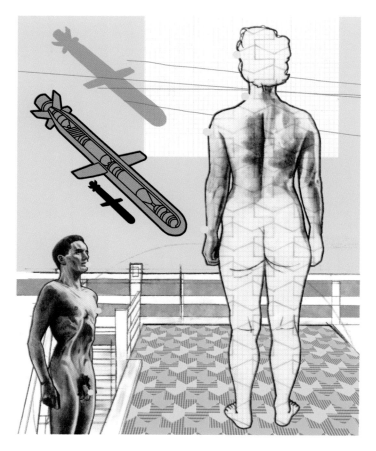

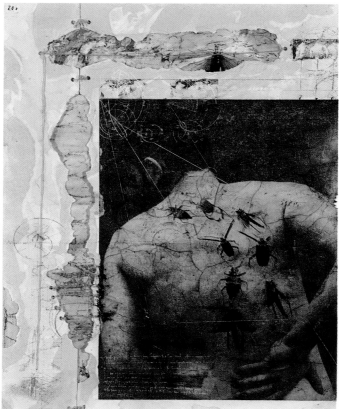

Toby Leigh

Off to the Match

M Pen, ink and mac

B To depict the mood
and tone outside a
football ground

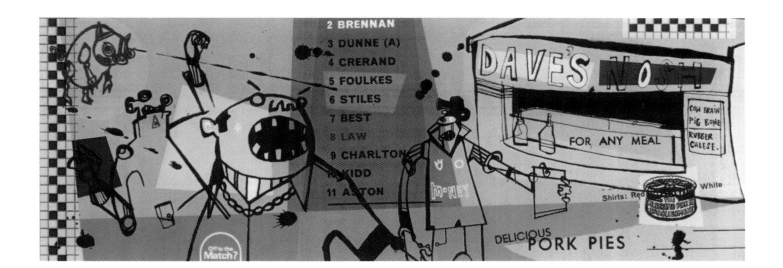

**Katherina
Manolessou**

Designers

M Screenprint

B In this double spread
from a book promoting
'Dutchman' paper,
different designers
communicate their
opinion about what
perfect paper is

Back Seat Driver

M Screenprint

B A personal piece
of work about the
influence of
conscience in
life choices

Running Out of Time

M Mixed media

B A woman wastes all
her day trying to stay
young and not run out
of time

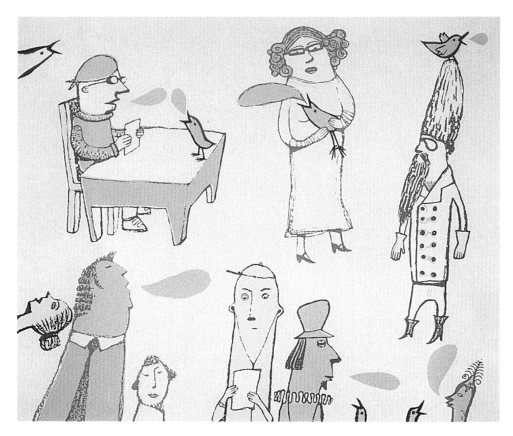

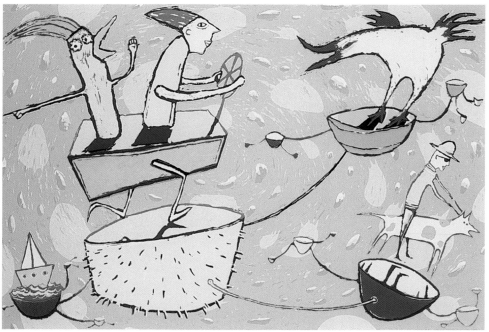

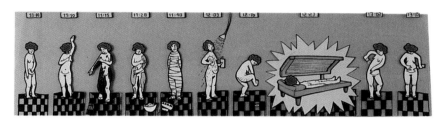

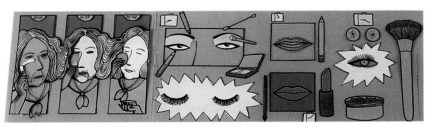

Roderick Mills

Preamble on How to Wind a Watch – No.1	Preamble on How to Wind a Watch – No.2	Catch 22 – No.1	Catch 22 – No.2	Catch 22 – No.3
M Pen and photocopiers	**M** Pen and photocopiers	**M** Pen and photocopiers	**M** Pen and photocopiers	**M** Pen and photocopiers
B To illustrate one of the stories in 'The Instruction Manual' by Julio Cortazar	**B** To illustrate one of the stories in 'The Instruction Manual' by Julio Cortazar	**B** Folio Society Illustration Awards – to capture the atmosphere of the novel 'Catch 22' by Joseph Heller	**B** Folio Society Illustration Awards – to capture the atmosphere of the novel 'Catch 22' by Joseph Heller	**B** Folio Society Illustration Awards – to capture the atmosphere of the novel 'Catch 22' by Joseph Heller

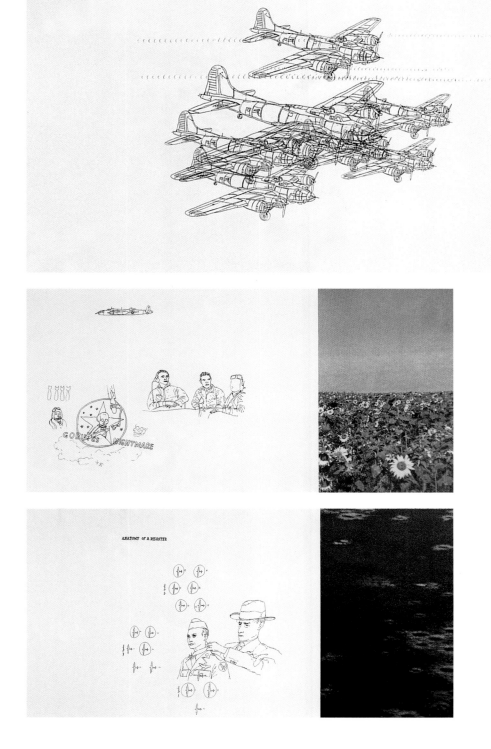

Barry Morgan
Twisting my
Melon, Man

M Silkscreen on paper

B The work is about the
more odd aspects of
'London Park Life'

John Murray
Gallop Around Fife

M Watercolour and
computer

B A final year self-initiated
project: 'Draw on
location throughout
the route of millennium
cycleways, Fife'. Then
develop three posters
advertising the route

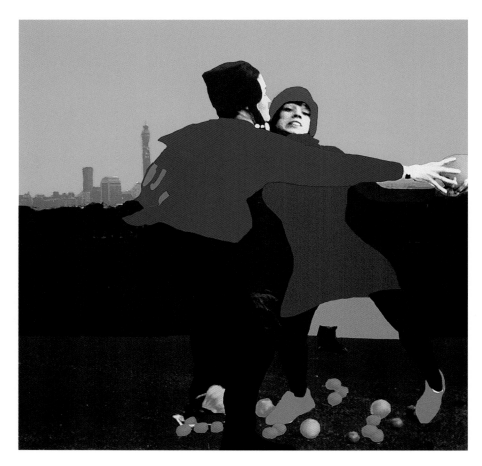

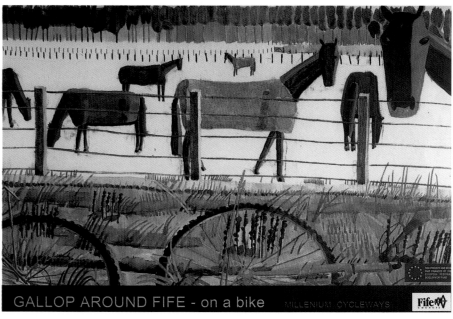

Suzanne Olding

From the Lighthouse

M Acrylic on paper

B Produce a series of
illustrations based on
the book 'The Snow
Goose' by Paul Gallico

The Unexpected Guest

M Acrylic and watercolour
on paper

B Produce a series of
illustrations based on
the book 'The Snow
Goose' by Paul Gallico

Donough O'Malley
Rendez-Vous

M Pastel

B Self-directed project,
centred on creating
a strong character,
i.e. a loveless panda
on a blind date with
a chicken

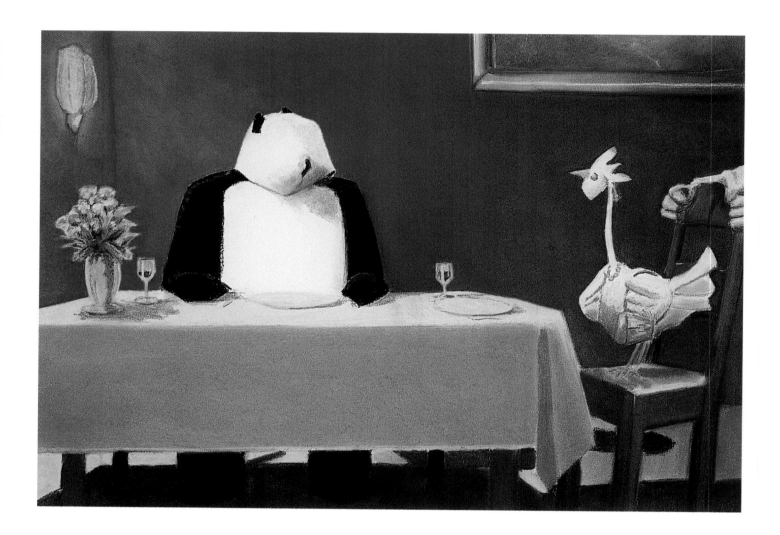

Jackie Parsons

Gone to the Dogs

Legs Eleven

M Collage/mixed media

M Collage/mixed media

B Self-promotional, inspired by a visit to Walthamstow dog track

B Self-promotional, one of a series based on British culture

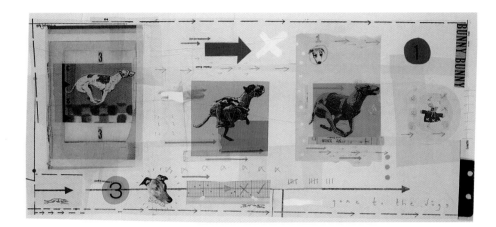

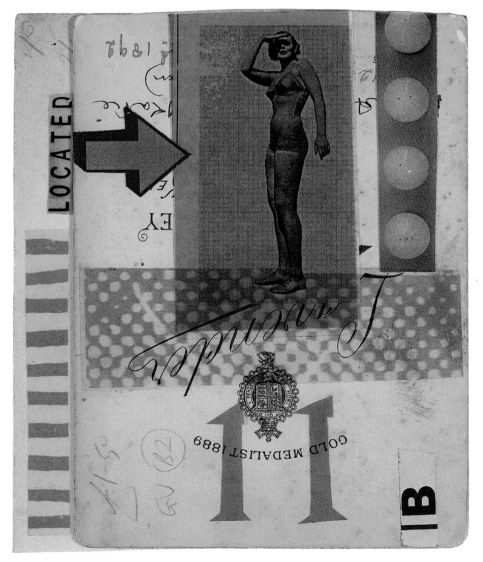

Daniel Pedersen

Sam's Bar

M Acrylic and digital

B To illustrate the location and mood of a New York bar. This piece deals with the end of a working day. Inspired by the book 'Sam's bar – An American landscape' by Donald Barthelme

London Eye in Progress

M Mixed media

B To create a drawing which captures the tension of the raising of the London Eye

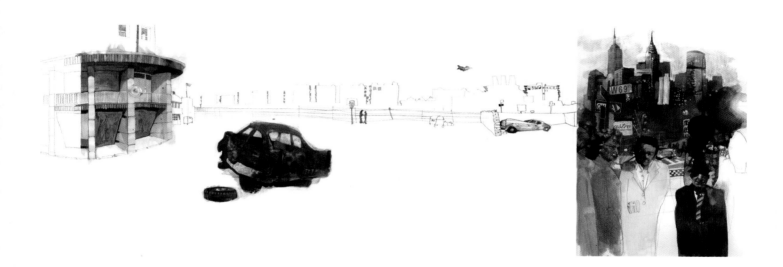

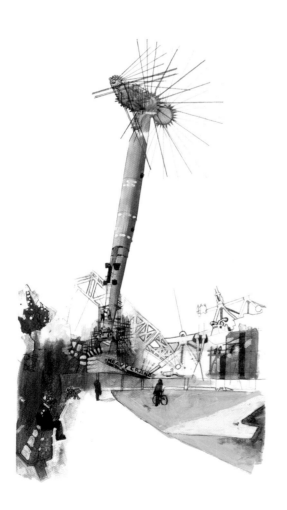

Alice Potterton
Dotty Potty Verse

M Monoprint and collage
B Illustrate one specific subject in children's verse. The type and imagery must work together and the overall solution – exciting, innovative and sensitive to the text

Catherine Powell
New York, New York

M Mixed Media
B Based on a recent trip to New York. Create a lively and atmospheric piece to accompany an editorial article about the city

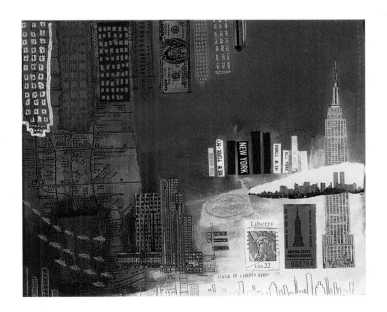

C William Webb
F Bloomsbury

Emma Rivett

Percy's Feathers

M Mixed media

B A 32 page children's
book – Percy's rare
peacock feathers are
stolen, but his dragonfly
friends have planned
a surprise for him

Julia Staite

Lion

M Mixed media

B To illustrate a poem
using multi media for
a poetry book called
'The Nation's
Favourite Poem'.
Poem must be
included in illustration

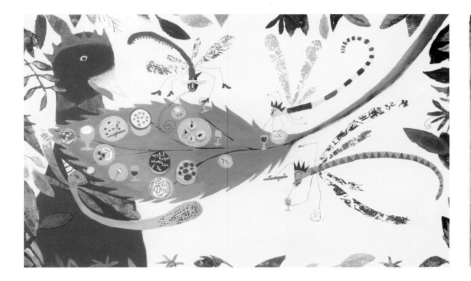

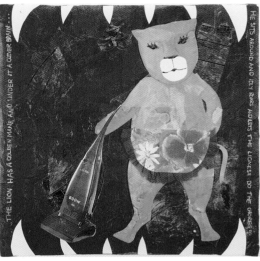

Marisa Willoughby

Primate Relationships

A comfortable Place

M Charcoal and gouache

B One of a series of illustrations exploring the relationship between primates and humans

M Gouache, collage and oil based ink

B Part of a project describing personal feelings of insecurity

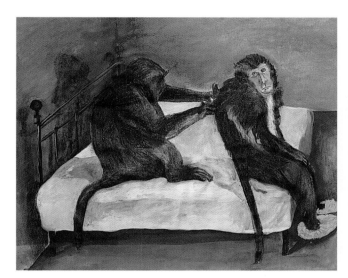

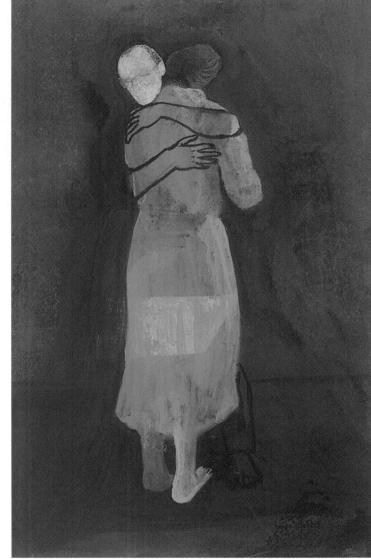

Luke Wilson
Spot the Gay Man

M Mixed media

B Self-promotional work

Kate Wilson
Doctor in the House

M Ink wash and
photograph
combined in
Photoshop

B Music Magazine
cover design for
DJ Surgeon

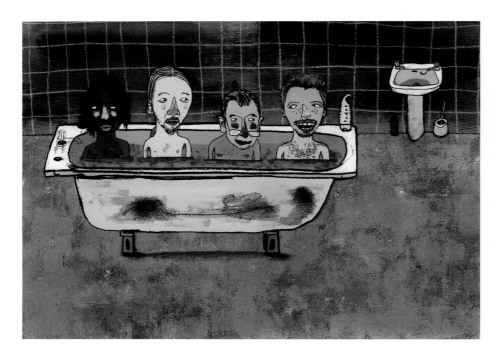

Unpublished
Gold award winner

Russell Cobb
G The Oil Works
M Acrylic
B To show diversity and
 heighten awareness
 of the illustrator's work.
 No.5 from a collect
 and keep series

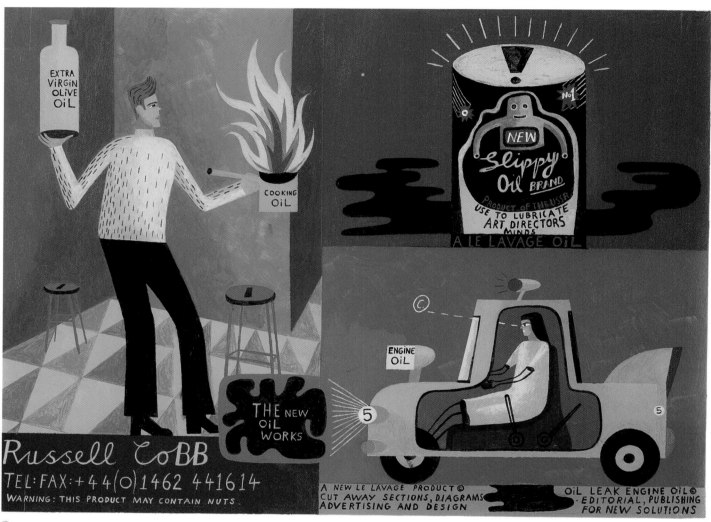

G

Nancy Anderson
Owl

M Linocut

B One of a series of
images for an animal
themed exhibition

Paul Bateman

Aquaria	Fly
M Collage	**M** Collage
B Self initiated piece, inspired by the word 'Aquaria'	**B** Self initiated concept based on the word 'fly'

Katherine Baxter
House Maze

M Watercolour,
pen and ink

B Maze for speculative
book project

Greg Becker
In the Orchard

M Oil

B Part of a series of paintings on the theme of trees, people and the passing of time

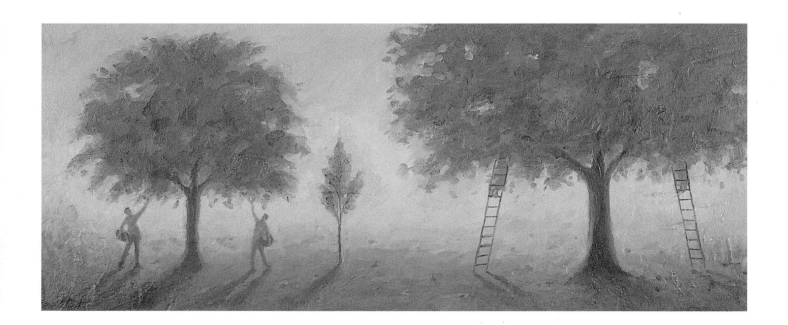

Carey Bennett
Beware

M Acrylic

B To produce an
image to appear
on a postcard for
self-promotion

Gillian Blease
Martini is...

M Digital

B To illustrate the perfect
simplicity of the classic
Martini cocktail

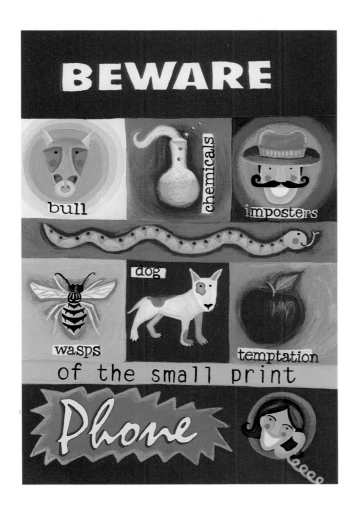

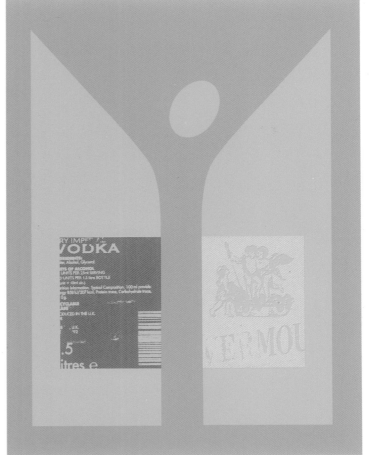

Paul Blow
Furniture and Their
Owners

M Acrylic

B To illustrate the view
that the owners of
stylish furniture are
not necessarily
stylish themselves

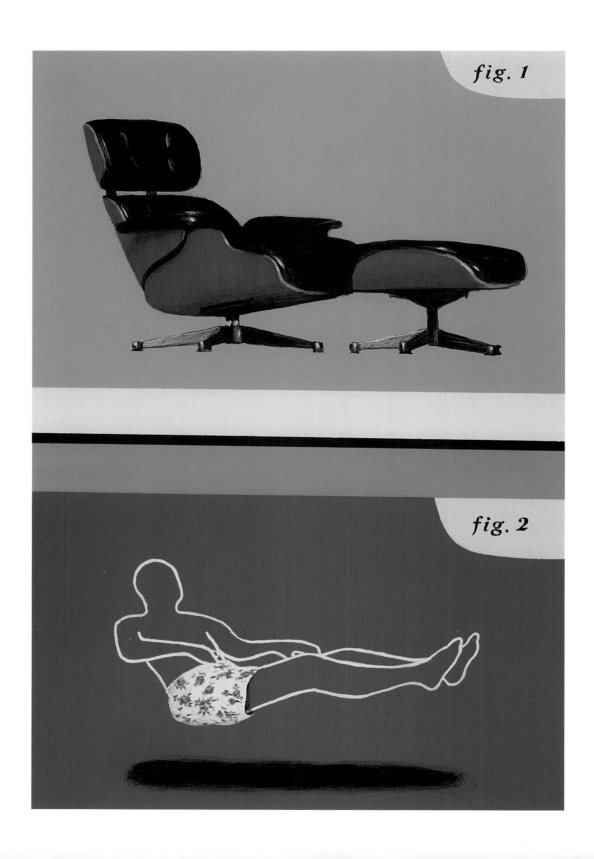

Michael Bramman
Leaving the City
M Acrylic
B Painting for proposed
future print series

Anthony Branch
Humpty Dumpty (1)
M Adobe Photoshop
B Personal work, one of
a series 'Noir Nursery
Rhymes'

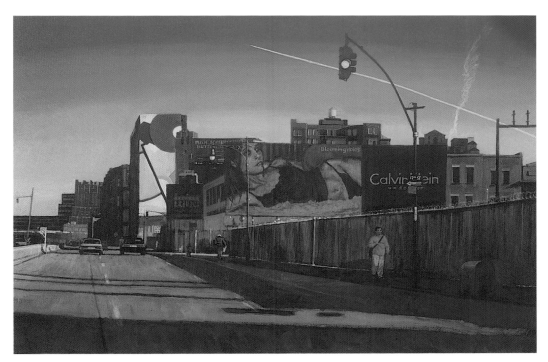

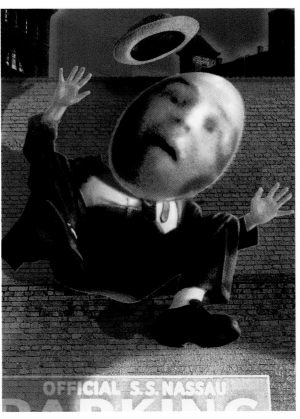

David Bray

Bothered

M Mixed media

B Self-promotional,
 experimental

Neil Breeden

The Quick and
The Dead

M Mixed media and
 Photoshop

B Having illustrated
 an album cover for
 Marvin Gaye 20 years
 ago, I've produced
 this work in the light
 of the prophecies
 Marvin Gaye made
 back in 1980

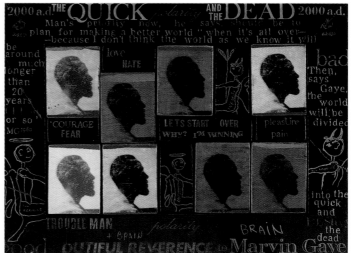

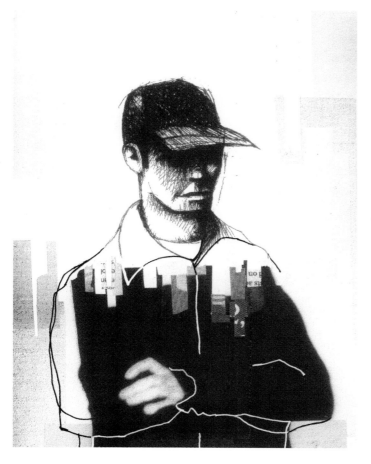

David Broadbent

Fat of the Land

M Mixed media

B To convey how I see
'The Prodigy' within
the musical spectrum,
to include elements
such as isolation
and darkness

James Brown

Goof Ball

M Biro and digital
(Photoshop)

B To design club flyers
that are eye catching
and amusing

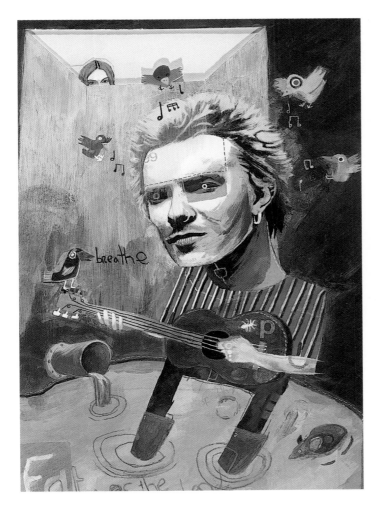

Goof Ball

Lizzie Buckmaster
The Woman
Inbetween

M Collage

B Self promotional.
Playing with the
concept of words
'in between' or
joining words

Monica Capoferri
Under the
Bedtime Story

M Acrylic and
Photoshop

B Illustration for 'Under
the Bedtime Story'.
There was a child
scared of the night
and a grandfather
who helped him with
a bit of tailoring...

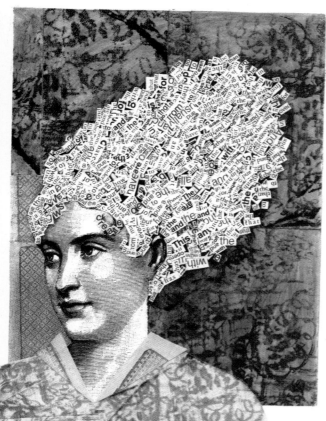

Scott Chambers
Space Invader

M Mixed media and
computer generated

B Self-initiated,
inspired by
a science
fiction novel

Sue Climpson
Rex's Afternoon
in the park

M Digitally produced,
containing also some
conventional artwork

B Self-promotion,
incorporating
elements of
published work
(editorial) which
refer to the
computer industry

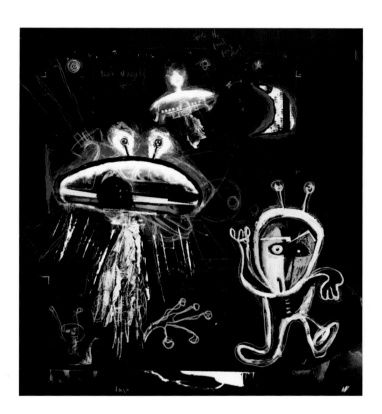

Russell Cobb

The Map Works

M Acrylic

B To show diversity and
heighten awareness
of the illustrator's work.
No.3 from a collect
and keep series

Collected Snapshots

M Acrylic

B To show diversity and
heighten awareness
of the illustrator's work.
No.4 from a collect
and keep series

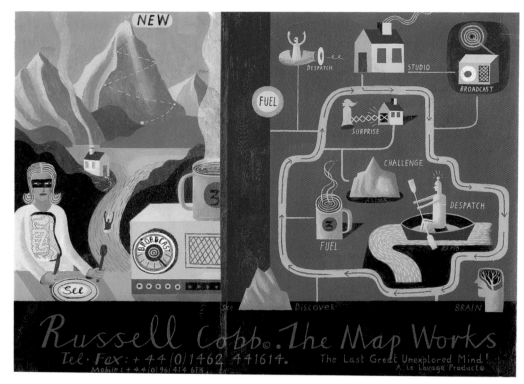

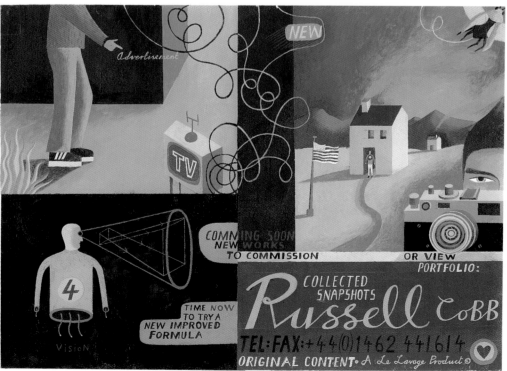

The New Anatomical
Works 1999

M Acrylic

B To show diversity and
heighten awareness
of the illustrator's work.
No.2 from a collect
and keep series

G The Oil Works

M Acrylic

B To show diversity and
heighten awareness
of the illustrator's work.
No.5 from a collect
and keep series

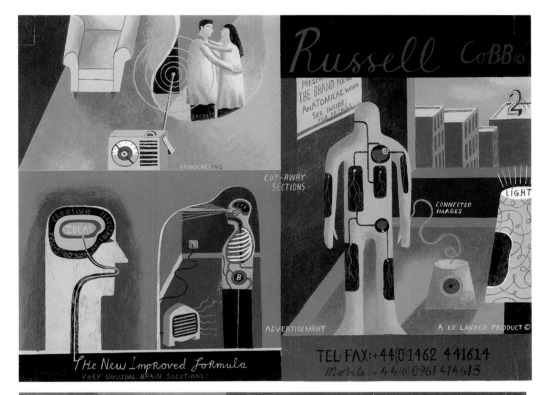

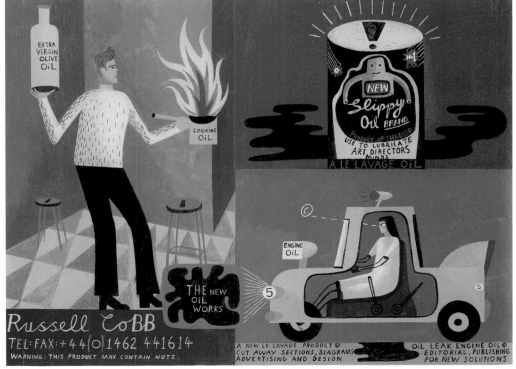

Jonathan Cusick
The British are bad at
tennis because their
manners get in the way
M Acrylics
B To illustrate the quote
in a humourous way

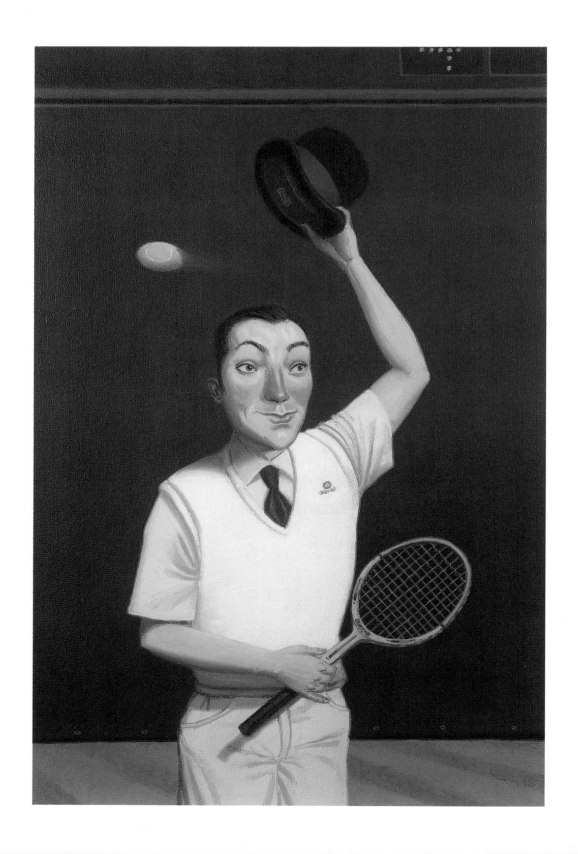

Jo Davies

New York Commuters

M Gouache

B One from a series of
images created from
sketches made on
location in New York

Peter Davies

Carnival Night

M Gouache and inks

B One of twenty
illustrations for a
childrens' book
written by the
illustrator

S Punch and Judy

M Chalks and inks

B Speculative
illustration for
portfolio aimed
towards the crime
fiction market

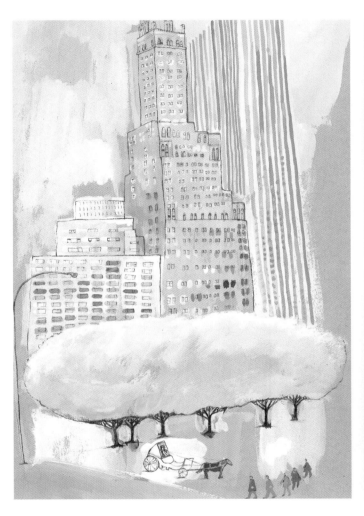

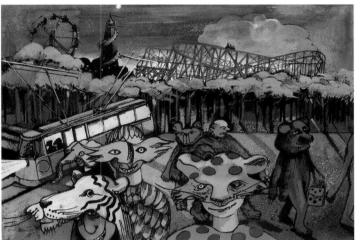

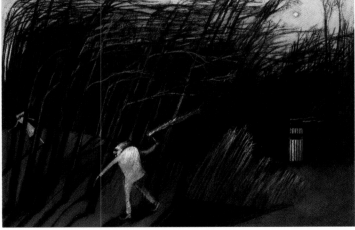

David Dean

Triangulation

M Acrylic

B Initially a greetings card idea, this is one of a series of experimental images wherein I wanted to explore simple geometric forms (triangles, circles, squares)

St. Matthew ch 8 v.23-27: Then he arose, and rebuked the winds and the sea; and there was a great calm

M Acrylic

B One of a series of images illustrating biblical stories in a contemporary way whilst still retaining links to a more traditional style of religious painting

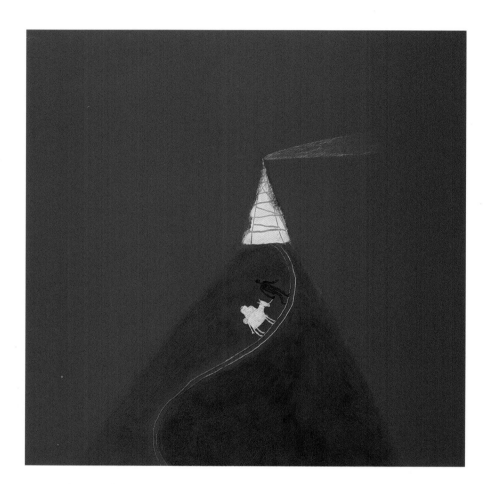

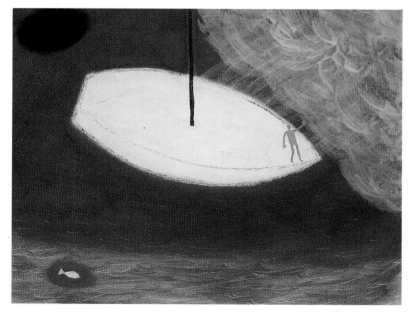

Matthew Dennis

B Meow!

M Silkscreen

B This image is one of a
set of prints inspired
by Mikhail Bulgakov's
novel 'The Master and
Margarita'

Philip Disley

Hendrix

M Ink and Photoshop

B Produce artwork
for a poster on the
theme of icons,
and experimental
John Kavanach
Moorfields

John Paul Early

Bathroom

M Computer generated

B Personal work,
unpublished

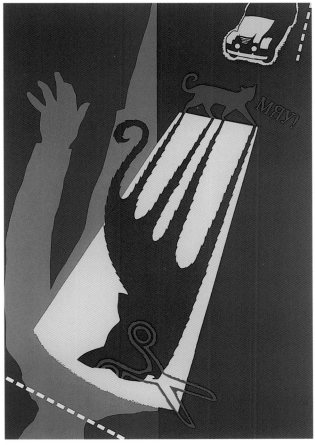

B

208

Christopher Embleton
London Town

M Gouache

B To create a poster depicting London involving relevant aspects of city life

Pete Ellis
Jack Nicholson

M Ink and acrylic

B Portrait/self-promotion

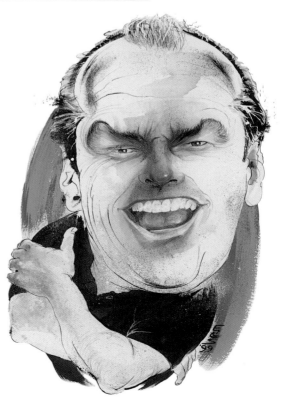

Julia Finzel
Tally Ho
M Oil on canvas
B A reflection on the
British sporting scene

Claire Fletcher
Owl and Pussycat
M Acrylic
B Self-promotional

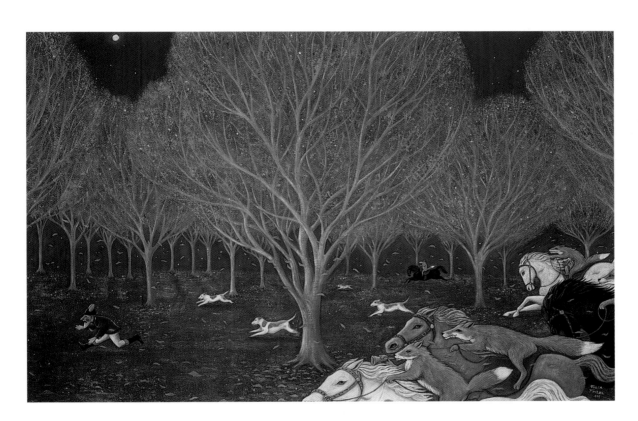

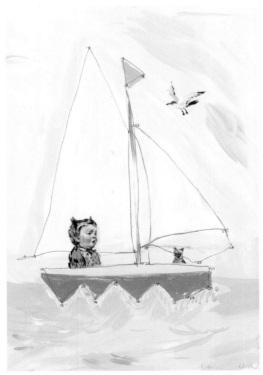

Andrew Foley
Nightmare No.1
M Acrylic
B Personal piece

Andrew Foster
Auschwitz, The Nazi
Perspective
M Mixed media
B Taken from a series of
50 images exploring the
theme of 'Britishness'
particularly nationalism,
unity, food, pub and
football culture

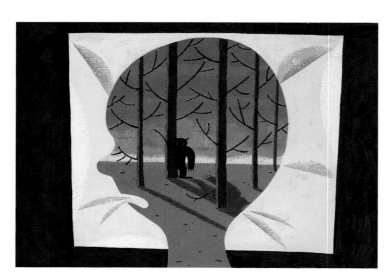

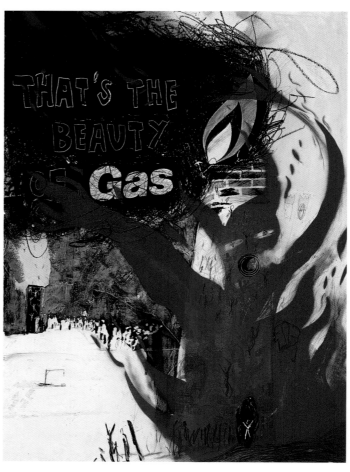

Lynda Frame

Medics

M Digital

B Self-promotional editorial regarding medics and stress

Gym Delights

M Mixed media

B Self-promotional editorial regarding the humiliation and sheer terror of joining a gym

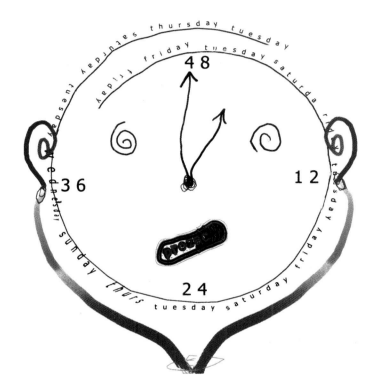

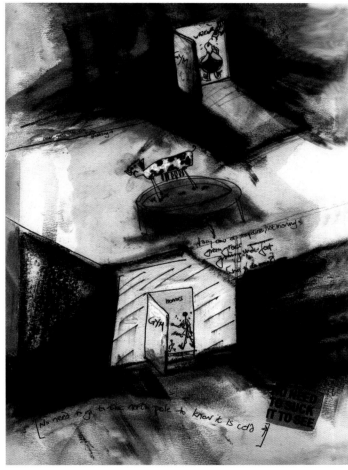

Adam Graff
Causes of Conflict
between Adolescents
and their Parents
M Pen and Computer
B Sample illustration for
English as a foreign
language course
book, to accompany
text entitled 'Causes
of conflict between
adolescents and
their parents'

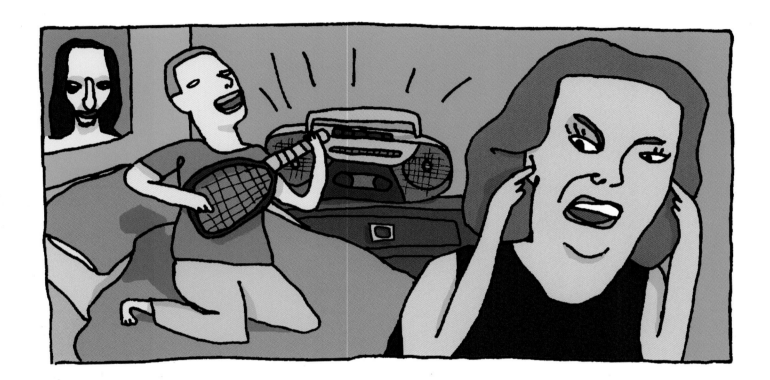

C Clive Russell
F Pearson Education

Jessica Greenman
Looking Glass

M Rotring pen on paper

B This is a picture that
could be used in a
book or on a cover
or for poetry, or a
card, or a poster

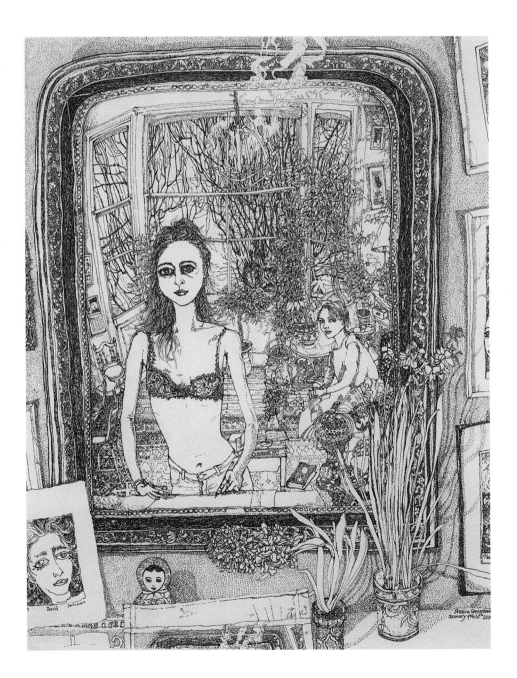

Brian Grimwood

	Proms 2000 (4)	Proms 2000 (3)	Poster
M	Brush and paint	**M** Brush and paint, and computer	**M** Brush and paint and computer
B	Proms out take catalogue cover	**B** T-shirt and banner – unpublished – for Proms 2000	**B** Poster image

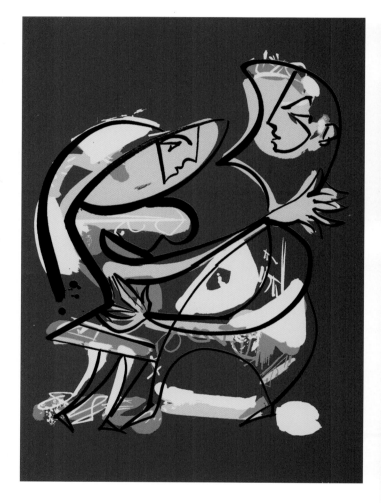

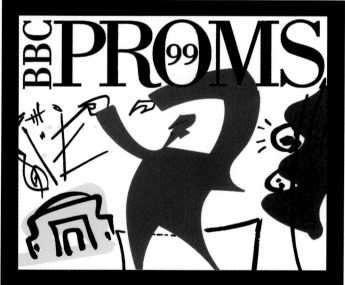

C	Tony Green	**C**	Tony Green	**C**	Roger Butler
F	Ideology	**F**	Ideology	**F**	Spice

Peter Grundy
Left Hand
M Illustrator 8
B Digital print
experiment

Peter Gudynas
AI – Mind Net

M Digital

B One of a series of
images concerned
with the theme of
posthuman futures.
For a personal book
project; speculative
illustrations and
posthuman
photofictions

David Hallows
A Rage in Harlem

M Acrylic

B Personal work to
illustrate the novel
by Chester Himes
(book jacket)

John Harris
The Threshold

M Oils

B An artist's illustration
of a city from his
travels through an
unknown region, from
'The Book of Fire'

Brent Hardy-Smith
Fizzy Headed

M Heat/Thermal paper

B Experimental Work

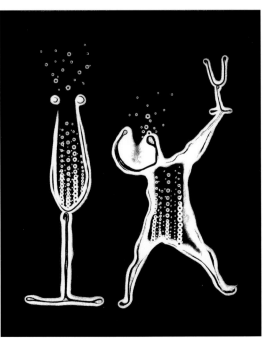

Kevin Hauff
The Enticer
(We Three Kings)

M Mixed media

B One of three
experimental images
based upon the
three wise men of
the future, illustrating
the advances in
biomechanical
robotics

Tony Healey
Louis Armstrong

M Ink and watercolour

B Character study – final
illustration featured
6 other characters
on the cover of 'The
Westminster Review'

C Harry Phibbs
F The Westminster
Review

Helen J Holroyd
The San Francisco
Museum of Modern
Art Café

M Sketchbook and digital

B Sketchbook drawing to
evoke the atmosphere
of the San Francisco
Modern Art Café

Peter Horridge
Stratford Swan

M Black ink

B Produce a calligraphic
swan for a first day
cover cancellation mark
for commemorative
Shakespeare stamps
issue. (not used:- at
the decision of the
Royal Mail)

C Howard Brown

Suzanna Hubbard
The Sea-Baby

M Mixed media

B Speculative work for children's publishing – one In a series of images to illustrate the short story by Eleanor Farjeon

Peter Hutchinson
The Parade, Kilkenny

M Pen and ink on drafting paper

B Competition for the redesign of 'The Parade', Kilkenny, Ireland

Mark Jamieson
Your Tiny Hand is
Frozen

M Mixed media

B One of two opera sets
commissioned by
L.C.A., situated at the
entrances to dining
rooms on a new Cruise
ship. Approx 1 metre
wide x 10cms deep

C Nicole Elstone

F London
Contemporary Art

Robert Jones
Tin Girl

M Freehand/Photoshop

B Part of a series
of images called
'Natural Mechanics'

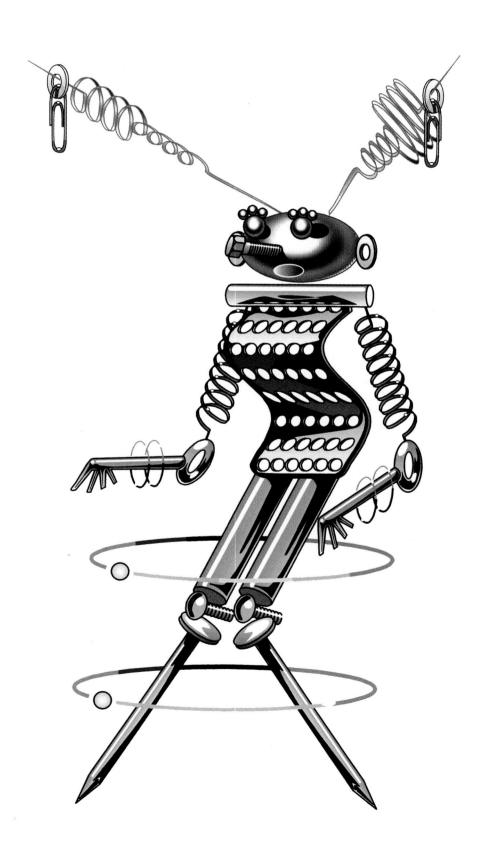

**Satoshi
Kambayashi**
Napoleon

M Line and wash

B To create an amusing
image of France

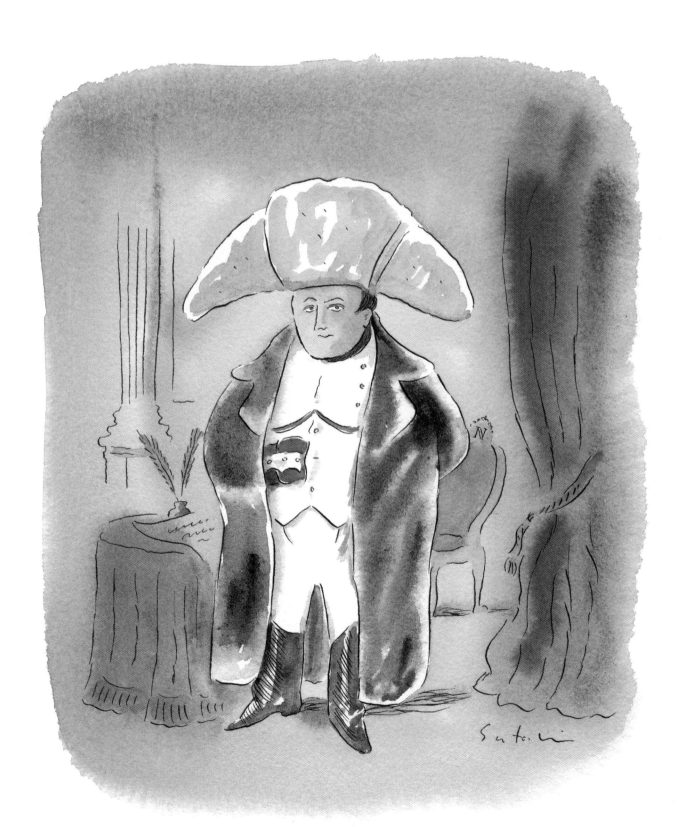

Frank Love

What's on the Box?	Safeman (keyframe)
M G4 Powermac – Photoshop 5	**M** G4 Powermac – Photoshop 5
B Depict a TV addict	**B** Pitch design for banking television commercial about a man oblivious to the possible threats around him and his property

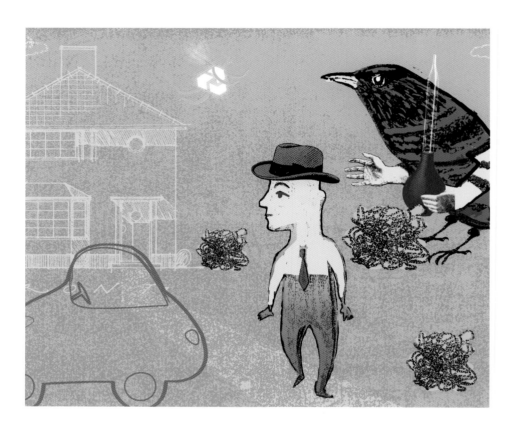

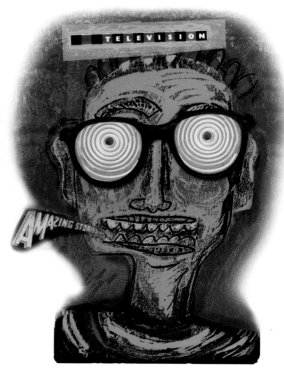

Robert Loxston
New York City

M Applemac

B Self promotional
piece to capture
hustle and bustle
of New York City,
emphasising tourist
attractions, places
of interest and
importance

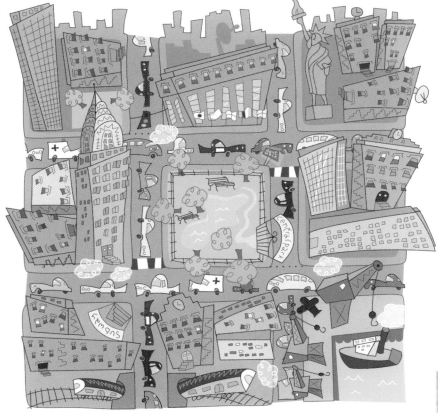

Mark Mackie
Shadows from the Past
(Don't Let Go)

M Oil pastel

B One of a series exploring
'memory' – personal
experimental work

Shane McGowan
Zebra Crossing

M Ink and Photoshop 5

B Part of a children's book I'm working on aimed at kids under 5 to illustrate the alphabet

Belle Mellor
Miracle Man

M Pen and ink

B Page from self initiated picture book

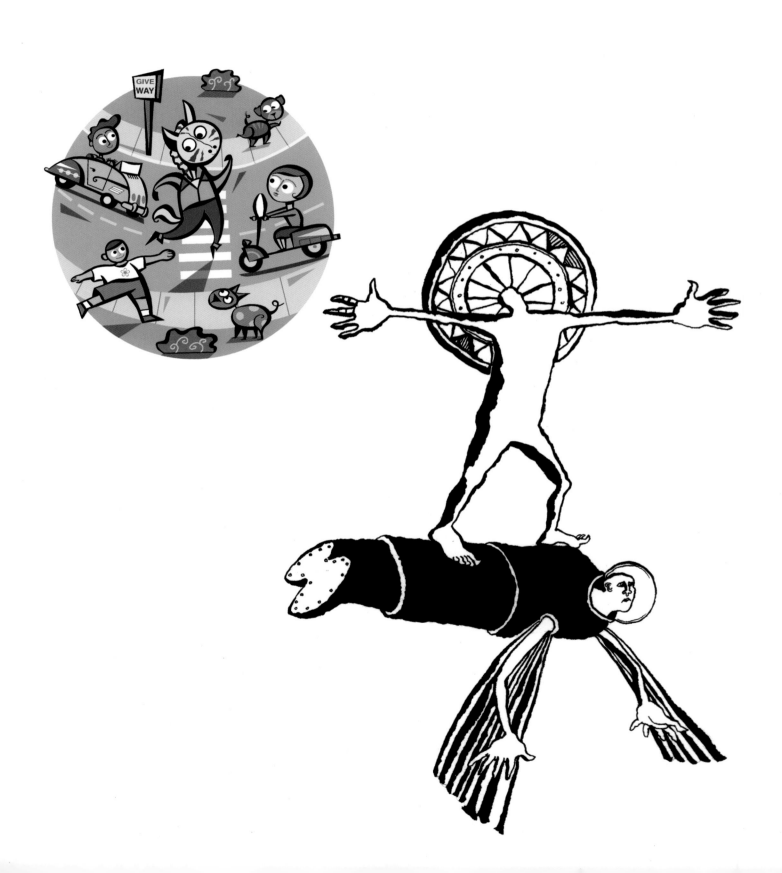

Belle Mellor

Sketches

M Pen and ink

B Collection of sketches
for self promotion

Julie Monks

Road Rage

M Oil paint/acrylic
paint on paper

B To illustrate an article
on Road Rage

All Cats are Grey
in the Dark

M Oil paint/acrylic
paint on paper

B Illustrate a proverb

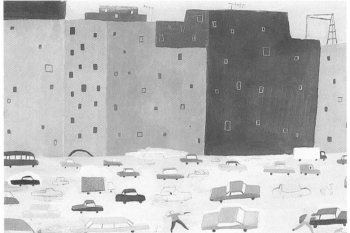

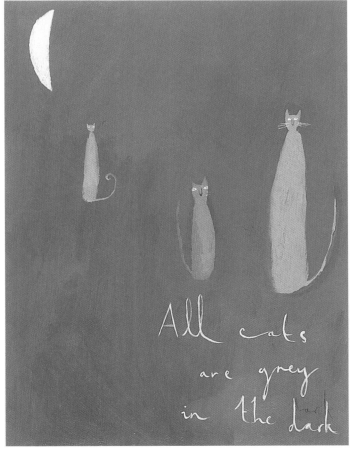

Ray Nicklin

Dressing Up/Flatcats

M Digital photographs, Photoshop and Painter software

B Self-promotional image demonstrating a variety of digital drawing techniques

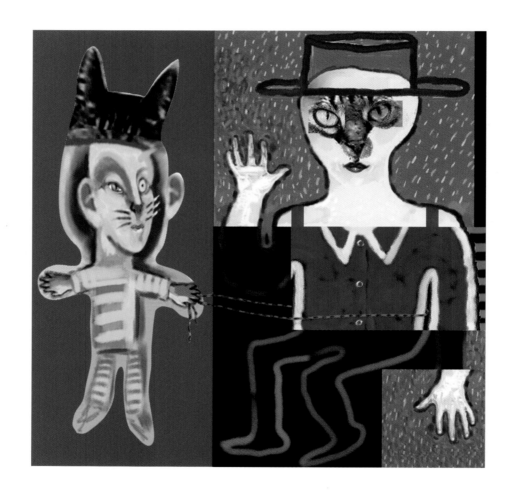

Mel Owen

Hope

M Screen print

B Commemorate the
lives of the unarmed
protestors who were
killed in the Tiananmen
Square massacre

Chrysler

M Screen print

B Personal work based
on a trip to New York

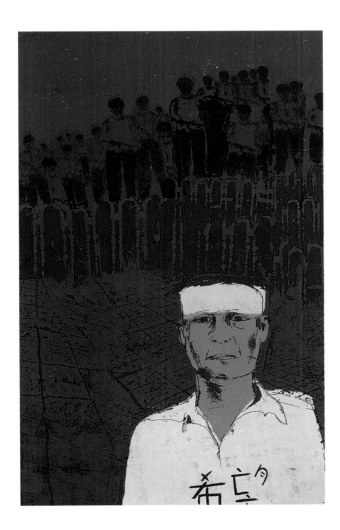

Paquebot

Will You Have Me?

M Photoshop

B To illustrate a man
trying to interest a
woman at a café

Lab Mouse

M Photoshop

B To depict the fate
of a lab mouse

Spaceman

M Photoshop

B To create an image
of space-age

Laughed At
(After telling your
boss your bright idea)

M Photoshop

B An employee tells his
boss what he thought
was a bright idea

Impossible
Relationship

M Photoshop

B To illustrate an
impossible
relationship

Hello!

M Photoshop

B To illustrate a man
saying hello to his
goldfish

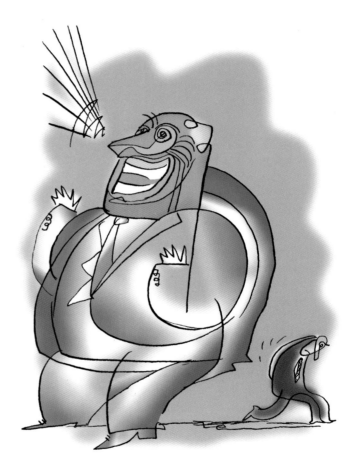

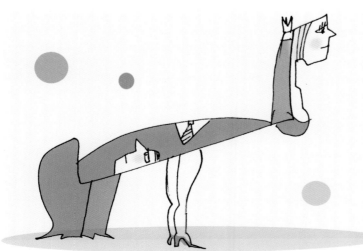

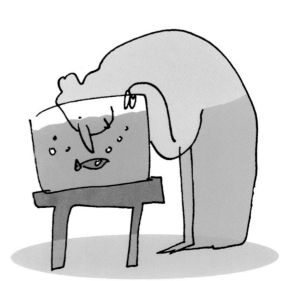

paquebot.

Pierre-Paul
Pariseau
The Fly
M Digital
B Promotional artwork

Garry Parsons
Cowbilly
M Acrylic
B Promotional work
 inspired by the short
 story 'Brokeback
 Mountain' by
 Annie Proulx

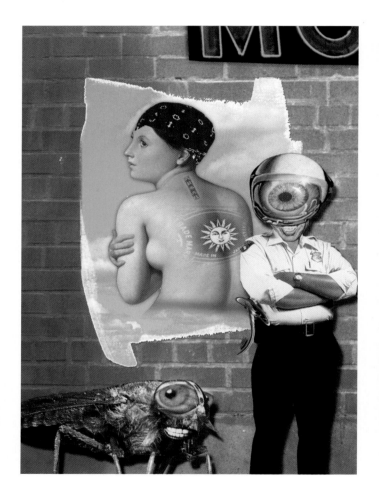

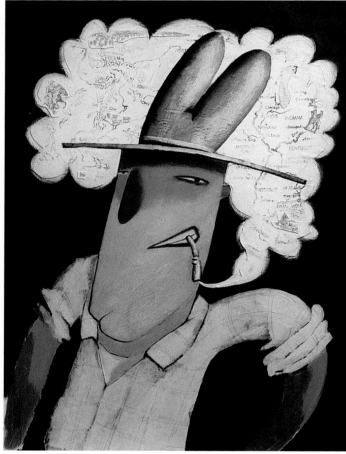

Jackie Parsons
Chip Forks &
Glamour Girl

M Collage/mixed media

B Self-promotional, one
of a series based on
British seaside culture

Ian Pollock
The Genealogy
of Jesus

M Watercolour, ink
and gouache

B One of 55 illustrations
for 'Pollock's New
Testament'. Major
series of illustrations
to commemorate
the illustrators death
following on from the
'Miracles and Parables'

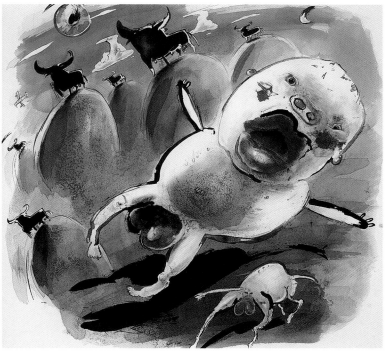

Matthew
Richardson

Nature of Creation

M Mixed media

B Experimental work
around the idea of
creative nurturing,
growth and impulse

Past Queen

M Mixed media

B Personal work
reflecting on
the history and
contemporary
place the monarchy
finds itself in

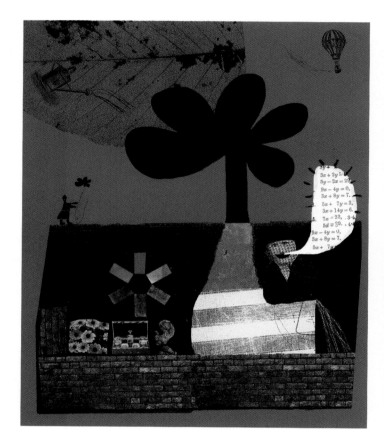
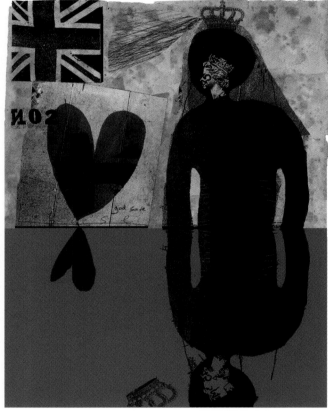

Johanne Ryder
Hey Diddle Diddle
No.1
Hey Diddle Diddle
No.2
M Mixed media, 3-D
and digital
B Produce a series
of images for the
nursery rhyme
'Hey Diddle Diddle'

Meilo So
Mouse
M Watercolour
B Development for
Martha Stewart
merchandising range

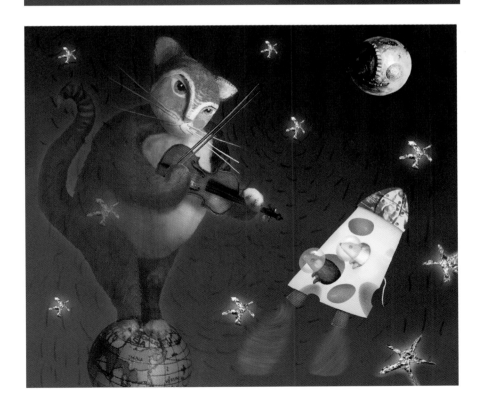

Simon Spilsbury
Madlife

M Mixed media

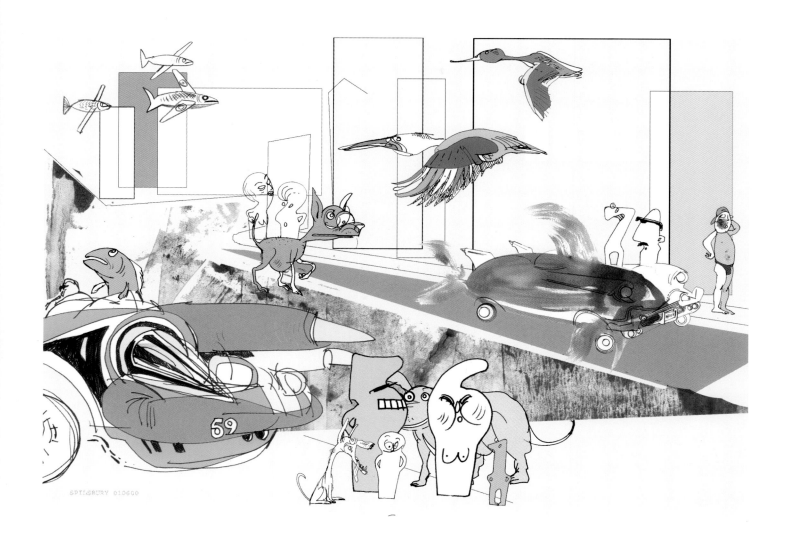

Ana Stankovic-Fitzgerald
Ballroom

M CGI

B This image was made in Photoshop from scratch for the purpose of web publishing, or laser printout

Deborah Stephens
Road Rage

M Heat-drying oil paint

B Yearly promotional: idea of showing fast pace of life today – hence the subject of road rage. Material to show clients use of visual puns

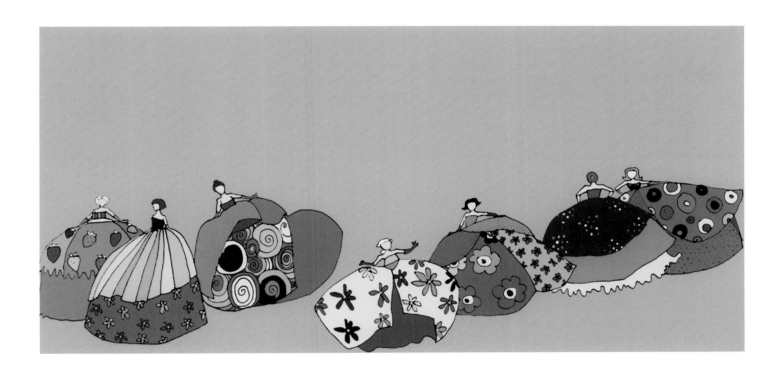

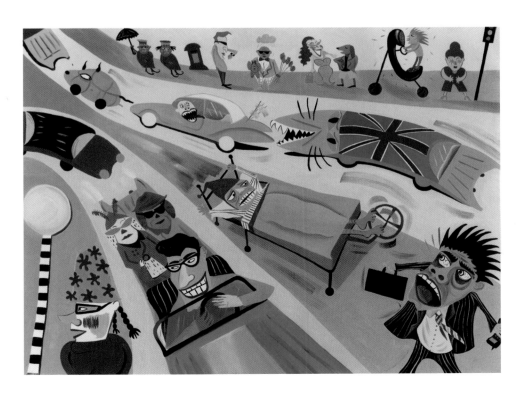

Andrew Steward
Caving In (CD Cover/
Sleeve for Monkey)

M Mixed media

B Illustrate the album
'Caving In' by Monkey,
Island Records. A
linear narrative sleeve
and cover capturing
the mood and feel
of the lyrics

Matthew Tillett
Too Hot to Handle

M Mixed media

B Piece for magazine
article based on
relationships

C Mark Higglesbottom
F Styleorouge

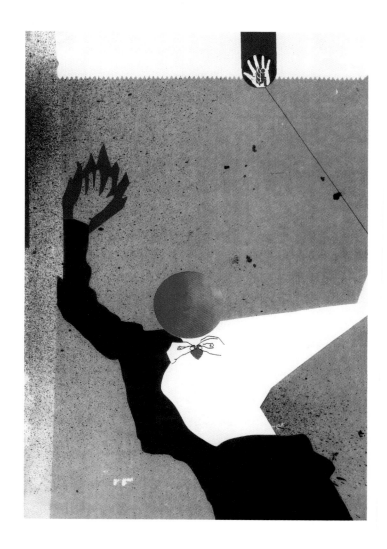

Mike Todd
Marriage

M Pencil, acrylic,
 ink and digital

B To convey the
 essence of marriage:
 a partnership of love,
 facing everything in
 life together, including
 the mundane

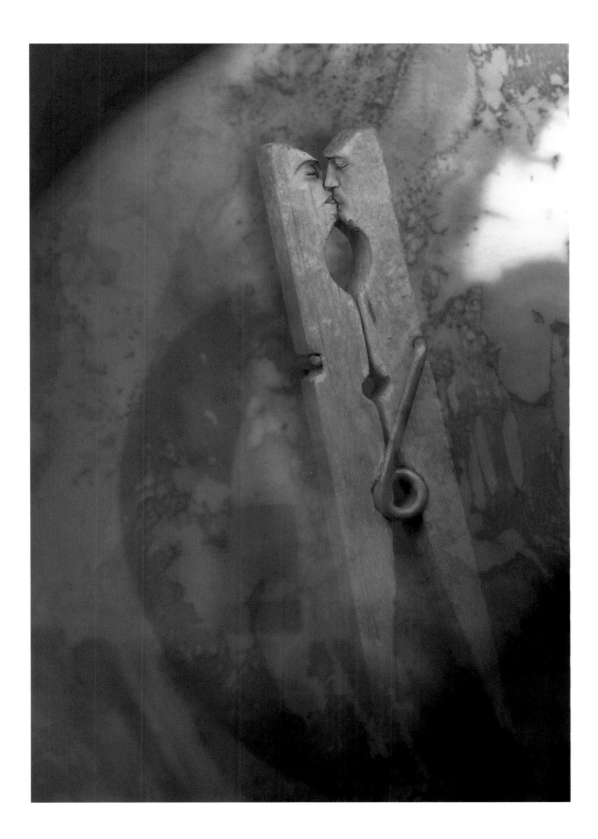

Peter Warner
Blackpool Mill,
Hartland

M Watercolour

B Study painted on
location for artist's own
project, which explores
the scale and effect
of the man-made in
otherwise uninhabited
landscapes

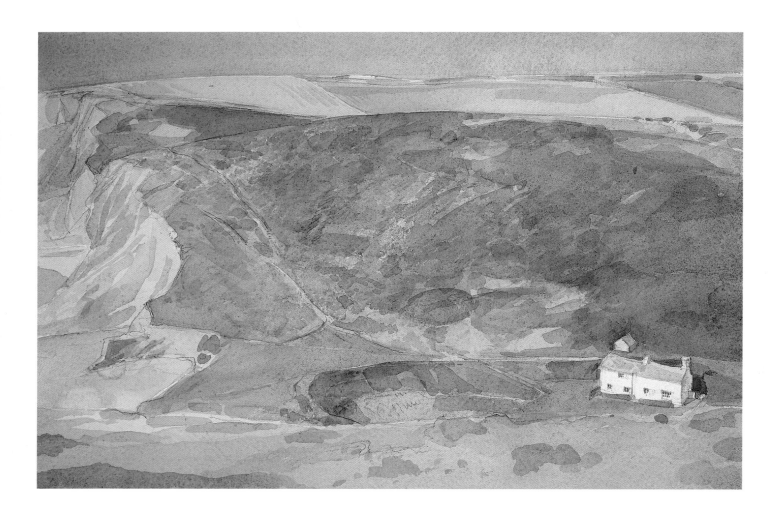

Louise Weir
'Turned Out
Nice Again!'

M Acrylic Painting

B Self initiated
promotional work
from a series of
strange realities

Greer Whitewick
Bastet

M Mixed media

B To produce a body of
 work illustrating a
 diverse collection of
 historical, mythical
 and fictional female
 characters and icons

Mark Wilkinson
Lightbulb Sun

M Digital

B Commissioned but
 unused image for
 cover of CD, Style –
 ideas forwarded by
 band – 'Porcupine
 Tree' included
 'Distressed and
 Grainy' – themes left
 to me, illustrating title

C Steven Wilson
F Porcupine Tree

Dan Williams

Sleeping Buddha

M Ink

B Location drawing done
on the streets of Krabi,
Thailand. To capture
the atmosphere
of the place

Anita Yeomans
Hello There
M Pencil/digital
B Self-promotional

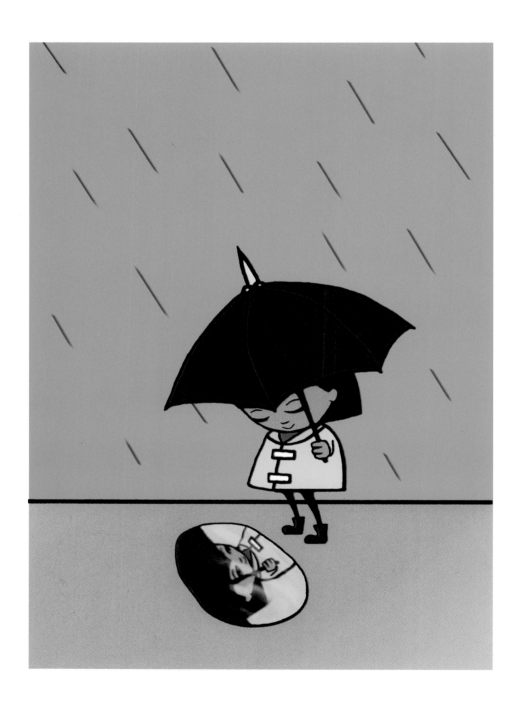

Atelier Works

Type Faces

M Letterpress

B Dear all,

Take a day out of the studio, spend it at Alan Kitching's letterpress workshop, and create a typographic self portrait.

Have some fun!

Alex Coe
Glenn Howard
Julian Seymour
Quentin Newark

David Hawkins
Ian Chilvers
Mette Heinz
Rohan MacCallum

Giovanni Rodolfi
John Powner
Natalie Turner
Smut (the dog)

Atelier Works
Design Consultants

A The Old Piano Factory
5 Charlton Kings Road
London NW5 2SB

T 020 7284 2215
F 020 7284 2242
E atelier@atelierworks.co.uk

www.aoi.co.uk

AOI

Gallery

A huge range of illustrators' portfolios, both members and non-members. Regularly updated, the Gallery now contains hundreds of images that are easily searchable by name, style, subject, keyword etc. Images are initially viewed as thumbnails with the artist's name providing a link to their contact details and biography.

Users have the option of saving selected images, together with any written comments, to a private folder. Additionally, two or more users can set up a shared image folder with its own password. It's never been simpler to find the illustrator you've been searching for.

News

Up to date industry news is regularly recorded. News archives are searchable by year, month and keyword.

Magazine

The Association's monthly magazine on-line. Archives contain a wealth of material fully searchable by keyword.

Chat

The place to post your thoughts and enter discussion on any topics of concern to the illustration community.

Info

General information about the AOI including a full list of services, events, publications and membership.

Other Features

Personal Web Address

Illustrators appearing on the site can have a personal web address linked directly to their images.

Postcards

Any chosen image from the Gallery can be mailed together with a message as an electronic 'postcard'.

I-mail

A secure internal e-mail system for users to contact each other. The site is open to all areas of the illustration community.

Illustrators or agents wishing to submit images to the Gallery can find complete details on-line or by telephoning the AOI office.

AOI on-line has been developed for the Association of Illustrators by Warp Interactive.

Contact Penny Pearson
E penny.pearson@btinternet.com

AOI membership benefits

The Association of Illustrators provides a voice for professional illustrators and by force of numbers and expertise is able to enforce the rights of freelance illustrators at every stage of their careers. Membership of the AOI is open to all illustrators, illustration students, agents, lecturers and illustration clients.

All categories of membership receive the following benefits:

Bi-monthly journal

Discounted rate for Images – call for entries, hanging fees and annual pages

Contact details on office database for enquiries from clients

Discounts from material suppliers

Regional group contacts

Discounts on AOI events and publications

In addition we provide the following services for particular types of membership:

Full Membership

This category is for professional illustrators who have had work commissioned and accept the AOI code of conduct:

Legal advice on contracts

Hotline information on pricing and professional practice

Discounted portfolio surgery

Business advice – an hour's free consultation with a chartered accountant on accounts, book-keeping, National Insurance, VAT and tax

Full members are entitled to use the affix 'Mem AOI'

Associate Membership

This one-year category is for newcomers and illustrators on their first year out of college who have not published work. In exceptional circumstances this membership can be extended by an extra year:

Hotline information on pricing and professional practice

Discounted portfolio surgery

Business advice – an hour's free consultation with a chartered accountant on accounts, book-keeping, National Insurance, VAT and tax

Student Membership

This service is for students on full-time illustration or related courses:

Discounted portfolio surgery

Corporate Membership

This service is for agents and clients from the illustration industry:

Bi-monthly journal

Free copy of the Images catalogue

All corporate members' staff and illustrators will receive discounts on events, Images and AOI publications

College Membership

College membership entitles the college to the following benefits:

A free lecture from an AOI Council Member or selected illustrator on the creative, ethical and business aspects of illustration

Free copy of Images annual

AOI bi-monthly journal

For an application form and cost details please contact:

Association of Illustrators

81 Leonard Street

London EC2A 4QS

T +44 (0)20 7613 4328

F +44 (0)20 7613 4417

E info@a-o-illustrators.demon.co.uk

W www.aoi.co.uk

AOI publications

Survive: The Illustrators Guide to a Professional Career

Published by the AOI, Survive is the only comprehensive and in-depth guide to illustration as a professional career. Established illustrators, agents, clients and a range of other professionals have contributed to this edition. Each area of the profession including portfolio presentation, self promotion and copyright issues are looked at in detail. The wealth of information in Survive makes it absolutely indispensable to the newcomer and also has much to offer the more experienced illustrator.

Rights: The Illustrators Guide to Professional Practice

Rights is an all inclusive guide to aspects of the law specifically related to illustration. It includes information about copyright, contracts, book publishing agreements, agency agreements, how to go about seeking legal advice, how to calculate fees and guidance on how to write a licence.

Rights is the result of a number of years research. It has been approved by solicitors and contains the most detailed and accurate model terms and conditions available for use by illustrators or clients.

Troubleshooting Guide

A handbook written by solicitors Ruth Gladwin and Robert Lands (Finers Stephens Innocent) covering essential legal issues surrounding subjects such as animation, collage, websites, and advice about taking cases to the small claims court.

Client Directories

Both Publishing and Editorial Directories list over 100 illustration clients with full contact details: the Advertising Directory holds details of over 200 advertising agencies who commission illustration – providing an invaluable source of information for all practitioners.

a to z of illustrators

About the illustrators

A Agent
T Telephone
F Fax
M Mobile
E Email
W Website
I ISDN

Nancy Anderson 191
8a Birdhurst Road
South Croydon
Surrey CR2 7ED
T 020 8681 0310
F 020 8681 0310
M 07713 176267
E n.anderson
@btinternet.com
W www.nancyanderson
.co.uk

Honor Ayres 147
50 Corston View
Odd Down
Bath BA2 2PQ
T 01225 830645
M 07790 685573

Camilla H Bache 148
c/o Soren Bache
Emil Slomannsvej 6
DK-2000 Copenhagen
Denmark

97 Rose Street
Edinburgh
Scotland EH2 3DT
T 00 45 38 10 24 72
M 0403 417 623

Andrew Baker 59, 133
A Début Art
30 Tottenham Street
London W1T 4RJ
T 020 7636 1064
E debutart
@coningsbygallery
.demon.co.uk
W www.debutart.com

Sarah Ballard 148
2 Hall Cottages
Little Whelnetham
Bury St Edmunds
Suffolk IP30 0DG
T 01284 386467

Simon Bartram 59
A Arena
108 Leonard Street
London EC2A 4RH
T 020 7613 4040
T 020 7613 1441
E info@arenaworks.com
W www.arenaworks.com

Paul Bateman
60, 133, 192
61 Chirton Dene Quays
Britannia Wharf
Royal Quays
Newcastle Upon Tyne
NE29 6YW
T 0191 258 5742
F 0191 258 5742
M 07980 344406
E bateman@dircon.co.uk

Katherine Baxter 193
A Folio
10 Gate Street
Lincoln's Inn Fields
London WC2A 3HP
T 020 7242 9562

Greg Becker 194
41 Whateley Road
East Dulwich
London SE22 9DE
T 020 8693 6120
F 020 8693 6120
M 07714 818164
W www.gregbecker.co.uk

John Bendall-Brunello
117
33 Cowper Road
Cambridge CB1 3SL
T 01223 411374
F 01223 411374
E john@glasspencil
.demon.co.uk

Alexander Paul Bennett
149
Hollis Farm
Pipe Lane
Orton on the Hill
Near Atherstone
Leicestershire CV9 3NF
T 01827 880829
M 07780 673577

Carey Bennett 195
44 Brookbank Avenue
London W7 3DW
T 020 8575 6572
F 020 8575 6572
M 0976 422369
E careybennett
@yahoo.co.uk
A Central Illustration Agency
36 Wellington Street
London WC2E 7BD
T 020 7240 8925
F 020 7836 1177
E central.illustration.a
@dial.pipex.com
W www.centralillustration
.com

David Bimson 150
30 Hewitt Avenue
Eccleston
St Helens
Merseyside WA10 4ER
T 01744 630299
M 07968 124282
E david.bimson@talk21.com

Christian Birmingham
118
A The Artworks
Attn. Allan Manham
70 Rosaline Road
London SW6 7QT
T 020 7610 1801
F 020 7610 1811
E info@theartwork.sinc.com
W www.theartwork.sinc.com

Gillian Blease 195
M 07951 548902

Stephen Bliss 33
Flat 4
110 Edith Grove
London SW10 0NH
T 020 7352 7686
F 020 7376 8728
M 07808 738719
E steroid@talk21.com
A Central Illustration Agency
36 Wellington Street
London WC2E 7BD
T 020 7240 8925
F 020 7836 1177
E central.illustration.a
@dial.pipex.com
W www.centralillustration
.com

Paul Blow 60, 196
24 St. George's Road
Brighton
East Sussex BN2 1ED
T 01273 681076
A East Wing
98 Columbia Road
London E2 7QB
T 020 7613 5580
E art@eastwing.co.uk
W www.eastwing.co.uk

John Bradley 61
18 Rutland Street
Old Whittington
Chesterfield
Derbyshire S41 9DJ
T 01246 238953
F 01246 238953

Sally-Ann Brady 150
25 Wolverhampton Road
Penkridge
Staffordshire ST19 5DP
T 01785 716447
F 01785 716447
M 07941 808922
E sal.brady@virgin.net

Michael Bramman
62, 197
104 Dudley Court
Upper Berkley Street
London W1H 5QB
T 020 7723 3564
F 020 7723 3564

Anthony Branch 197
27 Ashdown Crescent
Hadleigh
Essex SS7 2LJ
T 01702 555421
F 01702 557445

David Bray 198
T 01743 350355
W www.pvuk.com

Neil Breeden 198
28 Vere Road
Brighton
East Sussex BN1 4NR
T 01273 700857
F 01273 700857
E nbreeden@kiad.ac.uk

Eddie Bridge 151
Moss House Farm
Moss Lane
Glazebury
Warrington WA3 5PL
T 01925 766254
M 07866 817543
E manco@gracias.co.uk

Stuart Briers 63
186 Ribblesdale Road
London SW16 6QY
T 020 8677 6203
F 020 8677 6203
E stuart.briers
@btinternet.com
W www.stuartbriers.com

David Broadbent 199
1 Thornwood Close
South Woodford
London E18 1RH
T 0208 2206600
M 07930 226851
E broadbent@hotmail.com
W www.dbroadbent
.fsnet.co.uk

James Brown 199
43 Springthorpe Green
Erdington
Birmingham B24 0TN
T 0121 350 8561
M 07944 577779
E jimmyjames
@btinternet.com

Lizzie Buckmaster 200
PO Box 24898
London E1 6FX
T 020 7366 8553
F 020 7366 8553
M 07930 410281
E lizziebuckmaster
@onetel.net.uk
W http://web.onetel.net.uk
/~lizziebuckmaster

Bill Butcher 64, 65
Sans Work
1 Sans Walk
London EC1R 0LT
T 020 7336 6642
F 020 7253 7675
M 0966 138028
E butcher@netcomuk.co.uk

Brian Cairns 66
26 Victoria Crescent
Clarkston
Glasgow G76 8BP
T 0141 644 0382
F 0141 644 0383
E brian@briancairns.com
W www.briancairns.com

Stephen Calcutt 151
30 Rosehill
Stalybridge
Cheshire SK15 1UT
T 0161 303 9672
M 07787 170351
E stephen@calcutt57
.freeserve.co.uk

Jill Calder 67
Flat 2f
84 Constitution Street
Leith
Edinburgh EH6 6RP
T 0131 553 2986
F 0131 553 2986
M 07881 520662
E jill.c@btinternet.com
W www.eastwing.co.uk
A Eastwing
98 Columbia Road
London E2 7QB
T 020 7613 5580
E andrea@eastwing.co.uk
W www.eastwing.co.uk

Charlotte Canty 152
The Coach House
Church Street
Goldhanger
Maldon
Essex CM9 8AR
T 01621 788285
M 07939 055975

Monica Capoferri 200
16 Wey Road
Godalming GU7 1ND
T 01483 427948
M 07967 281304
E mcapoferri.spck
@virgin.net

Ben Carter 153
17 rue de Sandweiller
L-5362 Schrassig
Luxembourg
T 00 352 358 604
M 07957 605720

Carolyn Carter 154, 155
64 Gallys Road
Windsor
Berkshire SL4 5RA
T 01753 867706
M 07967 353640
E carolynjcarter@yahoo.com

Helen Carter 156
10 Winchester Crescent
Ilkeston
Derbyshire DE7 5EJ
T 0115 932 4220
M 07801 945821
E hels_bels20
@hotmail.com

Ben Challenor 156
89 Corondale Road
Weston-Super-Mare
North Somerset BS22 8PZ
T 01934 413406
M 07989 796257

Ian Chamberlain 157
114 Grattons Drive
Pound Hill
Crawley
West Sussex RH10 3JP
T 01293 413961
M 07765 662916
A Meikle John Illustration
5 Risborough Street
London SE1 0HF
T 020 7593 0500

Scott Chambers 201
Flat 4
44 Grange Park
London W5 3PR
T 020 8840 4678
M 07790 420367

Garry Parsons
49, 125, 232
Studio 115
Clerkenwell Workshops
31 Clerkenwell Close
London EC1R 0AT
T 020 7490 1882
F 020 7490 1882
M 07931 923934
E bachimitsu@aol.com

Jackie Parsons 183, 233
218 Elmhurst Street
Clapham
London SW4 6HH
T 020 7837 4629
F 020 7837 4629
M 07957 121818
E parsons@dircon.co.uk
A Central Illustration Agency
36 Wellington Street
London WC2E 7BD
T 020 7240 8925
F 020 7836 1177
E central.illustration.a@
dial.pipex.com
W www.centralillustration.
com

Daniel Pedersen 184
La fosse au Bois
St Ouen
Jersey JE3 2HB
T 01534 483642
M 07797 728859
E djvadpedersen
@yahoo.co.uk
For 2001, please contact
the AOI for my current
address details

Ali Pellatt 21
1st Floor Studio
Back Building
150 Curtain Road
London EC2A 3AR
F 020 7613 0731
M 07932 726725
E ali.p@cowboytime.co.uk
W www.cowboytime.co.uk

Simon Pemberton
102, 103
47 Turner Road
London E17 3JG
T 020 7923 9639
F 020 7923 9639
M 07976 625802
A Monster
Studio 32
10 Martello Street
Hackney
London E8 3PE
T 07790 986670
E monsters
@monsters.co.uk
W www.monsters.co.uk

Ingram Pinn 104
33 Alexandra Road
London W4 1AX
T 020 8994 5311
020 7873 3154
F 020 8747 8200
E ingram@pinn33
.freeserve.co.uk
W www.ingrampinn.com

Ian Pollock
22, 49, 105, 233
171 Bond Street
Macclesfield
Cheshire SK11 6RE
T 01625 42€205
F 01625 261390
M 07770 927940
E ian@pollocki
.freeserve.co.uk
W www.ianpollock.cjb.net
A The Inkshed
98 Columbia Road
London E2 7QB
T 020 7613 2323
W www.inkshed.co.uk

Alice Potterton 185
1 Kings Road
Evesham
Worcestershire
WR11 5BP
T 01386 45868
M 07990 687670
E alicepotterton
@hotmail.com

Catherine Powell 185
29 Victoria Road
Sheffield
South Yorkshire S10 2DJ
T 0114 266 1978
F 0114 266 1978
M 07773 617506
E glitter2dj@hotmail.com

Paul Powis 50
Four Seasons
Battenhall Avenue
Worchester WR5 2HW
T 01905 357563
F 01905 357563

Paul Price 106
A Début Art
30 Tottenham Street
London W1T 4RJ
T 020 7636 1064
E debutart
@coningsbygallery
.demon.co.uk
W www.debutart.com

Demetrios Psillos 107
17f Clerkenwell Road
London EC1M 5RD
T 020 7250 1344
F 020 7490 1175

Shonagh Rae 23
T 01743 350355
W www.pvuk.com

Nik Ramage 51
99a Newington
Green Road
London N1 4QY
T 020 7354 8355
M 07976 314302
E nikr@appleonline.net
W nikramage.com
W www.thehatstand
.force9.co.uk

Red Dot 36
M 07966 283237
M 07973 616054

Matthew Richardson
51, 141, 234
A Illustration Ltd
1 Vicarage Crescent
London SW11 3LP
T 020 7228 8882
F 020 7228 8886
E team@illustrationweb.com
W www.illustrationweb.com
/MatthewRichardson

Emma Rivett 186
5 Townsend Road
Norwich
Norfolk NR4 6RG
T 01603 454948
F 07773 598796

David Roberts 125
70 Hartington Court
Lansdowne Way
Stockwell
London SW8 2ED
T 020 7622 3546
F 020 7622 3546
A Artist Partners Ltd
14-18 Ham Yard
Great Windmill Street
London W1D 7DE
T 020 7734 7991
E chris@artistpartners
.demon.co.uk
W www.artistpartners.com

David Rooney 142, 143
The Loft House
Woodbrook
Bray
County Wicklow
Ireland
T 00 353 1 282 5635
F 00 353 1 282 5635
E lofthaus@iol.ie

Rachel Ross 144
15 Dudley Terrace
Edinburgh EH6 4QQ
T 0131 554 4174
F 0131 554 4174
A The Inkshed
98 Columbia Road
London E2 7QB
T 020 7613 2323
W www.inkshed.co.uk

Brett Ryder 24
A Heart
Top Floor
100 De Beauvoir Road
London N1 4EN
T 020 7254 5558
E heart@dircon.co.uk
W www.heartagency.com

Johanne Ryder 235
the dairy
5-7 Marischal Road
London SE13 5LE
T 020 8297 2212
F 020 8297 2212
M 07930 492471
E joh@thedairystudios.co.uk
W thedairystudios.co.uk

Jonathan Satchell 108
A Folio
0 Gate Street
Lincoln's Inn Fields
London WC2A 3HP
T 020 7242 9562

Karen Selby 24
5 Dence House
Turin Street
London E2 6BY
T 020 7729 5641
M 07946 606376
E karen@karenselby.co.uk
W www.karenselby.co.uk

Anne Sharp 126
A Folio
10 Gate Street
Lincoln's Inn Fields
London WC2A 3HP
T 020 7242 9562

Michael Sheehy 109
115 Crystal Palace Road
East Dulwich
London SE22 9ES
T 020 8693 4315
F 020 8693 4315
A Central Illustration Agency
36 Wellington Street
London WC2E 7BD
T 020 7240 8925
F 020 7836 1177
E central.illustration.a@
dial.pipex.com
W www.centralillustration.
com

Sue Shields 126
19 Heol Isaf
Radyr
Cardiff CF15 8AG
T 02920 842357
F 02920 842357
E ss.shields@virgin.net

Paul Slater 110
22 Partridge Close
Chesham HP5 3EH
T 01494 786780
01494 792562
F 01494 792562
A Thorogood Illustration
5 Dryden Street
Covent Garden
London WC2E 9NW
T 020 7829 8468
W www.thorogood.net

Andy Smith 52
T 01743 350355
W www.pvuk.com

Meilo So 127, 235
A The Artworks
Attn. Allan Manham
70 Rosaline Road
London SW6 7QT
T 020 7610 1801
F 020 7610 1811
E info@theartwork.sinc.com
W www.theartwork.sinc.com

Simon Spilsbury 236
A Central Illustration Agency
36 Wellington Street
London WC2E 7BD
T 020 7836 1090
F 020 7836 7366
M 0585 629597
E simon@12foot6.com
E central.illustration.a@
dial.pipex.com
W www.centralillustration
.com

Julia Staite 186
The Old Manse
25 Westfield Road
Barton-on-Humber
North Lincolnshire
DN18 5AA
T 01652 635982
M 07713 603234

Ana Stankovic-Fitzgerald
237
137a Bell Lane
London NW4 2AR
T 020 8202 4761
M 07940 715101
E ana-sf
@fever0.demon.co.uk
W www.uberkunst.com

Deborah Stephens 237
52 Whitehall Lane
Buckhurst Hill
Essex IG9 5JG
T 020 8504 6221
F 020 8504 6221
M 07798 828123
E deborah.stephens
@talk21.com
W www.contact-uk.com
/deborahstephens
A Three in a Box
468 Queen St. East
No. 104, Box 03
Toronto ON
M5A 1T7
Canada
T 020 8853 1236

Simon Stern 53
19 Corringham Road
London NW11 7BS
T 020 8458 8250
F 020 8458 8250
E simonstern@atlas.co.uk
W www.contact-me.net
/simonstern
A The Inkshed
98 Columbia Road
London E2 7QB
T 020 7613 2323
W www.inkshed.co.uk

Andrew Steward 238
28 Hanover Terrace
Brighton
East Sussex BN2 2SN
T 01273 692726
F 01273 692726
M 07880 641175
E steward@btclick.com
W http://home.btclick
.com/steward

Peter Suart 25
The White Cottage
High Street
East Meon
Petersfield
Hampshire GU32 1PX
T 01730 823104
F 01730 823104
E siege.perilous@virgin.net

Brian Sweet 53
A Arena
108 Leonard Street
London EC2A 4RH
T 020 7613 4040
T 020 7613 1441
E info@arenaworks.com
W www.arenaworks.com

Alastair Taylor 111
105 High Street
Maldon
Essex CM9 5EP
T 01621 850528
F 01621 853640
E alas@btinternet.com
A The Inkshed
98 Columbia Road
London E2 7QB
T 020 7613 2323
W www.inkshed.co.uk

Mark Thomas 26
62 Kings Road
Teddington
Middlesex TW11 0QD
T 020 8943 4626
F 020 8943 4626
E markthomas@illustrating
.demon.co.uk
A Central Illustration Agency
36 Wellington Street
London WC2E 7BD
T 020 7240 8925
F 020 7836 1177
E central.illustration.a@
dial.pipex.com
W www.centralillustration.
com

Matthew Tillett 238
5 Narrow Lane
Warlingham
Surrey CR6 9HY
T 01883 624624
E matthewtillett
@hotmail.com

Mike Todd 239
79 Eleanor Road
Waltham Cross
Herts EN8 7DW
T 01992 636737
F 01992 636737
E mike@oddballproductions
.co.uk
W www.oddballproductions
.co.uk

Nancy Tolford 112
20 Park Road
Walthamstow
London E17 7QF
T 020 8520 9204
E nancytolford
@appleonline.net
W www.nancytolford.com

Oyvind Torseter 112
Ullevalsveien 67
N-0454 Oslo
Norway
T 00 47 9180 8095
F 00 47 2320 2566
E oey-to@online.no

Bob Venables 26
109 Tuam Road
London SE18 2QY
T 020 8316 0223
F 020 8316 0223
M 07752 437487
E robert.venables@virgin.net
A Thorogood Illustration
5 Dryden Street
London WC2E 9NW
T 020 7829 8468
F 020 7497 1300
W www.thorogood.net

Russell Walker 54
2 St Albans Road
Colchester
Essex CO3 3TQ
T 01206 577766
E fetch.walker@virgin.net
W www.russellwalker.co.uk

Holly Warburton 27
T 01743 350355
W www.pvuk.com

Peter Warner 240
Peter Warner's Studio
Hillside Road
Tatsfield
Kent TN16 2NH
T 01959 577270
F 01959 577271
M 07958 531538
E thestudio
 @peterwarner.co.uk
W www.peterwarner.co.uk
I 01959 577171

Stephen Waterhouse
128
2A Norwood Grove
Birkenshaw
Bradford
West Yorkshire BD11 2NP
T 01274 877111
F 01274 877111
E stephenwaterhouse
 @hotmail.com
W www.contact-me.net
 /stephenwaterhouse
A Heather Richards
9 Somerville Lea
Church Farm Green
Aldeburgh
Suffolk IP15 5LH
T 01728 454921

Tony Watson 54
124 Cambridge Street
Wolverton
Milton Keynes MK12 5AQ
T 01908 316273
F 01908 316273

Paul Wearing 28, 55, 113
P W Art Limited
Unit B4, Metropolitan
Wharf
Wapping Wall
London E1W 3SS
T 020 7481 4653
F 020 7481 4654
E paulwearing@illustrator
 .demon.co.uk

Louise Weir 241
Studio 32
10 Martello Street
London Fields E8 3PE
T 020 7923 9639
F 020 7923 9639
M 07966 284090
A Monster
Studio 32
10 Martello Street
Hackney
London E8 3PE
T 07790 986670
E monsters@monsters.
 co.uk
W www.monsters.co.uk

Chris West 29
A David Morrison,
 Black Hat
4 Northington Street
Bloomsbury
London WC1N 2JG
T 020 7404 6936
 020 7430 9146
F 020 7430 9156

Ian Whadcock 30, 32
E whadcock@mailbox.co.uk
A Eastwing
98 Columbia Road
London E2 7QB
T 020 7613 5580
E art@eastwing.co.uk
W www.eastwing.co.uk

Greer Whitewick 242
132c Brixton Hill
London SW2 1RS
T 020 8671 2421
M 07946 528288
E wink@misswhitewick
 .fsnet.co.uk

Mark Wilkinson 56, 242
A Illustration Ltd
1 Vicarage Crescent
London SW11 3LP
T 020 7228 8882
F 020 7228 8886
E team@illustrationweb.com
W www.illustrationweb
 .com/MarkWilkinson

Bee Willey 129
A Illustration Ltd
1 Vicarage Crescent
London SW11 3LP
T 020 7228 8882
F 020 7228 8886
E team@illustrationweb.com
W www.illustrationweb
 .com/BeeWilley

Dan Williams 243
A Big Orange
2nd Floor, Back Building
150 Curtain Road
London EC2A 3AR
T 020 7739 7765
F 020 7613 2341

Alex Williamson 144
A Début Art
30 Tottenham Street
London W1T 4RJ
T 020 7636 1064
E debutart
 @coningsbygallery
 .demon.co.uk
W www.debutart.com

Marisa Willoughby 187
Flat 1
27 Maygrove Road
London NW6 2EE
T 020 8450 8541
F 020 8450 8541
M 07909 962715
E m.willoughby
 @appleonline.net

Anne Wilson 130
A Illustration Ltd
1 Vicarage Crescent
London SW11 3LP
T 020 7228 8882
F 020 7228 8886
E team@illustrationweb.com
W www.illustrationweb
 .com/AnneWilson

Kate Wilson 188
2 Star Brewery Workshops
Castle Ditch Lane
Lewes
East Sussex BN7 1YJ
T 01273 486718
F 01273 486718

Luke Wilson 188
29 Grove Road
Weston Super Mare
North Somerset BS22 8EY
T 01934 415240
M 07779 119486

Janet Woolley 114
A Arena
108 Leonard Street
London EC2A 4RH
T 020 7613 4040
 020 7613 1441
E info@arenaworks.com
W www.arenaworks.com

Anita Yeomans 244
26 Hannay Lane
Crouch End
London N8 9QQ
T 020 7272 8002
M 07759 115496
E anitayeomans
 @lineone.net
W www.imaginita.co.uk